CRAFTS

Contemporary Design and Technique

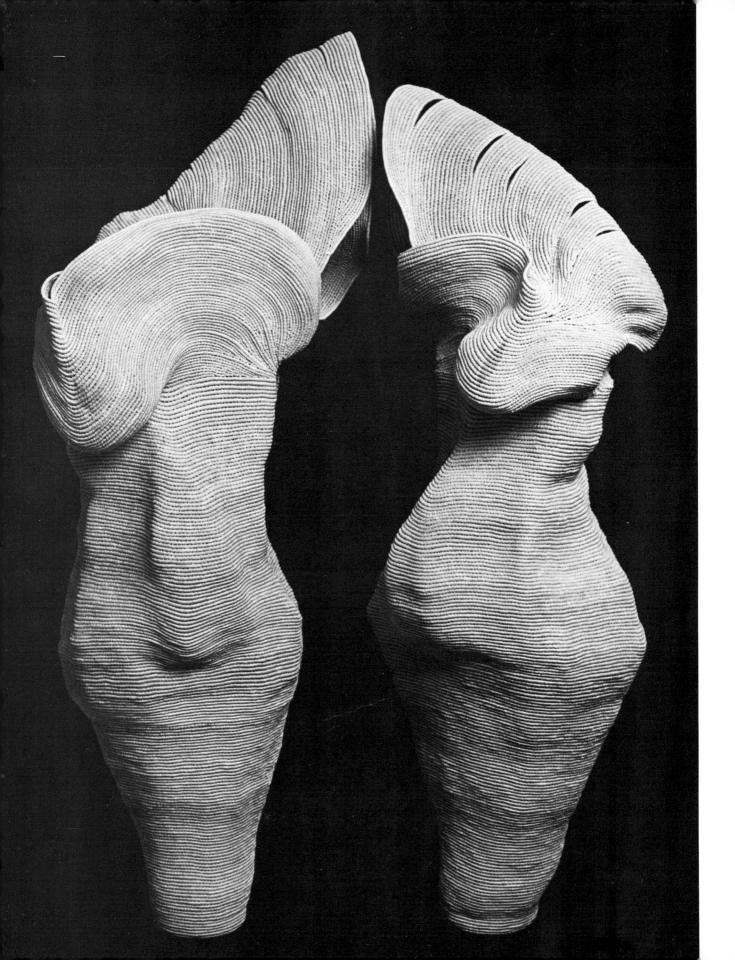

CRAFTS

Contemporary Design and Technique

Alice Sprintzen

Davis Publications Inc. Worcester, Massachusetts

To Shirley and Dan

Design: Susan Marsh
Printed in the United States of America
Library of Congress Catalog Card Number: 86-70902
ISBN: 0-87192-180-4

10 9 8 7 6

Front cover:
Judith Content. Pleated paper fans; parchment, crayon,
paint and ink. 12″ X 16″. 1986. Photo by the artist.

Back cover:
Sid Garrison. DISTANCE AND DIRECTION #2. Leather
box. 1984.

John Flemming. L'APPRENTI SORCIER. Leather mask.
30″ X 26″. 1985.

Frontpiece:
Barbara Joan Solomon. TWO FOR ONE. 15″h. X 37″w.
X 7″d. Waxed linen thread wrapped around linen twine.

Contents:
Red Grooms. RED ROXY. 8″ X 12″ X 6″. (Detail). Cut
and folded lithograph. Courtesy Van Straaten Gallery,
Chicago.

Lillian Donald. ABAT. 32″ X 72″. Tie-dye on silk. Photo
by Gyuri Hoffmann.

Randy Fein. BROWNSTONE CONTAINER. Photo by
Brian Van den Brink.

William Barash. Box with drawers.

Daphne Lingwood. Cowhide, dye, acrylic paint, magnets.

Dominic DiPasquale. THE ZIPPER. Sterling silver
neckpiece.

✦ ✦ ✦ ✦ ✦ ✦ ✦ ✦ ✦ ✦ ✦ ✦ ✦ ✦ ✦

Contents

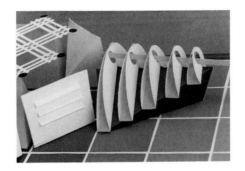

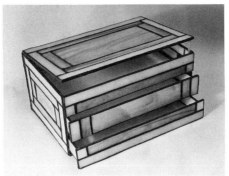

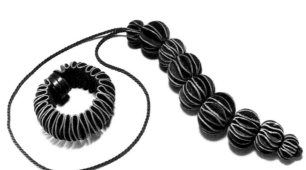

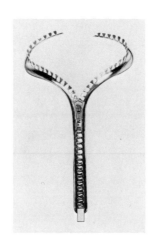

Acknowledgements

Part of the joy of writing this book was having the opportunity to work with many craftspeople who warmly and generously shared their expertise and time. I am proud to be part of a movement whose members are both appreciative of one another's gifts and who are so willing to share their body of knowledge. In particular, I would like to thank the following people: Arlene Absath, William Barash, Harriet Berke, Fran Bisso, Sheldon Bloom, Charlotte Brown, Tafi Brown, the faculty of the C.W. Post College Crafts Center, Layne Goldsmith, Lisa Gralnick, Joan Harrison, Barbara Karyo, Rose Krebes, Joel Kupferman of Worth Leather Company, Dorothy Lazara, Arlene Maxfield, Russel Maxfield, Renee O'Brien, Alice Wansor, Graziella Weber, Don Wiener of Pro Chemical and Dye Company, Ronnie Wolf, Julian and Sylvia Wolff.

I am also grateful to the students at Suffok County Community College, Oyster Bay High School and Syosset High School on Long Island. My thanks to the following for providing their work: I-Hua Chiu, Ellen Goldfader, Sue Gurney, Linda Hirschhorn, Donna Lasky, Lori Lemanczyk, Elizabeth Monroy, James Seufert and Belanne Ungarelli.

It was only through organizations dedicated to furthering crafts, including the Long Island Craftsmen's Guild, the American Crafts Council, the Brookfield Crafts Center and the U.S. Department of the Interior, Indian Arts and Crafts Board, that I was able to contact many of the people who generously contributed photographs of their work and who supported my efforts through words and deeds.

I would also like to thank Tom Kirkman of J.T.M. Photo for the fine job he did of printing the photographs, and to Elyse Sommers who had more faith in my abilities than I did and thereby started me off on this marvelous pursuit.

I am especially grateful to Alice Medine King for her poignant words of wisdom and to Wyatt Wade, my editor, for being the knowledgeable, supportive and kind person that he so naturally is.

My husband, David, and son, Daniel, who supported me through thick and thin and put up with my involvement in this manuscript sometimes to the exclusion of everything else, deserve a particularly warm thanks.

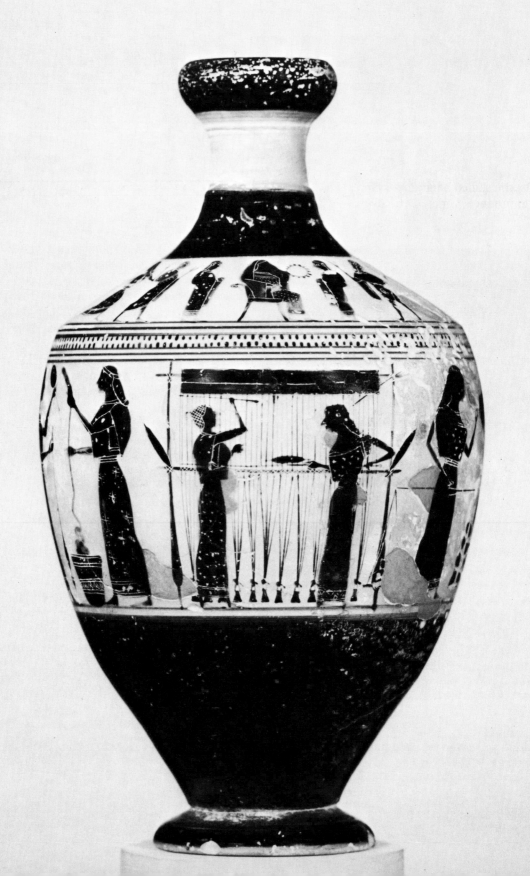

1 · INTRODUCTION

In the crafts, the skilled hand and the creative mind join to produce works of art governed by the constraints of utility. The role of crafts has expanded and contracted throughout time to meet the demands of each era. Today's crafts movement is undergoing an exciting period of rapid growth. It has passed through adolescence and emerged a mature, rich and complex form of expression.

Crafts are unique in that they merge form and function to yield solutions that are beautiful as well as practical. In recent years the distinction between art and craft has blurred. Many works of craft now have increasingly less to do with function. Jewelers may mount their work on a display stand, presenting it as sculpture as well as jewelry. Weavers create painting-like wall hangings that transcend utilitarian function. At the same time, fine artists are incorporating more of the materials and techniques traditionally associated with crafts in their work.

This book presents an overview of crafts techniques. They are explored at a sophisticated yet technically manageable level. In some cases a more advanced form of a craft is presented because it yields superior results, warranting the extra effort. In other cases, a simple method will produce excellent results and is thus preferred. Projects are designed to acquaint the reader with the basic tools and processes of each craft.

The book is extensively illustrated with the work of a wide range of craftspeople. Their work is both aesthetically and technically of very high quality. It is presented to expose the reader to the possibilities of the media and to serve as a source of inspiration.

Greek Attic black-figured vase. **WOMAN WORKING WOOL. VI B.C. The Metropolitan Museum of Art, Fletcher Fund, 1931. (31.11.10)**

Design in Craft

Ideas for design grow from our encounters with the natural as well as the constructed environment. Our powers of observation tell us a great deal about texture, form, color and pattern. Our emotions add further depth to our work. Artists often use the works of other artists as a source of inspiration. Studying the art of our predecessors and contemporaries in books, museums and galleries exposes us to a wide range of viewpoints.

Ideas also grow from the inherent qualities of materials and techniques, as well as from the functional demands of the objects themselves. Designing a unique means of attaching metal jewelry to the body or producing a clay teapot that is comfortable to handle and pours well invites creative solutions to old problems. These experiences expand our reservoir of design ideas.

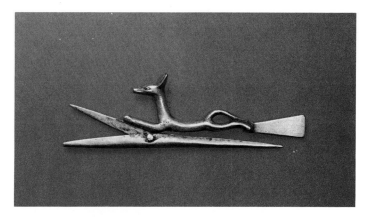

Egyptian ca. 1570 B.C. Gold hair curler. The Metropolitan Museum of Art, Purchase, Lila Acheson Wallace Fund, Inc., Gift, 1977. (1977.169)

Judging the effectiveness of a design is a continuing process. Through constant self-evaluation you will decide what works and what must be changed. Through experimentation and practice you will gain confidence in your ability and discover your unique style. Future projects will reflect a continuing growth in your craft.

✦ ✦ ✦ ✦ ✦ ✦ ✦ ✦ ✦ ✦ ✦ ✦ ✦ ✦ ✦ ✦

History of Craft

At one time, crafts were a way of life. Before mechanization, objects used in daily life were by necessity made by hand. People being creative by nature often were not content to make ordinary, crude objects. Drawing the raw materials from their immediate surroundings, they began fashioning functional objects in original, aesthetic ways. Thus their need for the basic implements of life inspired beautiful works.

The Industrial Revolution

Towards the end of the Middle Ages as the feudal barter system was replaced by a money economy, the expansion of trade created an ever widening demand for goods. To accommodate the demand, manufacturing gradually developed from individualized hand production, through the development of the cottage industry, to the grouping of production workers under one roof.

This change facilitated the process of mechanization and division of labor. Rather than one craftsperson being responsible for the entire production from design through fabrication, individuals were reduced to increasingly narrow roles in the production process. The quality of the article became secondary to the quantity that could be produced quickly.

The expensive machines which replaced hand tools brought about the production of standardized goods at a lower cost. But they also drove the craftsperson out of business. The general standard of living improved, but there was a price to be paid: the decline of hand production. By the middle of the 19th century, crafts were thought to be old-fashioned and outmoded. Few continued working in the old tradition.

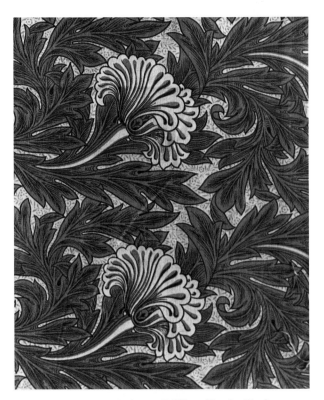

Morris & Company, designer: William Morris. Block printed textile. 1834–1896. The Metropolitan Museum of Art, the Theodore M. Davis Collection, bequest of Theodore M. Davis, 1915. (30.95.44)

The Arts and Crafts Movement

A desire to improve the increasingly poor quality and design of mass-produced products motivated the Arts and Crafts Movement in late 19th century England. The Gothic Revivalists, Pre-Raphaelite painters and the writings of the English social theorist John Ruskin gave impetus to this new movement which reinstated the notion of design, function and craftsmanship as integral parts of society.

The leader of the Arts and Crafts Movement, William Morris, was a painter and architect. He rejected the trend toward mechanization. Morris crusaded for the exploitation of the true essence of materials and worked to restore the status of handcrafts. To these ends Morris started his own company which produced handcrafted household articles including stained glass, wallpaper, fabric and furniture. The quality and popularity of crafts today owes much to this revival.

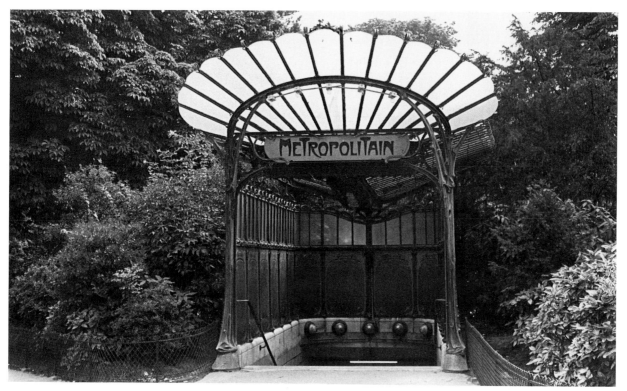

Hector Guimard. **MÉTRO ENTRANCE, Porte Dauphine, Paris.**

Art Nouveau

The Art Nouveau movement began in the late 19th century and spread throughout Europe and America. Influenced by the art of Japan as well as the Arts and Crafts Movement, it rejected the emphasis on the art of classical antiquity. In its place this "new art" looked directly to nature, using plant-like forms and replacing straight lines with curves. It sought to unify form and content and place the decorative arts on an equal footing with the fine arts. The designs for the Paris Metro entrances by the French architect Hector Guimard exemplify the qualities of the Art Nouveau style.

Another designer who worked in this style was the American Louis Comfort Tiffany. His studio is best known for its handmade glass from which it produced magnificent vases, stained glass windows and lamps.

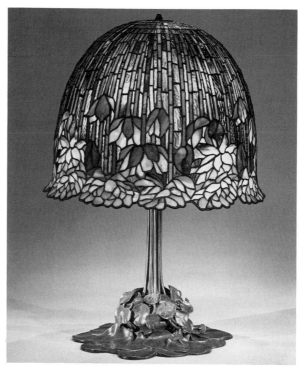

Tiffany Studio. Table lamp. Leaded glass shade and bronze base. XIX–XX century. The Metropolitan Museum of Art, Gift of Hugh Grant, 1974. (1974.214.15)

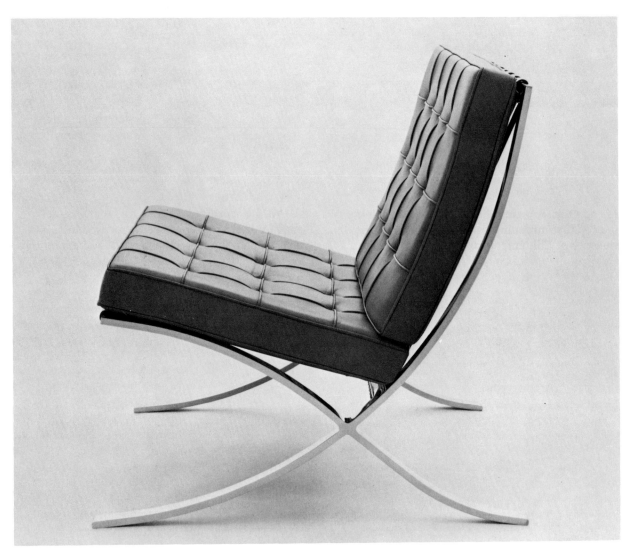

Ludwig Mies van der Rohe. BARCELONA CHAIR. Chrome-plated flat steel bars with pigskin cushions. 29⁷⁄₈" X 29¹⁄₂" X 29⁵⁄₈". 1929. Collection, The Museum of Modern Art, New York. Gift of Knoll International.

The Bauhaus

While the followers of Morris and the Arts and Crafts Movement viewed the machine as a destructive force, some had a more positive view of technology's role in the crafts. Under the direction of architect Walter Gropius, the Bauhaus was opened in Germany in 1919. The purpose of this most influential art school was to integrate fine art, craft and technology. To this end both fine artists and master craftspeople were hired to teach. Students were encouraged to create tapestries, stained glass, pottery, furniture as well as paintings and sculpture. The same aesthetic principles were applied to all. At the Bauhaus, people trained in the arts were encouraged to design industrial mass-produced products. A new field of industrial design was thus created.

In 1933 the Nazis forced the Bauhaus to close. Many faculty members and students moved to the United States where they found a setting ripe for their ideals. One of the Bauhaus instructors, Moholy-Nagy, founded the Chicago Institute of Design which continued to foster the philosophy of the Bauhaus.

Contemporary Crafts in United States

The modern crafts movement owes much to potter and crusader for the crafts, Aileen Osborn Webb. In 1940 she opened a retail store in New York known as America House. It was devoted entirely to promoting fine crafts. In 1943 she founded the American Craftsmen's Council to encourage the artist-craftsperson and educate the public. Out of this organization grew the magazine *Craft Horizons* and the first museum devoted entirely to crafts, the Museum of Contemporary Crafts. The World Craftsmen's Council followed in 1964 stimulating communication between craftspeople on an international scale. These new avenues of communication and opportunities for exposure were instrumental in raising standards in the field.

New life was breathed into the crafts movement following World War II. After witnessing the devastation of war, many veterans returned home seeking practical ways to pursue their careers. Encouraged by the G.I. Bill which granted money to veterans to further their education, many chose fields where they could work with their hands. They enrolled in university crafts courses thus creating a demand for greatly expanded programs in this area. University training in the crafts has continued to this day.

The 1950s saw a movement away from crafts' traditional concentration on function. The boundaries between crafts and "fine art" were breaking down. The Abstract Expressionsist Movement influenced craftspeople such as Peter Voulkos who abandoned traditional constraints in favor of personal expression. He expanded the limits of traditional pottery and moved into the realm of sculpture, creating work that pertained more to form and emotion than function. Woodworker Wendell Castle began to stack laminate wood strips to produce a block that could be carved like sculpture, creating furniture not limited by conventional joinery. Weaver Lenore Tawney developed her work into three dimensions and thus freed weaving from the wall. Boundaries were being expanded and there was no turning back.

Crafts in the 1960s were popular among the counter cultural generation. They fostered a way of life based on personal exploration and basic back-to-the-earth living. Crafts were an important adjunct to the cooperatives and communities which cropped up throughout the U.S. at this time.

As the speed of technological change quickened in the 1970s, craftspeople focused increasingly on developing technical skills and exploring the limits of materials as well as processes. Many technique books were published, and people enrolled in crafts courses in record numbers.

Today there has been an explosion of interests in the crafts. Fine crafts now appear in department stores; corporations are commissioning handcrafted works to decorate their buildings; universities are expanding their offerings to include courses on a wide variety of crafts as well as crafts marketing. An unprecedented number of galleries, museum exhibits and fairs are being dedicated to crafts, providing exposure for the craftsperson as well as an education for the public. This exposure has promoted a wide market for unqiue works of craft. Concurrently, the professional craftsperson is learning business skills, making it feasible to earn a living at something that was, until recently, enjoyed primarily as a labor of love.

The current vitality of the crafts movement is evidence of the pleasure we gain from working in direct contact with materials and processes. While modern technology separates the individual and the hand from the product, crafts reestablishes that link. By combining creativity, technical mastery, personal statement and functional capability, crafts offer a challenge to which increasing numbers of people are looking.

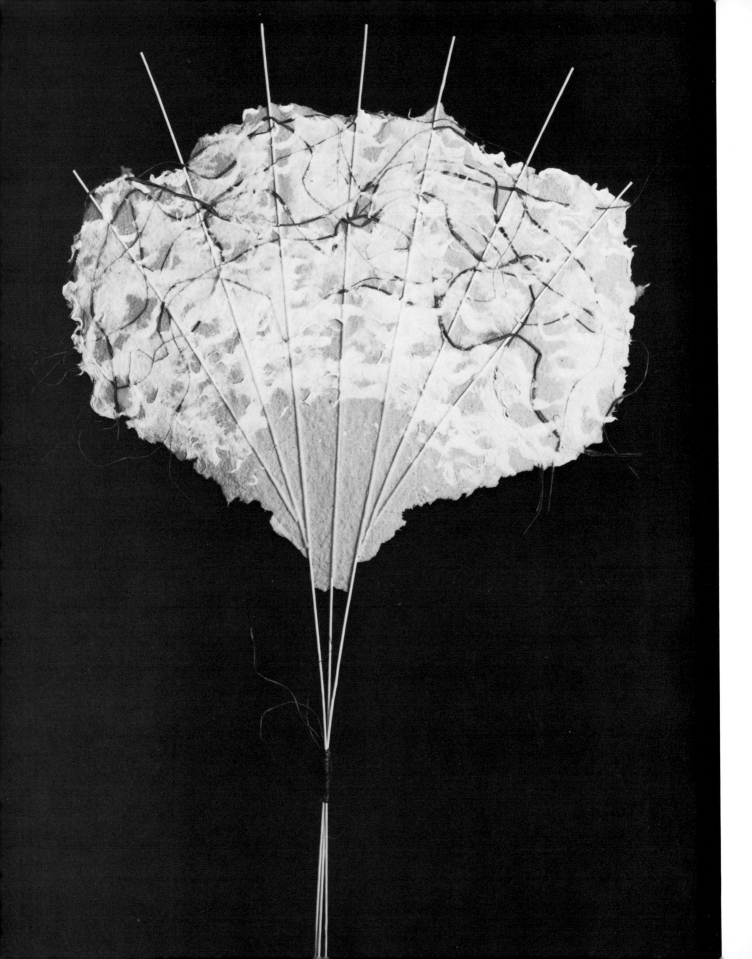

◆ ◆

1 ⋅ PAPER

Nothing is more common than paper; yet it presents infinite possibilities for creating unique works of art. Paper was first invented in China about 2000 years ago. Today it is an ever-present part of our lives, and is made into anything and everything from money to clothing, furniture to building materials. The average person in the U.S. consumes over 600 lbs. of paper each year.

developing the more appealing ideas. Keep your mind open to new combinations of materials and techniques. Try working in different sizes, combining a variety of colors and forms and working two- and three-dimensionally, to make your own statement in paper.

◆ ◆ ◆ ◆ ◆ ◆ ◆ ◆ ◆ ◆ ◆ ◆ ◆ ◆ ◆

Manipulating Paper

Paper has many qualities that make it suitable for manipulating in a variety of ways. It can be strong or delicate, waterproof or absorbent, rigid or flexible, textured or smooth, transparent or opaque. It is easily rolled, bent, scored, folded, cut, ripped, crushed, twisted, glued, woven, laminated, dyed and curled. Paper can do all of this; yet its vast potential as a craft medium is often overlooked.

The techniques for manipulating paper in this book are merely take-off points from which to begin explorations. They represent a few of the many ways paper can be used in crafts. Since paper is inexpensive and readily available, experimentation with any of these techniques may be undertaken without being overly concerned with making "mistakes." Take this rare opportunity to learn the techniques and branch off in different directions, discarding work that is not fruitful and

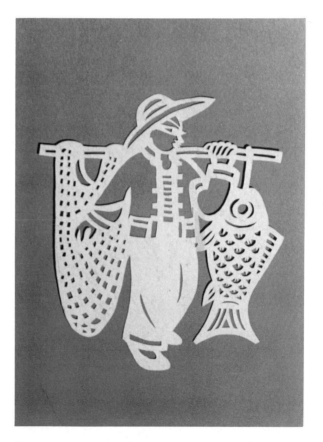

Constance Miller. PAPER FAN Series. 24" X 36". Reeds and fibers are trapped between layers of dyed paper pulp to produce this handsome fan. The structural lines of the fan's skeleton contrast with the free-floating threads embedded in the paper.

Paper cutouts are a popular craft in China. Sometimes several layers of paper are cut simultaneously to produce identical designs. Here, the contrast of the lacy image against the dark background highlights the intricate cuts.

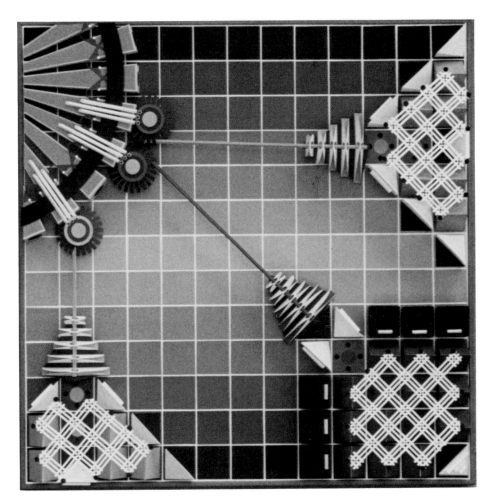

Brian K. Arbogast de Hubert-Miller. HDC #1647. One panel of three. Commissioned for Litton Industries, Laser Division Headquarters. 48" square. 1985. This cut, scored and folded paper construction reflects the forms of a technological age.

Detail of the above.

Folding

Everyone has folded paper, but how many of us fully appreciated the sculptural possibilities of this simple procedure? When folding, the paper is bent upon itself. For successful folding, it is important to use the proper weight paper so that creases will be crisp. For precise lines, bend the paper over a straightedge. Then use your fingernail or an instrument such as the side of scissors to press down the fold. Folding paper a number of times upon itself will add dimension as well as strength.

Origami. Origami is the art of Japanese paper folding that originated in medieval Japan where the technique and associated legends were

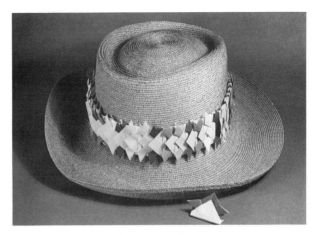

Origami hatband. Colored origami helmets were threaded together to create an attractive pattern.

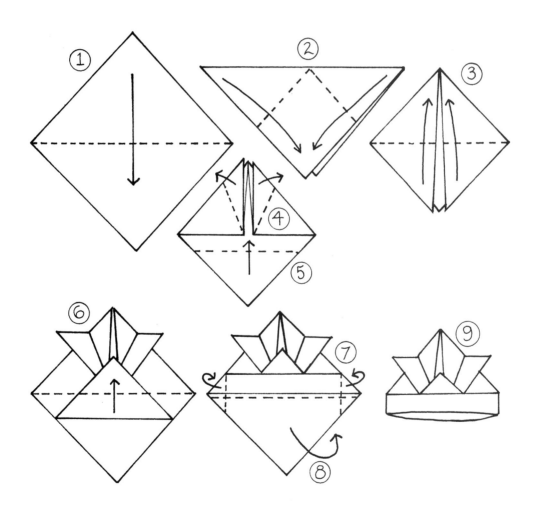

Fold a square piece of paper along the dotted lines, as shown in the diagram, to create this origami helmet.

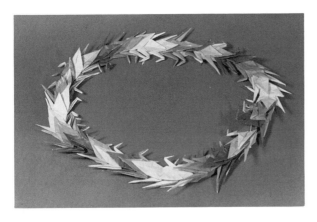

Origami necklace. These origami cranes, strung on a strong thread, can be worn as a necklace.

passed on by the women from generation to generation. Virtually any form can be folded from an ordinary sheet of paper. Animals, flowers, birds, insects, figures and abstract shapes take shape with just a few folds.

The forms presented here show some of the basic folds. You may wish to experiment and invent your own folds and combinations. Advanced books on origami give instructions for creating many additional forms. It is a good idea to practice some of the traditional forms until the language of origami becomes second nature to you. Then, with a vocabulary of folds at your fingertips, you will be able to create your own forms.

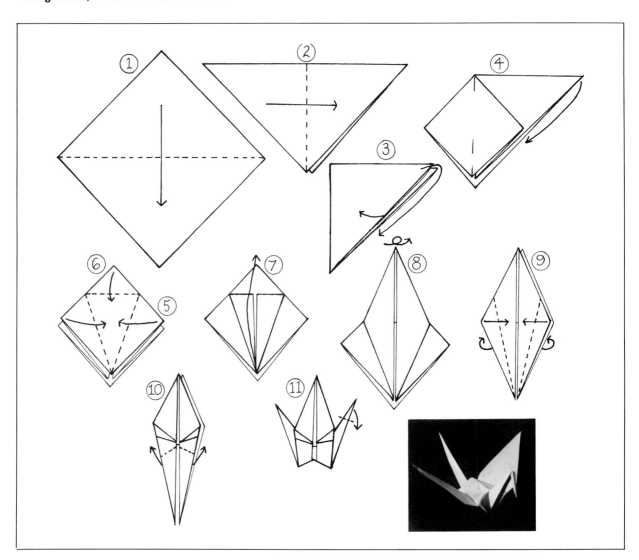

Fold a square piece of paper along the dotted lines, following the diagram, to create an origami crane.

Special origami paper (white on one side and colored on the other) may be purchased at most art supply stores. Origami paper is traditionally square. If it is difficult to obtain origami paper, or if you wish to try other types of paper for variation in size, pattern, texture or other qualities, any lightweight paper which can be easily folded is appropriate. Magazine pages, newspaper, wrapping paper or even candy wrappers may be used. For large forms, heavier paper may also be used.

Ripping

We have all torn paper accidently; however, ripping may also be a controlled process. The ripped paper edge may be exploited for its irregular, textural quality. Some paper, such as newspaper, will rip straighter with, rather than across its grain.

Scoring

Before you bend a thick sheet of paper, score it to insure an accurate fold. Heavy paper such as bristol board is ideal for scoring. The design to be scored may first be drawn lightly in pencil. A scored line is either compressed or incised into the paper with a pointed or sharp instrument such as a compass point or knife.

To score the line, guide the knife gently along a straight or curved edge, or work without a guide. The line is thus compressed or incised, creating a break in the continuity of the paper, along which it can be bent. Take care not to cut too deeply. Make your curves simple since gently curving lines are easier to bend than sharp curves. Score on both sides of the paper at different locations for even greater variety. By experimenting, you will become familiar with the limits of this elegant, sculptural technique.

Several strips of paper were ripped and glued to background paper. The torn edges impart texture.

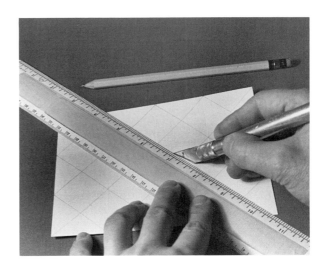

To score a straight line, draw a knife along a straightedge, incising part way through the paper. The paper can then be easily bent along this line.

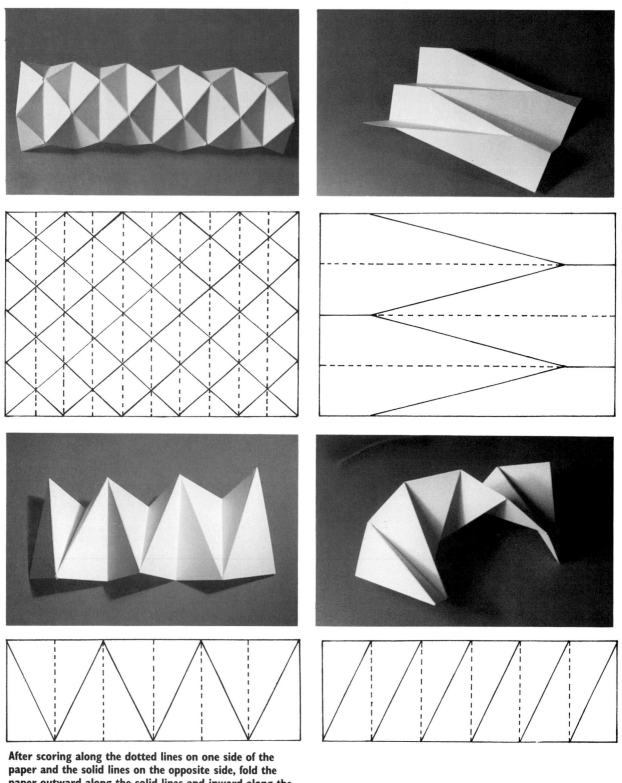

After scoring along the dotted lines on one side of the paper and the solid lines on the opposite side, fold the paper outward along the solid lines and inward along the dotted lines to create the forms corresponding to each diagram.

Brian K. Arbogast de Hubert-Miller. HDC #1635. 60" X 84". Commissioned by the Kirchman Corporation. 1985. Crisp folds and stark white paper reflect different values of light in this elegant relief.

Detail of the above.

Cutting

A range of effects may be created by cutting paper with a razor, knife or scissors. Among the possibilities presented are internal cuts, border cuts, cuts in which parts of the paper are totally removed or where they remain anchored to the original sheet. Try making repeated cuts along an edge to create a fringe. Experiment on folded paper. Make groupings of tiny cuts to create a textural surface pattern.

The story of Noah's Ark is interpreted symmetrically in cut paper was produced by cutting paper that was first folded in half.

This Polish farm scene was cut and glued in layers to a background sheet of paper. This craft, known as wycinanki, was developed in the 19th century by Polish farmers who used sheep shears to cut detailed pictures.

Donna Coats Friedman. PRIMARY LIGHT. 21" X 21. This composition was created by folding the paper away from razor-cut Xs.

Donna Coats Friedman. Detail of ECHO. Cut and folded paper.

Cut slits with a knife and fold the paper away from the slit. Textural dots may be poked with a pointed tool such as a compass point.

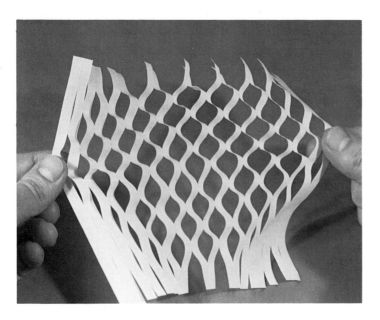

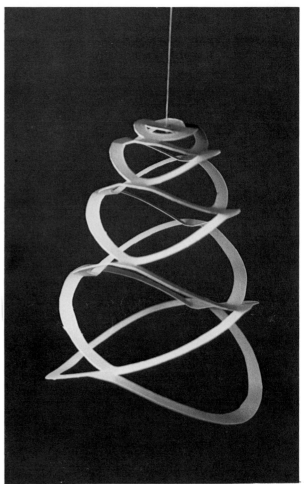

Use a knife to cut along the solid lines to create these two expanded paper forms. A flat sheet of paper can thus be transformed into a sculptural form.

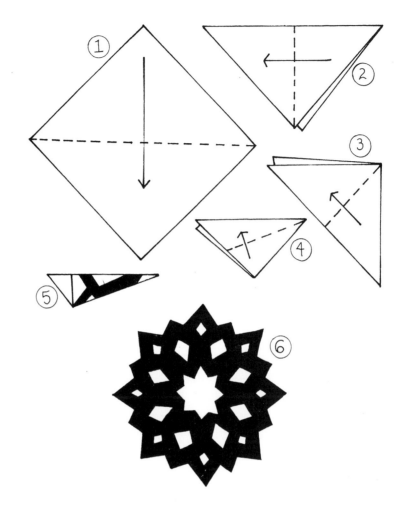

Fold along the dotted lines according to the diagram and cut shapes out from either side of the resulting triangular form to create a circular cutout. The variations are infinite.

Circular cutouts add decoration to cards, boxes, windows or just about anything.

Weaving and Braiding

Woven or braided paper is made from straight or curved interlaced strips of paper. The resulting forms may be two- or three-dimensional. Interweave horizontal and vertical paper strips of contrasting colors to create color patterns. Wavy strips of varying widths produce particularly exciting patterns. Some of the weaves described in the fiber section of this book may also be executed in paper.

To braid, lay three or more strips of paper alongside one another. Pass the first strip on the right alternately over and under the strips to the left. Repeat, always beginning with the first strip on the right and passing it over the second strip. Thus the first strip becomes the last. Continue until the desired length of braided paper is completed. To introduce pattern into a braided piece, work with strips cut from colored paper or magazine photos.

Two strips folded alternately over one another will yield this accordion form.

Braiding may be done with three or more strips of paper. Varying the colors will introduce pattern into the braids.

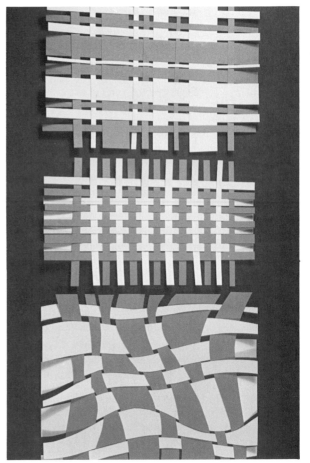

By varying the width and shape, as well as the color of the paper strips, dynamic patterns can be created.

Twisting and Curling

Twist or curl paper when you wish to create three-dimensional forms without the hard edges produced by folding. To curl, draw the paper tautly under or over the side of a ruler or a table edge or scissors blade. The outer surface of the paper will thus be stretched, causing the paper to curl.

Manipulating Paper: Branching Out

✦ Create a mobile using a variety of folded forms. You may wish to hang the forms from thin wire, fishing line or thread suspended from a hoop, an "X" of strong wire or a large folded paper form.

✦ Fold or score multiples of a single form and join them together with glue, string or thread to form a modular sculpture, necklace or other form.

✦ Select two pages from a magazine. Choose strong images that complement one another. Cut one page into horizontal strips and the other into vertical strips. Interweave the two images to create a new image.

✦ Using sturdy paper such as bristol, score and bend a sheet several times to create a sculptural form or a lampshade.

Create a mask from paper that is scored, folded, fringed, twisted, braided, curled, slit and otherwise manipulated.

✦ Experiment with folded paper that is cut with a small, sharp scissors to create realistic or abstract images. If the paper has been folded in half, each side will be a mirror image of the other. If it is folded several times, multiples of the image will appear when the paper is unfolded.

✦ Using a pin, create a variety of elegant note cards by piercing designs into the cover of each card.

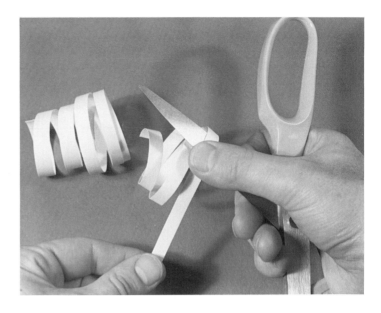

Curl paper by drawing it over the edge of a scissor.

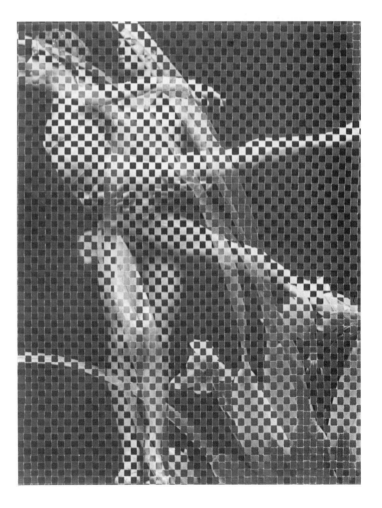

Carol Hartsock. NASCENSE. 1983. The graceful, radiant forms of two dancers contrast strongly with the darker checkerboard pattern in this paper weaving formed from two complimentary images cut into strips. Photo by Marie-Christine Basset.

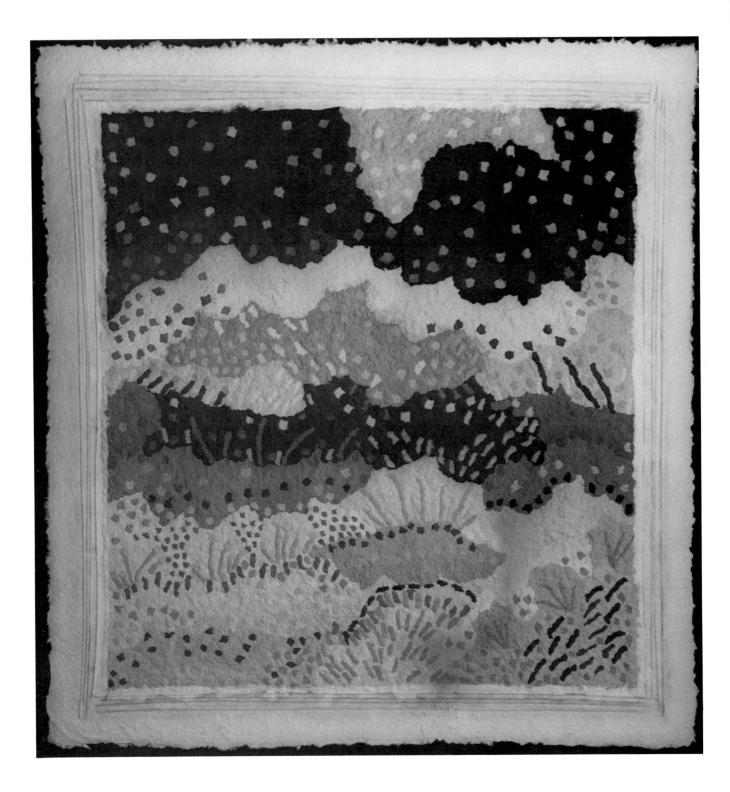

Constance Miller. ROW BY ROW Series. 48" X 54". Dyed paper pulp was used to make the design on this handmade paper. Confetti-like fragments accented the rhythmic bands of color.

◆ ◆ ◆ ◆ ◆ ◆ ◆ ◆ ◆ ◆ ◆ ◆ ◆ ◆ ◆

Handmade Paper

Handmade paper has aesthetic qualities which reach well beyond commercially manufactured paper. Not only can an elegant sheet of paper enhance a work executed upon it, but handmade paper stands on its own as a work of art. Whether you use traditional or contemporary methods to create your paper, this craft offers many opportunities for creativity. The materials and techniques are simple, inexpensive and accessible. The possibilities are inexhaustible.

Paper pulp, the material from which paper is made, can be sprayed, poured, dipped or manipulated by hand to create sheets of texturally rich or smooth paper of any thickness. The pulp as well as the finished sheet may be dyed to incorporate an image, flecks or other color variations. To expand the possibilities of this medium into three dimensions, pulp may be cast into a mold or applied to a three-dimensional framework.

Pouring a Sheet of Paper

A paper sheet is formed on a mold composed of two sections; the deckle and frame. The pulp is deposited on the frame in any one of several ways including pouring, patting by hand or dipping the mold into a vat of water in which pulp is suspended. The frame is usually made from wood strips over which screening is stretched. It acts as a porous platform upon which the paper is formed. The fibers lock together when the water drains through the screening of the frame. The deckle determines the size and shape of the paper and is placed over the frame. It defines the borders of the paper by restricting the flow of the pulp. Although traditionally a rectangle, this mold may take any form.

Materials for Constructing a Mold. All of the materials needed for constructing a mold may be purchased at a hardware or variety store including wood molding strips, waterproof glue, aluminum or nylon window screening, scissors and rustproof staples or tacks.

The deckle is made from four pieces of molding strips glued together with waterproof glue. A picture frame offers a ready-made deckle.

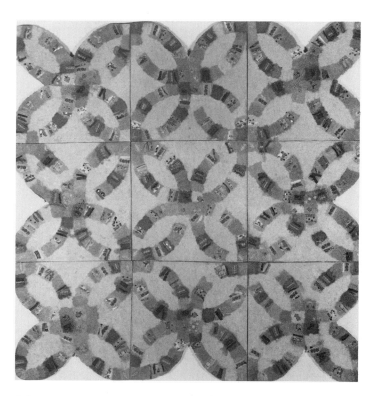

Arlene Absatz. THE GATHERING. 48" X 48". 1983. Scraps of ribbon, lace and fabric are sandwiched between areas of colored pulp to produce this patchwork design, reminiscent of the traditional wedding ring quilt.

The frame is fashioned in the same way as the deckle; however, a sheet of window screening is stretched over this frame and stapled or tacked to the wood. Use rustproof materials when constructing the mold since rust will stain paper. If rustproof staples or tacks are not available, cover corrosive materials with waterproof tape.

Materials for Pouring a Sheet of Paper. In addition to the deckle and frame you will need: cotton linter (or scrap papers), water, an electric cake mixer (if you are using cotton linter), a kitchen blender, plastic basin, materials to add to the pulp (such as feathers, dryer lint, thread, petals, potpourri, glitter), fabric dyes, a plastic-covered board, rubber gloves, thin fabric such as a sheet, a sponge, and a woven wool or felt blanket. Optional: plastic squeeze bottles.

Paper is made from cellulose; therefore, almost any plant may be transformed into a sheet of paper. Some fibers, however, are easier to process than others.

One of the least expensive ways to make a sheet of paper is to recycle old paper. Different

papers such as typing, magazine and drawing paper may be combined and remade into pulp to form a new sheet with its unique texture, thickness, color and size. Paper made from recycled papers (newspaper, for example) may yellow with age, depending upon the quality of the original paper.

To make high quality paper that will withstand the rigors of time, fine paper such as good watercolor paper may be recycled. A cotton fiber known as cotton linter may also be made into paper and is available in sheet form. Linter is used by many contemporary papermakers. It is excellent for both making sheets and casting in three dimensions.

Making the Pulp. To make pulp, the material from which the paper is to be made must be torn into small pieces, soaked and mixed with water so that it can be beaten until the fibers separate. A Hollander beater is a machine used by many papermakers to make pulp. This machine, however, is quite expensive. A kitchen blender, in most cases, may be used successfully in its place. For tough materials such as cotton linter, it is advisable to break down the fibers with an electric cake mixer or an electric drill adapted to mixing paint, before throwing them into the blender.

Before the old paper or cotton linter can be beaten or put into the blender, it should be torn into small pieces (approximately 1/2" squares) and soaked for a minimum of a half-hour in hot water. If time allows, soak it overnight.

A lot of water is used to make paper. Add a handful of the soaked material to a blender about half-filled with warm water. Start the blender motor at slow speed and gradually increase to full speed as the material breaks apart. Blend the fibers to a thin, milky suspension.

Small amounts of soft materials such as flower petals may be blended into the mixture to create interesting effects. At this point, dye may also be added if you wish to color the pulp. Since paper is made from cellulose, most fabric dyes may be used to color the pulp. Natural dyes, described later in the fiber section, may also be used. Wear rubber gloves when using dyes.

Casting a Sheet of Paper. Once the pulp has been made, it may be poured into the mold. Hold the mold at the base of a plastic basin so that the water in the basin just touches the screen. A small cup strainer is helpful for pouring the pulp onto the mold. When pouring, distribute the pulp

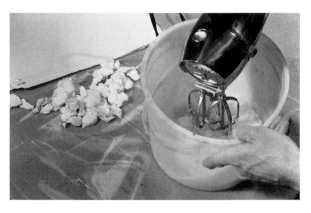

(1) After soaking, the cotton linter is broken down with an electric cake mixer.

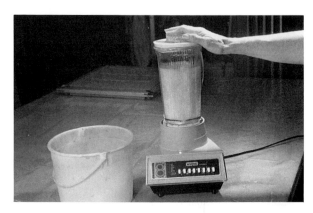

(2) A kitchen blender blends the water and linter to make pulp.

evenly over the screen. Gently pat it down as you work if you wish to create a thick, even sheet of paper. Shake the mold back and forth gently as you lift it to lock the fibers in place. When all of the water has drained, the deckle may be removed.

The next step, called couching, involves transferring the sheet to a damp woven wool or felt blanket known as a felt. Place the felt on a plastic-covered board. Turn the screen over and, rolling from one end to the other, transfer the paper onto the felt. Press down on the screen to remove some of the water. Then lift the screen, again rolling from one end to the other, leaving the paper on the felt.

At this point, materials such as petals, feathers, dryer lint and threads may be applied to the surface of the paper. When all of the materials are in place, cover them with a piece of thin cloth such as a bed sheet. Gently sponge the surface to remove excess water. The materials will adhere to the pulp.

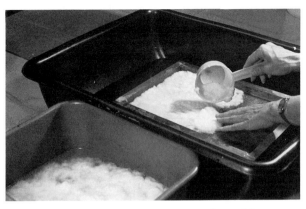

(3) Pulp is poured and then patted onto the mold.

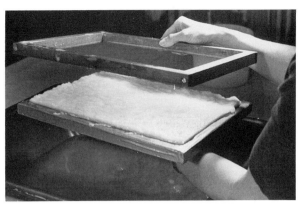

(4) The deckle is removed after the mold has been lifted out of the water and the excess water has drained through the frame.

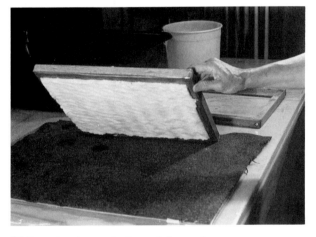

(5) Transfer the newly formed sheet of paper onto a blanket by flipping the frame over . . .

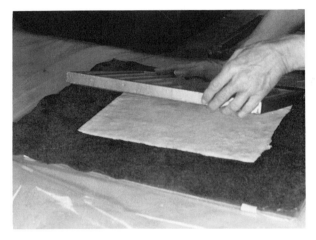

. . . and rolling the paper from one end to the other onto the blanket.

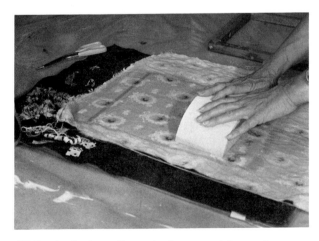

(6) Petals, feathers, lint and other materials may be applied to the surface of the paper and sponged down under a thin cloth.

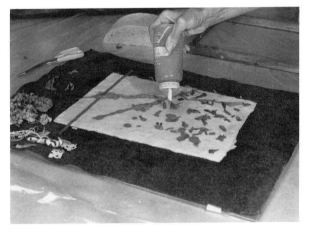

(7) Colored pulp squirted from squeeze bottles will adhere to the damp pulp without being sponged down.

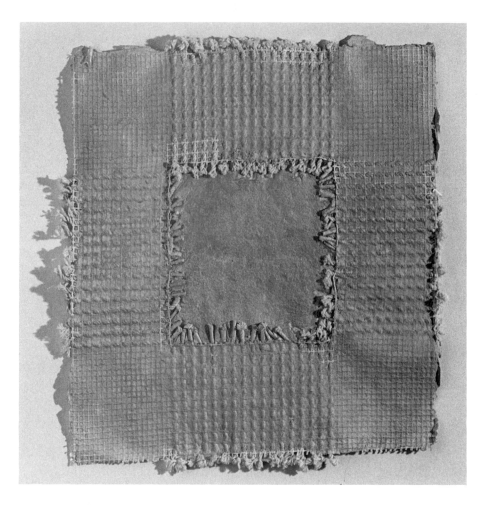

Arlene Absatz. The string captured between layers of handmade paper and then left exposed, invites you to explore the textural surface. Photo by William Haussler.

Colored pulp may be squirted onto the surface from small squirt bottles. Designs added in this manner need not be blotted down.

Leave the newly formed sheet on the felt until it is dry. Use a hair dryer or fan to speed up the drying. Transferring the felt to a raised screen will allow air to circulate and promote drying.

When cleaning up, do not pour pulp down the drain, for pulp may clog your drain. Excess pulp may be strained off and reused.

Experimenting

There are a number of techniques for integrating materials into the paper. Objects can be trapped between layers of translucent (thin) paper, and, if desired, sections may be left to protrude from the paper's edge. Pulp can also be squeezed from a bottle onto the paper, or it can be added and manipulated with your hands. Sheets of different sizes, materials, colors and shapes can be laminated together by couching one sheet upon another. An embroidery hoop will make a round mold, and the resulting round sheet of paper may be couched onto a rectangular sheet. Experiment to discover your own methods for creating a work of art made from paper pulp.

Hand Forming with Paper Pulp

This very direct technique for forming paper may be used to produce sheets or for casting into a mold. Several differently colored pulps may be laid down together in a manner similar to painting. When forming a sheet with this technique, work on a damp blanket. A deckle contains the pulp.

Use your hand to lay in the colored pulp, one color at a time. When all of the pulp has been properly placed, remove the deckle and cover the sheet of paper with a thin cloth. Use a sponge to squeeze the moisture from the newly formed sheet. Press down on the cloth with the sponge to absorb the water. Squeeze the sponge into a bucket until the sheet of pulp is compacted and as much water as possible has been removed.

Casting Into a 3-D Mold

A mold may be made from anything that will support the paper and separate from it when dry. See the section of this book on One-Piece Plaster Molds for instructions on making a plaster mold suitable for casting paper. Found molds such as chocolate molds are fun to experiment with. Molds may be sprayed with silicone mold release for easy removal. The resulting castings may be combined or incorporated into a sheet of handmade paper.

Handmade Paper: Branching Out

◆ Cast several sheets of paper and bind them at one side to make a book.

◆ Try casting paper pulp into or over a found mold such as a basket. Any media such as ink, watercolor or acrylic paint may be used to embellish the completed cast form.

◆ Experiment with different materials to produce as many different paper samples as possible. Cut or tear the papers and use them to make a collage.

◆ Create a body adornment — clothing, jewelry, or an accessory — from paper.

◆ Using two or more colors, cast several sheets of paper and make a package of stationery.

◆ Cast paper into a plaster mold of a face and use several castings to make different masks. Materials such as feathers, glitter, beads and fabrics may be glued onto the surface. Markers and paints may also be used.

Brown pulp was pressed into this chocolate mold to cast little rabbits. Elements such as these rabbits may be incorporated into a larger work or used to make small pieces such as jewelry.

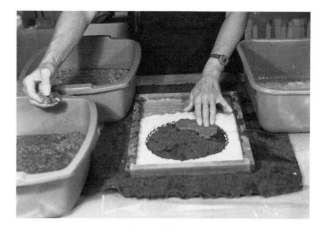

To hand-form a sheet of multi-colored paper, lay the pulp, one color at a time, onto a damp blanket. In the work shown above, a deckle was used to contain the outer edge of the paper and a piece of thick wire to contain the inner circle.

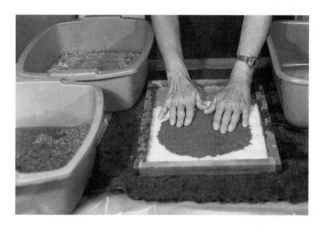

The inner wire was removed after the pulp circle was formed, and the surface patted down. A thin cloth may be placed over the newly formed sheet and a sponge used to absorb excess moisture.

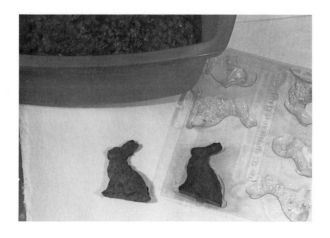

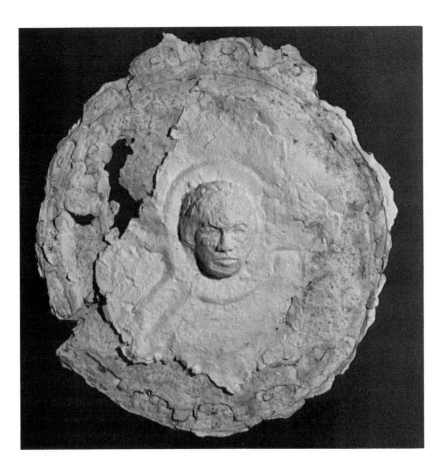

Sylvia Wolff. The mold for this cast paper head relief was first modeled in clay and then cast in plaster. Silicone mold release was sprayed into the plaster mold before casting the paper.

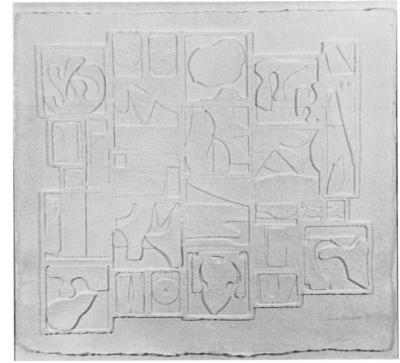

Louise Nevelson. DAWNSCAPE 1975. 31½" X 34". The stark, white cast paper and the hard-edged forms create a puzzle-like relief. Courtesy VanStraaten Gallery, Chicago.

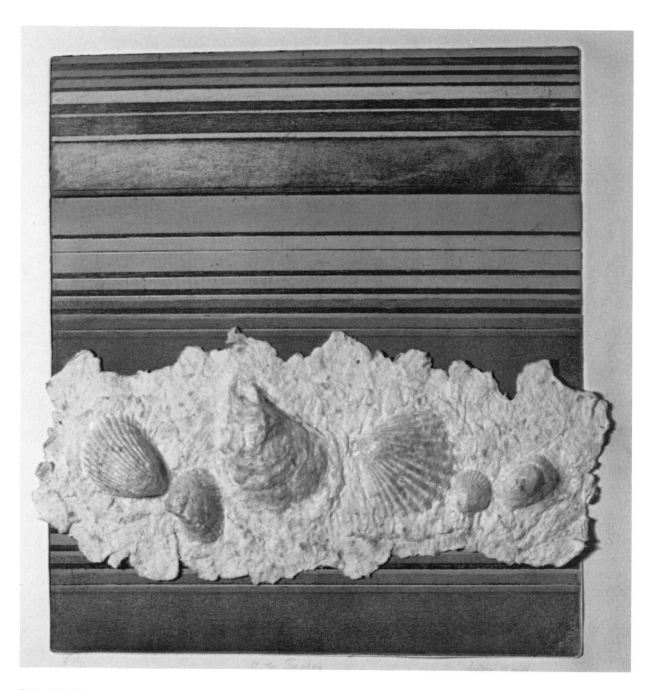

Sylvia Wolff. Actual shells were used to make a plaster mold for casting the paper pulp in this piece. The background was printed beforehand.

Papier-Mâché

Papier-mâché is another method for working in paper. Strips of paper are impregnated with a pasty substance such as wallpaper paste and built up, layer by layer, to create a stiff form. The cost of the materials is negligible and the technique simple, yet the finished product may be large in concept as well as size.

Papier-mâché has a number of qualities that make it particularly suitable for making theater masks, props and stage sets as well as parade props and large sculptures. Unlike most materials that can be worked on a grand scale, papier-mâché is inexpensive, light, relatively durable and will readily accept paint and glue. Virtually any material can be glued, stapled or sewn onto it including beads, fur, fabric, feathers and other forms of paper.

At the other extreme in size, papier-mâché may be worked delicately and formed into fine detail to create jewelry, boxes and small sculpture.

To make papier-mâché, paper is torn or cut into strips and coated with wallpaper paste. The layering of even a few applications of saturated paper over an armature makes a surprisingly strong structure when dry. Wads of saturated paper may be used to build up forms. The paper is applied to an armature constructed from wire, or newspaper that has been coated with wallpaper paste and rolled into tight tubes. When the tubes have dried, they become strong and may be bent, and tied or taped into the desired form. Other structures such as bowls, balloons, wads of paper or clay that is removed after the papier-mâché has dried may also be used as a base on which to build up the papier-mâché form. Small or flat forms do not require an armature.

Materials. Newspaper or newsprint, white paper towels, wallpaper paste or art paste, an air-tight container, 1/2" or 1" paint brush, masking tape, scissors, a pointed instrument such as a pencil, a utility or X-Acto knife, gesso, acrylic paints and a brush, trimmings, a wooden base, nails, a hammer and glue.

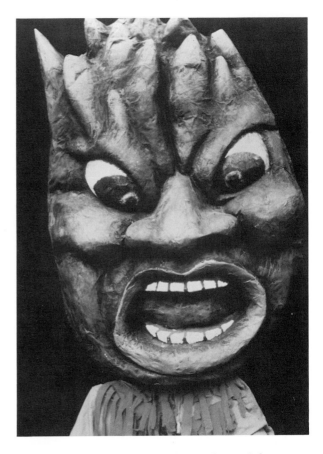

Bread and Puppet Theater. Papier-mâché mask from DIAGONAL MAN - THEORY AND PRACTICE. 1982. Exaggerated features give character to this powerful theatrical mask. Photo by George Lange.

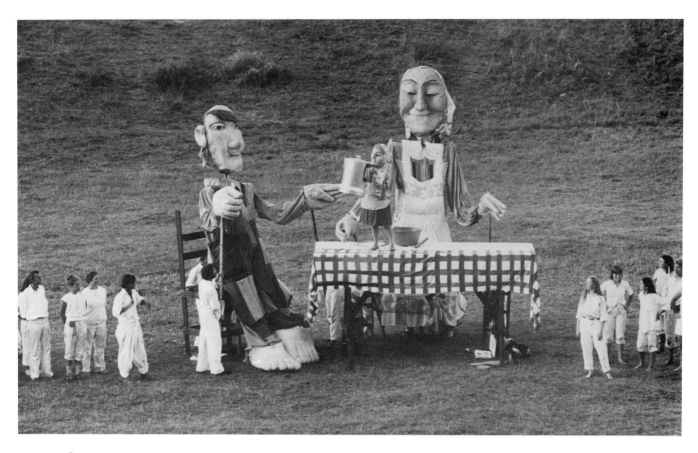

Bread and Puppet Theater. GIANT GARBAGE MAN AND WASHER WOMAN in DOMESTIC-RESURRECTION-CIRCUS- PAGEANT. 1983. Papier-mâché allows manipulation of scale not possible in other media. Photo by Renata Breth.

Mexican papier-mâché doll.

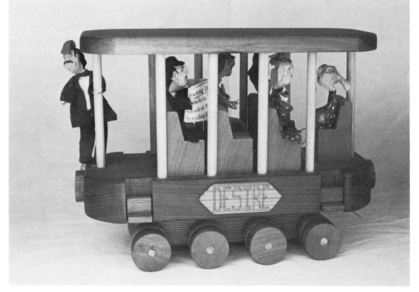

Gus Kuhn. A STREETCAR NAMED DESIRE. The expressive heads of the characters riding this streetcar were made from papier-mâché.

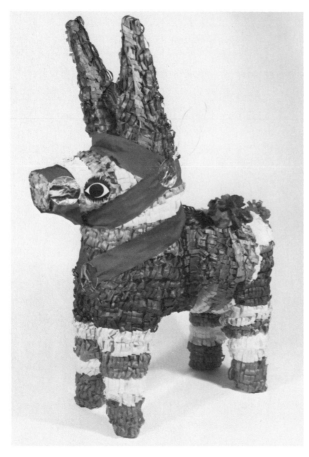

This pinata from Mexico is sculpted in papier-mâché and covered with fringed colored tissue.

Making a Paper Armature

To sculpt a papier-mâché figure, you will need to make an armature from three papier-mâché tubes. Make animals and abstract forms in the same manner as described below, using any number of tubes.

Begin by mixing the wallpaper paste according to the directions on the package to make approximately one cup of paste. Use an airtight container to hold the paste so that the excess may be stored for future use. Brush the paste onto the bottom 3″ or 4″ area of a sheet of newspaper or newsprint. Then fold this saturated section of the paper in half from the bottom up, and then in half again. Repeat until it cannot be folded any thinner. Wet the remainder of the sheet and tightly roll the folded area towards the top of the sheet until the tube is no thicker than the thinnest part of the figure that you are making. Cut or tear off any excess paper.

After the tubes have dried, tape them together to form a stick figure armature. Use one tube to form the arms, a second bent in half for the legs and a third looped around the first two to form the torso. The head will be added later. Join the tubes with masking tape. If a tube should break, simply tape it back together. Bend the newly formed armature into the desired position, capturing a particular pose or action. In order to impart more character to a figure, exaggerate rather than underplay a pose.

Adding Volume to the Armature

The volume of the figure is built up with wads of papier-mâché added to the armature. The saturated paper is quite plastic and can be modeled in the same fashion as clay. It is a good idea to brush a sheet of paper with an ample amount of paste and, keeping the center of the paper smooth, roll and crumble the edges under the smooth center to create whatever form is needed. Add this new form to the armature with the smooth side facing outward. Use strips of papier-mâché to attach it to the armature.

For easy tearing, strips should be torn in the direction of the grain of the paper. Test to find the grain by ripping in a horizontal and then a vertical direction. The torn edge will be less irregular when you tear in the direction of the grain.

You may wish to begin with the torso and, using the method described above, create a triangular form. Since this form is smooth on one side and rough on the other, an identical form may be made and the two triangular forms added, smooth sides facing outward, on either side of the armature. Use strips of papier-mâché to join them together.

Repeat this procedure for the arms, legs, head or anything you wish to add. Use small pieces of paper for small forms.

Whenever the figure becomes too soft and unmanageable, set it aside to dry overnight. Use wads of dry newspaper to prop the figure in the desired position so that it does not slump as it dries. To hasten the drying process, place the figure near a heater. Add more papier-mâché when it stiffens.

When you have completed the basic form, add details. Make the features of the face from tiny modeled pieces of papier-mâché and lay them in place. Then cover the entire face with a sheet of

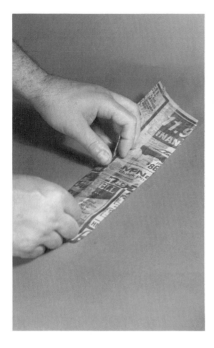

A sheet of newspaper is coated with wallpaper paste, folded and then rolled into a tight tube.

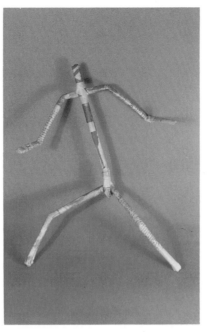

The tubes are taped together to form an armature.

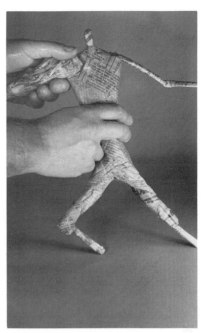

Wads of papier-mâché are added to the armature to build up the form.

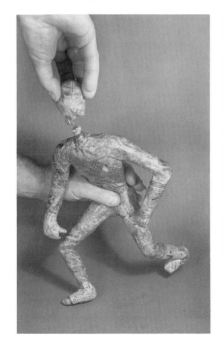

Body proportions are adjusted.

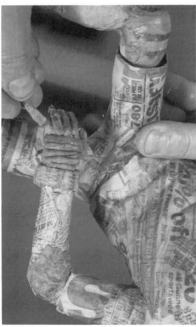

Fine detail may be added with small pieces of carefully formed papier-mâché.

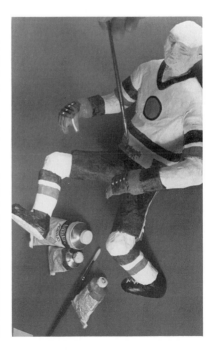

The entire surface is coated with gesso and the clothes painted on with acrylic paint. Yarn, metal foil and wood are added to create the realistic details that give life to the figure.

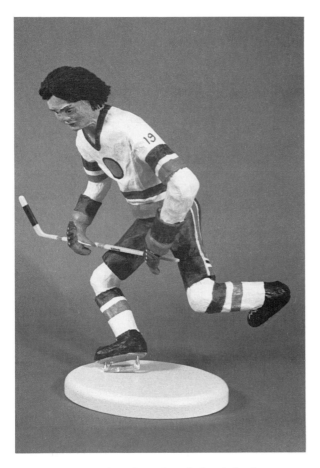

The completed hockey player is nailed and glued to a wooden stand.

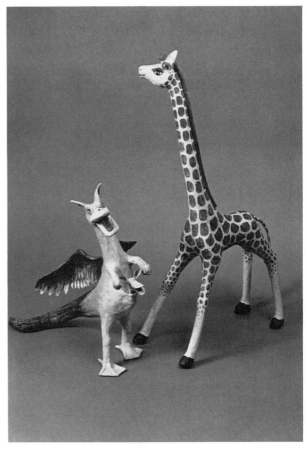

Sheldon Bloom. Papier-mâché animals.

papier-mâché of the approximate size of the face. This will unify the face and obscure the small creases. Use a pencil or other pointed instrument to further define the features. This same technique may be used to make other details such as hands and feet.

Garments may be fashioned from sheets of papier-mâché that have been folded several times along the edge to build up a dress hem or sleeve cuff. These garments may be attached to the figure with strips of papier-mâché. Realistic details such as folds may be made in the garment before it is attached.

Completing the Figure

When the figure is completely modeled and dry (this may take several days), it may be refined with

a sharp knife, file or sandpaper. The final layer of paper is then applied using white toweling or newsprint rather than newspaper. After the figure has been "mummified" and dried, brush on a coat of gesso to seal the paper and further smooth the creases and bumps.

The completed work may be painted with acrylic paint and trimmings added to enhance the character. Subtle details are very effective in creating a convincing character.

You may wish to nail the form to a block of wood. Add glue for additional support.

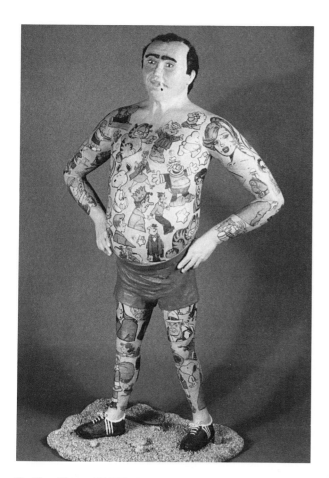

Sheldon Bloom. VANITY-THE TATTOOED MAN. 1983. Newspaper comics, hair, wood, string, sand and acrylic paint were added to the surface of this papier-mâché figure. The artist's social comment is at once both serious and humorous.

Papier-Mâché: Branching Out

✦ Cover an already existing form, such as a bowl, with papier-mâché strips. Any form that has no undercuts may be used for the original form. Three or more layers of papier-mâché are needed for adequate strength. A coating of petroleum jelly, liquid soap c: a layer of plastic wrap may be applied to the form prior to application of the strips for easy separation when the papier-mâché has dried. When the strips are dry, separate the paper from the original form. Decorate it with acrylic paint and trimmings if desired.

✦ Make a mold from plasticine and cover it with three layers of papier-mâché strips. When the strips harden, remove the clay. This is a particularly effective method for making masks.

✦ Tape a selection of paper tubes, boxes or other forms together to form an animal, figure or abstract form. Cover everything with two layers of papier-mâché. Paint and trimmings may be added to complete the image.

✦ Soak finely shreaded newspaper in hot water for several hours. When soft, mash the paper until it forms a fine pulp. A blender may be used to aid in the mashing. Be certain to use a great deal of water when blending so that you do not overtax the blender. When the paper is well mashed, squeeze out the excess water. Then add wallpaper paste and sculpt small objects or jewelry as if you were working with clay. When dry, decorate the surface with acrylic paints, and shellac, if desired.

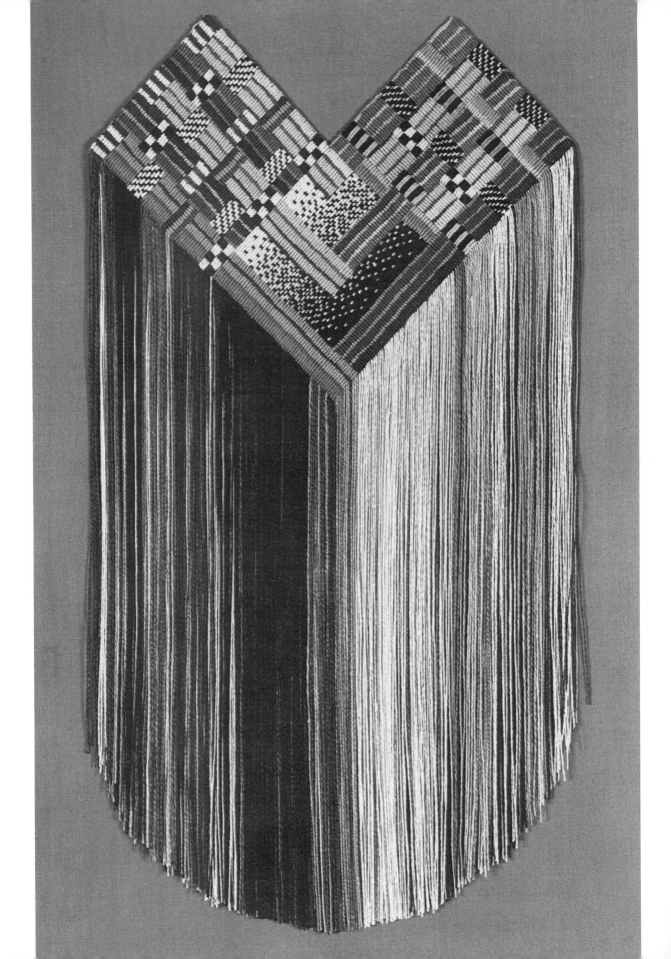

2 · FIBER

The fiber arts afford an extensive range of expression. Designs, pictures, patterns, and symbols can be applied to cloth by any one of hundreds of methods. Designs can also be woven directly into the fabric.

Prehistoric people found ways to use fiber to protect themselves from the elements and to create objects that performed other functional tasks. As a crafts medium, the emphasis is on extending fiber beyond its purely functional aspects. New combinations of materials and techniques have been built upon past knowledge. Many of the same methods used for creating cloth have been applied to decorating and weaving baskets or making jewelry. Traditional techniques in fiber have also been translated into other mediums such as metal, clay and leather.

Works in fiber have spanned the gamut, from the splendor of a silk gown and the power of a woven ceremonial blanket, to the inventiveness of a contemporary wall hanging. In this chapter, several of the most popular contemporary techniques are discussed. Some of these techniques may be combined to expand further the possibilities for innovative works.

Weaving

The art of weaving developed in prehistoric times when people needed to clothe themselves. They used animal hairs and fibers from their environment to spin yarn, and by interlacing vertical and horizontal yarns, they created cloth.

In weaving, the warp, or vertical threads, are generally stretched taut on a loom. The warp is interlaced with the weft, or horizontal threads, which are passed over and under, generally at right angles to the warp. In some of the earliest weavings, however, the weft was woven through the warp which was simply anchored at the top and allowed to hang freely. Thus a branch and some yarn were all that was needed to weave.

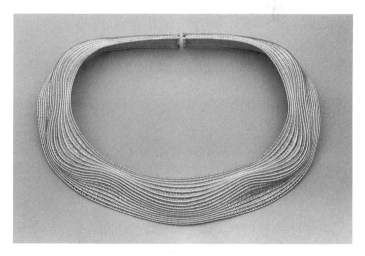

Diane Itter. KENTE CONSTRUCTION IV. Knotted linen. 16" X 20". 1982. This squared-off heart shape, with heavily textured squares and rectangles, flows downward to a graceful, rounded fringe. Photo by David Keister.

Mary Lee Hu. CHOKER #55. 1980. Weaving techniques apply to materials other than fibers. This silver and sterling silver choker was woven in wire; the tight weave imparts strength and texture.

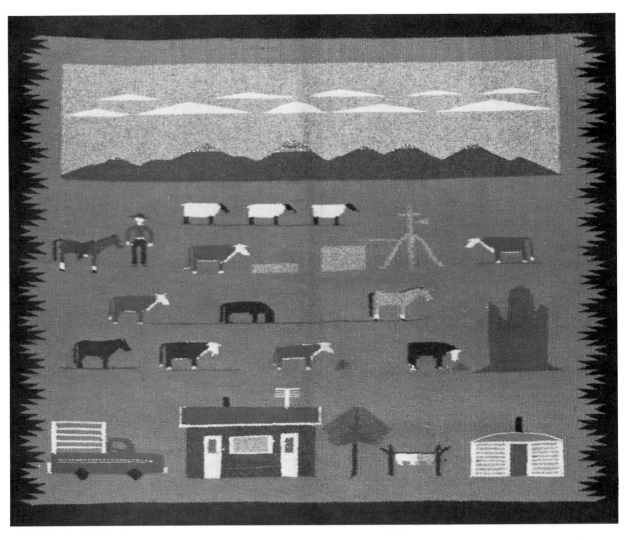

Ella Begay. RANCH SCENE. 38½" X 32". 1980. Realistic detail is the focus of this Navajo weaving. Photo courtesy of the U.S. Department of the Interior, Indian Arts and Crafts Board.

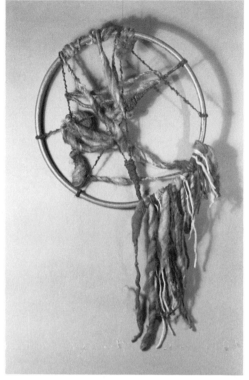

Graziella Weber-Grassi. Linen, paper and mylar. 1984. Diagonal and vertical stripes bring out the inherent beauty in the materials and the weaving process.

Student work. A hoop is the loom for this textural free-form weaving.

Since almost any material may be incorporated into a weaving, including wire, strips of fabric, fur, paper, leather, plastic, feathers, shells and yarns in many colors and textures, there is no limit to the creative potential of this craft. Beyond the materials used, there are many weaves which make possible a wide range of textures and designs. Whether you are weaving patterns, geometric or realistic designs or simple stripes, weaving can be a highly satisfying and functional craft.

Looms

Although all looms function basically to hold the warp threads evenly spaced and taut so that they may be raised and lowered to accept the interlacing of the weft, there are a wide variety to choose from. Some looms are small and portable, while others are massive and fill an entire room. Some provide mechanisms to speed up the weaving process. A shedding device, for example, raises several warp threads at once so that they do not have to be lifted individually by hand. Thus the shed (the opening between the warp threads that are raised and those that remain stationary) may be made quickly, allowing for the insertion of the weft. There are several ways to mechanically lift groupings of warp threads. Some looms are quite sophisticated in their ability to do this.

One need not, however, go to a lot of trouble and expense to make beautiful and even sophisticated weavings. Looms may be as simple as a frame or hoop. Even a forked branch or picture frame will support a warp. Nails driven into the wood will hold the warp, or the warp may be held in notches that have been filed or sawed at regular intervals. Sometimes simply wrapping the warp around the frame will be sufficient to hold it in place.

The simplicity of a loom does not restrict the size of the product, either. As long as the frame is well constructed, a large, complex weaving may be created even on the simplest of looms.

Making a Simple Frame Loom

To make a simple frame loom, use a ready-made frame or construct your own from four strips of wood or canvas stretchers. A good size to start with is approximately 18" x 24". If you are using strips of wood, lay the two horizontal short strips over the two longer vertical strips to form a rectangle. Screw or nail the four strips together at each corner. If you are using stretcher strips, simply fit the strips together to form your rectangular frame. The corners may be reinforced with metal braces screwed in place.

Once the frame is constructed, a row of 1¼" brads is hammered into the two horizontal strips to accommodate the warp. The brads will keep the warp evenly spaced and taut. Place the brads at ¼" intervals, and drive them in at an angle pointing away from the center of the loom so that the warp will not slip off. To prevent the wood from splitting, alternate the brads on two rows. Use a pencil to draw two guide lines across each of the horizontal strips. Dots marking the points for the brads should be alternated at ¼" intervals along the lines. Leave a minimum of 1" between the two end brads and the vertical sides of the loom.

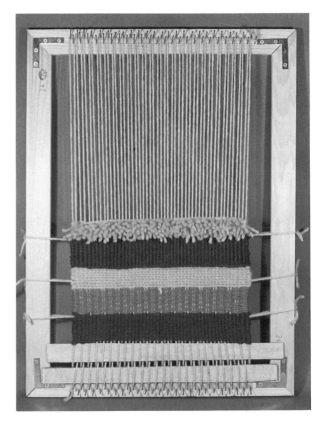

Frame loom.

Warping the Loom

To warp the loom, choose a yarn that is smooth and strong. Test the yarn to be certain that it cannot be easily broken. The warp must withstand the stresses of the weaving process. It may be made up of a one or several colors and may vary in texture and thickness.

When you have chosen your warp, tie the end to the first brad. Stretch the continuous thread across the loom to the opposite two brads. Continue zig-zagging back and forth between pairs of brads until the entire loom is warped. If you wish to change colors or add additional warp, be certain to tie any knots at a brad rather than in the middle of the weaving. Keep the warp taut and tie the end to the last brad.

A shed stick is helpful when weaving plain weave or whenever you wish to lift the warp threads through which it is threaded. It is at least 1" wide, approximately ¼" thick and longer than the width of the loom. To insert a shed stick, weave

the stick over and under successive warp threads. Simply turn the stick on end to open the shed. The shed stick may be used on alternate rows since only one set of threads may be lifted with this device. Leave the shed stick in place at the top of the loom when not in use.

Materials. In addition to the warped loom, you will need scissors, yarn and other materials for the weft, a fork or comb and a needle and thread.

Starting to Weave

Now that the loom has been warped, you are ready for the fun. Before you begin weaving, gather your yarns and other materials that you intend to use for the weft. Practically any material can be used for the weft since it is not under the same tension as the warp. Observe how the different materials, colors and textures interact. Choose your materials with care. They are your palette, and their characteristics will greatly affect the quality of the finished product. Experiment with a variety of weaves and

materials. Try twisting yarns together for interesting effects.

To prevent the yarn from tangling as you work, wind it around a flat wooden or cardboard shuttle or make it into what is known as a butterfly. To make a butterfly wind the yarn, with your hand stretched open, in a figure eight around your thumb and little finger. To hold this bundle together, wrap the end of the yarn around the middle of the butterfly and tie it with two half-hitches. In this way, the untied end of the yarn may be pulled out from the center as the yarn is needed. Do not overload a shuttle or butterfly since it should be thin enough to pass easily through the warp.

The Heading. Before you begin weaving your actual design, approximately 2″ of a contrasting yarn or two strips of cardboard are woven to distribute the warp evenly. This is known as the heading. The heading is removed when the weaving is completed.

Beating. In order to compact one row of weaving upon another, the weft is beaten down with the fingers, a comb or fork. Commercial hand beaters made specifically for this purpose may be purchased from a weaving supply house. The beater on a floor or table loom is an integral part of the loom.

Starting and Ending the Weft. To start the first row of weft or to begin a new weft in the middle of a weaving, weave a row leaving 3″ of extra yarn hanging from the edge. Pass this end around the last warp and back into the same shed as the row you have just woven. Allow any loose ends to hang on the back of the weaving. Then continue weaving. Introduce any new new piece of yarn in this manner, whether you are changing colors, yarns or simply adding a new piece of the same yarn. To keep the weaving even, start a new weft on the opposite side from where you end the old weft.

To end a weft, pass the end of the yarn (approximately 3″ long) around the end warp and back into the same shed as the row you have just woven.

Preventing Distortion of the Warp. A common problem for beginners is counteracting the tendency of the weft to pull on the selvages, thus distorting the weaving. This occurs because the novice often does not take into account the extra weft needed, beyond the width of the woven area,

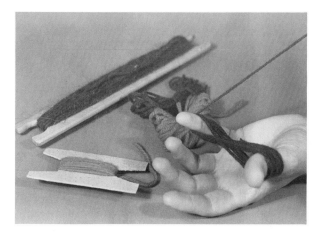

Yarn is wound in a figure eight around the thumb and pinkie. When tied, this bundle can be woven without getting tangled.

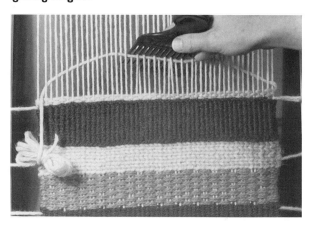

Beating down the weft.

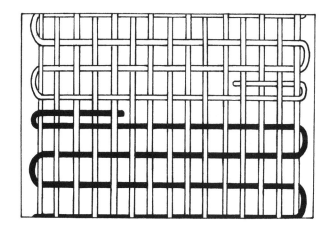

Ending and beginning a new weft thread.

to travel over and under the warp. To deal with this problem, the yarn may be bubbled, meaning that it is woven in an arc across the warp rather than in a straight line. When the weft is beaten down, the slack in the yarn will be taken up, and there will be no pull on the end warp threads. As the weaving progresses, the first and last warp threads may be tied to the side of the loom with a short string every few inches. This will also help prevent the warp from becoming distorted.

Weaves

In addition to the weaves illustrated here, there are many others which may be discovered through experimentation or from books on weaving. Feel free to create your own weaves and combinations; any weave that works is appropriate.

Plain Weave. The simplest and most popular weave is called the tabby or plain weave. The weft travels over and under successive warp threads, alternating this pattern with each row. Thus a warp thread that was woven over on one row is woven under on the next. The shed stick may be turned on end to make the shed on alternate rows, or the individual warp threads may be lifted by hand. Plain weave may be compacted tightly or space may be left between each row to produce a more open weave.

Basket Weave. A variation on the plain weave is the basket weave. This is the same as the plain weave except that two warp threads are interlaced with two weft threads. If the warp and weft are of two contrasting colors, you will create a checkerboard pattern.

Twining. Twining is a weave used for its texture and pattern. It is also used to help space the warp evenly and to border unwoven areas in a weaving. As in basketry, twining uses a long weft that is folded in half. The two resulting threads are woven simultaneously. One of the threads passes over while the other passes under each warp. (This weave may also be done around more than one warp at a time.) The two threads twist around one another and exchange places between each warp. The twists should always be executed in the same direction.

Soumak. Another weave which adds variety is the soumak weave. Here, the weft passes over two warp threads and then back under one. Thus

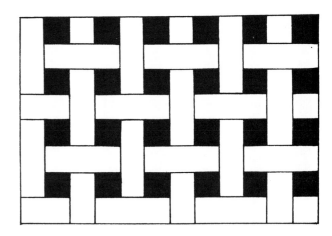

Plain weave.

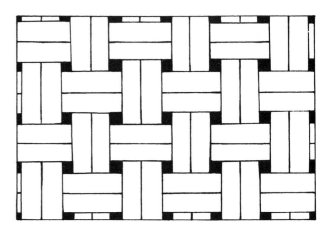

Basket weave.

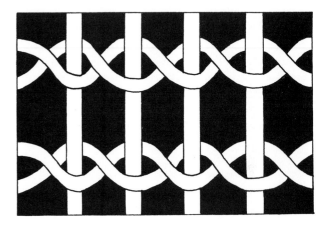

Twining.

Soumak.

Rya.

From top to bottom: plain weave, basket weave, twining, soumak, rya.

the weft wraps completely around every warp. This may also be done, passing over more than two warp threads and then wrapping around one or more. This weave is usually alternated with a row of plain weave. When the weft is thick, this weave can add a great deal of textural quality to a piece.

Rya. The rya knot is a very effective way of adding dimension to your work. The Scandinavians are well known for their shaggy rugs made entirely with this knot. Short, equal lengths of yarn are needed to make the knots. They are made by wrapping yarn around a piece of stiff cardboard that is cut slightly wider than the desired height of the pile. After wrapping the yarn several times around the cardboard, use scissors to cut it at one end. Do not hesitate to combine several shades or colors together.

To make the knot, lay one (or more) strands of yarn over two warp threads. Then draw the two ends of the strand around and up between the two warp threads. Pull the ends so that they are of equal length and tight against the previous row of weaving. Alternate rows of rya knots with at least one row of plain weave to hold the knots closed and avoid making slits in the weaving. The pile ends may be trimmed evenly or sculpted by cutting them unevenly.

Tapestry Weaving

Any kind of design, simple or involved, realistic or abstract, may be woven using the tapestry technique. In traditional tapestry, the warp is entirely hidden by the weft. Each row is beat down upon the previous row with a comb, fingers or a tapestry fork.

In traditional tapestry weaving the plain weave is used to create designs by changing yarn colors throughout the weaving at any point. Thus, rarely is a row woven in one color from selvage to selvage. Contemporary tapestry weavers do not restrict themselves to using the plain weave alone, but rather combine several weaves.

To be certain that the warp is easily covered, leaving the design solely in the providence of the weft, space the warp threads wide enough apart so that the weft may be beaten down tightly, thus covering the warp. The warp should also be of a thinner material than the weft.

Michelle Lester. **SHADOW GARDEN.** Wool tapestry. 1983.
Diverse elements of line and shape combine with subtle
gradations of value.

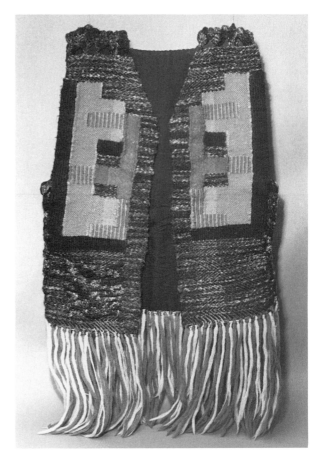

This vest, woven by a student in the tapestry method, is
made in three sections sewn together.

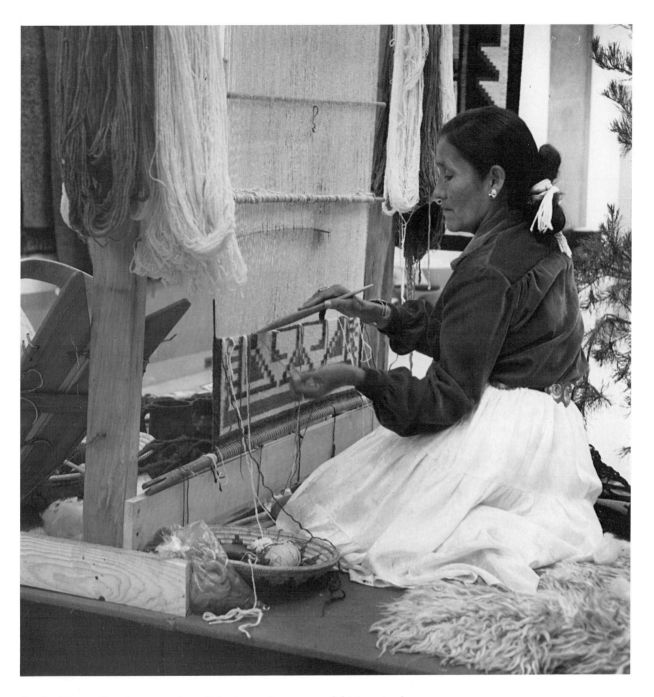

Bertha Stevens, Navajo weaver from Arizona, works on an upright tapestry loom.
Photo courtesy of the U.S. Department of the Interior, Indian Arts and Crafts Board.

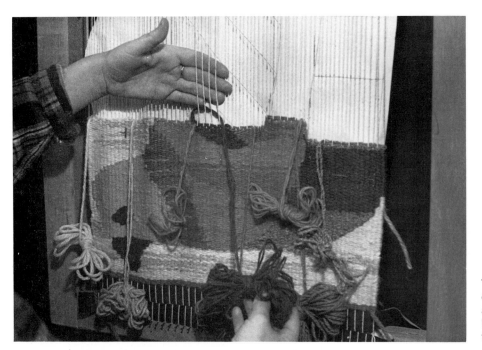

The design in a tapestry is created by changing yarns anywhere in the weaving to build areas of color and texture.

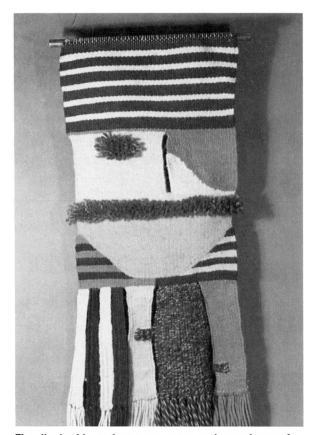

The slits in this student tapestry are an integral part of the design.

The Cartoon. Since the warp is entirely covered in most tapestries, the sketched design, known as the cartoon, may be transfered directly onto the warp. This is accomplished by drawing the cartoon, full size, on paper, pinning it behind the warp and tracing it with a marker. To prevent puckering in the weaving, avoid using yarns or materials of extremely different thicknesses next to one another.

Joining Areas of Color

Because there is usually more than one color of yarn on a single row of weaving, something must be done where they meet so that the weaving looks uninterrupted. There are several techniques for joining one color segment to another. The simplest method is to reverse the direction of each thread where they meet by turning the two threads around adjoining warp threads. This will leave a small space between the two yarns. When several rows are turned on the same two warp threads, a slit will be created. This may or may not work effectively for your purposes. You may wish to create a slit for functional or aesthetic reasons. Unwanted slits may be sewn together when the weaving is completed.

When two weft threads turn around adjacent warp threads, a slit is formed.

Dovetailing.

Interlocking.

Another method of integrating abutting weft threads is by dovetailing. In dovetailing, both weft threads turn around the same warp thread, leaving a slight ridge where they meet.

A third method of joining two different weft threads on a single row is by interlocking. Here the weft threads themselves are turned around each other and thereby linked together.

Finishing

To remove the weaving from the loom, cut or disengage the warp from the brads. There are many ways to keep the cut edges from raveling. One method is to hem the top and bottom edges with a needle and thread, as you would a garment. Another method is to tie or braid groups of warp threads to make a fringe. Yet another way to deal with these loose ends is to sew the last two rows of weaving with a diagonal overcast stitch that crosses over these two rows of weft and one warp thread.

Weaving: Branching Out

✦ Weave on an unusually shaped loom such as a hoop, branch or found object that can be warped.

✦ Create a weaving in which analogous colors are used throughout, or in some way limit the color scheme.

✦ Create a weaving using several different weaves as well as different materials.

✦ Weave a functional object, accessory or garment, such as a vest, pocketbook, scarf, pillow or placemat.

✦ Weave a wall hanging in which the warp is woven into in some areas and left exposed in others. You may wish to make the ratio of visible warp to weft approximately equal.

Natural Dyeing

Yarns may be purchased in an enormous variety of textures, colors and shades. Still greater variety is available if you choose to dye your own yarn. Commercial dyes may be purchased at grocery stores and weaving supply houses; however, dyeing with natural materials that you have gathered yourself is particularly rewarding.

There is no shortage of available dye sources. Out among the weeds there is a rainbow of color. Although some sources produce more desirable dyes, almost any plant will yield some color. Natural dyestuffs may be purchased from a weaving supply company or gathered from your surroundings. Any season, any location, there is always color to be had.

Materials. Dye may be extracted from flowers, leaves, stems, grasses, bark, nuts, berries, roots, lichens and some insects. Most of these materials can be used when freshly picked, or dried and stored until needed. Store plant material out of the sun, in the open air or in a porous container such as a paper bag.

Natural materials produce incredible variations, in every shade of color imaginable. Each dyestuff will yield different results depending upon many factors including the season and location at which it is gathered, the mordant being used and the yarn being dyed. These circumstances interacting to produce a specific color add to the excitement of the process. It is the resulting subtle variations which give naturally dyed yarn its extraordinary qualities.

Although there is an optimal season for gathering most dyestuffs, do not be deterred from experimenting at any time, with anything. Sometimes a subtle, pale color may make a stronger statement than a strong dye and may harmonize perfectly with your work.

In order to extract the dye, the plant material is boiled in water for about an hour. Although delicate materials such as flowers and berries may be boiled without presoaking, heavier materials such as bark and wood should be soaked before boiling. Presoak these materials for twenty-four hours before boiling. After boiling, the plant material is strained from the dye liquid and disposed of, leaving the clean liquid dye.

It is recommended that the beginner experi-

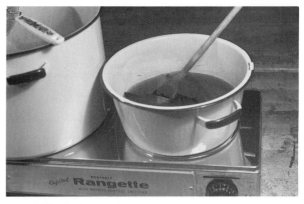
Plant material is boiled in order to extract the dye.

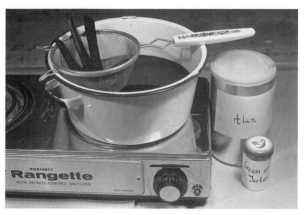
After straining, only the clean liquid dye is left. Alum and cream of tartar are added to the dyebath.

ment by dyeing with different materials, keeping a written record of the results. Make an index card for each material. Punch holes along the edge of the card so that the yarn samples, dyed under different conditions, may be tied on. All necessary information may be recorded next to the sample. Try dyeing yarn with each dyestuff without a mordant and then with alum. Record the dyestuff used, where and when it was gathered and the process by which it was dyed.

The following is a list of some common materials found in the home and outdoors: acorns, annatto seeds, blackberries, black walnut hulls, chamomile flowers, chrysanthemum flowers, coffee grounds or beans, fresh daffodil flowers, dahlia flowers, dandelion flowers, goldenrod, marigold flowers, fresh mulberries, onion skins, peach leaves, privet leaves and twigs, tea and turmeric (spice).

Many of these materials produce yellows, browns, tans and greens. Some of the more difficult colors to produce, such as blue, red and purple

may be obtained from logwood, madder and cochineal (an insect), which can be purchased from a commercial supplier (see Sources of Supply).

In addition to natural dyestuffs you will need the wool to be dyed; water; soap; water softener (optional); a plastic tub; stove or hot plate; kitchen strainer; enamel, stainless steel or Pyrex pots; a stirring stick; alum; cream of tartar; an ounce scale; and rubber gloves.

Preparing the Yarn for Dyeing

Any natural fiber (cotton, wool, silk and linen) may be dyed using vegetable dyes. For the sake of simplicity, we will describe the method for dyeing wool.

Before you begin, the yarn should be wound and loosely tied to prevent tangling. Wash the yarn in a plastic tub filled with lukewarm soapy water, agitating as little as possible. In locations where the water is hard, a water softener may be added. The yarn is washed to allow the dye to penetrate the fibers more effectively.

Mordanting

Most dyes need to be combined with a *mordant*. The mordant gives the dye permanence by bonding it chemically to the wool. It also influences the color produced. The most common mordants are alum (potassium aluminum sulfate), iron (copperas or ferrous sulfate), tin (stannous chloride) and chrome (potassium dichromate). Alum and iron are basically harmless. Alum may be used on all fibers. **CAUTION: Chrome is highly toxic. Tin is also toxic. It is therefore recommended that a safer mordant such as alum or iron be used.** Although most dyes will color wool to some extent even without mordanting, adding a mordant will intensify (and often change) the color. Intense colors, however, are not necessarily better than subtle colors.

For the purposes of safety and simplicity, we suggest mordanting with alum. Cream of tartar is added to keep the wool soft. For 1 pound of wool, add 3 or 4 ounces of alum and 1 ounce of cream of tartar in 4 gallons of water.

The mordant may be added directly to the dye-bath or the wool may be pre-mordanted. A pre-

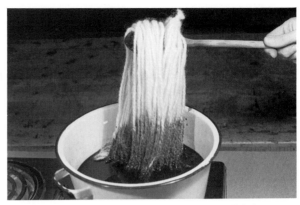
Add the wool to the dyebath and simmer until it has reached the desired shade.

mordanted wool will usually take the dye better; however, excellent results may be achieved by dyeing and mordanting in one pot.

To pre-mordant wool, gradually heat it to simmering temperature (never allow it to boil) and simmer it in the mordant bath for one hour. Allow the wool to cool gradually. Squeeze excess liquid from the wool. The wool is then ready to be dyed. Keep the wool wet in a plastic bag if you do not intend to dye immediately after pre-mordanting.

It is important to note that wool should never be shocked by extreme changes in temperature. Always allow the wool to heat or cool gradually. Agitate as little as possible to prevent it from matting.

Dyeing

To dye, add the clean, wet yarn to the strained dye liquid to which extra water has been added so that the wool will be completely immersed. If you are mordanting and dyeing in the same pot, the cream of tartar and alum should be stirred in before adding the wool. Slowly bring the liquid to simmering temperature. Simmer, stirring occasionally, until the wool has reached the desired shade. This will take anywhere from 10 to 45 minutes. Remember that wool always looks darker when it is wet, so dye the wool a few shades darker than desired. When your yarn is dark enough, allow it to cool. Then, wearing rubber gloves, gently squeeze out the excess dye and proceed to rinse the wool. Rinse in room temperature water until the water runs clear. Hang the wool to dry, away from direct sunlight.

Tie-Dyeing

Tie-dyeing is a resist technique for dyeing designs into fabric. This very direct means of dyeing has long been popular for fabric decoration in India, Africa, Japan and China. It involves tying, knotting, twisting, clamping or otherwise constricting the cloth in order to prevent the dye from penetrating certain areas. Thus the dye is resisted in places that are tightly bound and absorbed in exposed areas.

Stunning fabric designs are produced by this simple process. A tied resist can be as beautiful as a design executed using a much more painstaking technique. Wall hangings, fashion and home accessories and soft sculpture may be dyed in this fashion. The method is simple, the materials readily available and the results pleasing. Careful planning and accidental effects make both the process and the products exciting.

Materials. Fabrics recommended for tie-dyeing with household dyes include cotton, silk, nylon, acetate, linen and rayon. Avoid most polyesters and fabrics that cannot be washed in hot water. Unbleached muslin is an inexpensive and popular fabric for tie-dyeing. White or pastel fabrics provide the greatest contrast for the colored dyes. Ready-made clothing such as T-shirts or plain cotton skirts may also be tie-dyed.

In addition to fabric, you will need liquid detergent; a pencil; rubber bands, string, a needle and strong thread, or other means of constricting the fabric; household dyes; water; a measuring cup; stove or hot plate; plastic bags; large enamel, glass or stainless steel pot; scissors; an iron and rubber gloves.

Preparing the Fabric

Before you begin to tie and dye, wash the fabric in a mild detergent to remove any sizing. Mark your design directly on the fabric in pencil. In this way you will be able to keep your bearings when the shape of the cloth is distorted by tying. The pencil marks will disappear in the wash.

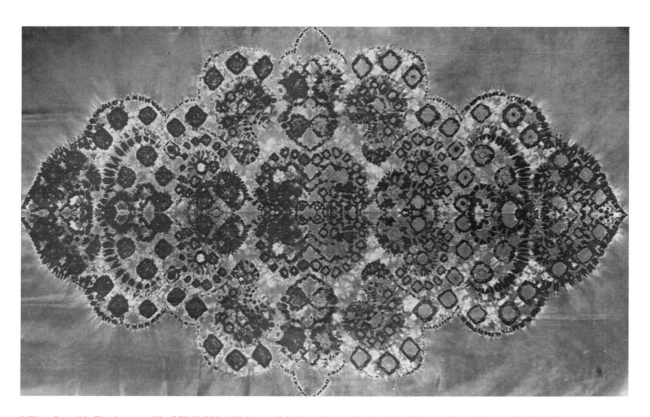

Lillian Donald. Tie-dye on silk. 37" X 70". With careful planning, a tie-dyed design can be quite sophisticated.

Resisting the Fabric

Wet the fabric before you begin to tie. To create the resist, constrict the damp fabric with cord, rubber bands, stitching, dental floss, clothespins or anything that will bind the fabric and prevent the dye from penetrating. The simplest means of creating a resist is by folding or twisting and then knotting the fabric itself. Wrapping rubber bands or stitching around small objects such as marbles, beans, rice or pebbles also produces interesting results. Detailed designs may be made by sewing a running stitch along a drawn line. Use strong thread with a knot tied at the end. Gather the fabric tightly by pulling it along the thread. Then take a few stitches at the end of the gather to hold it together. Make all knots or bindings tight if you wish to create a sharply defined resist.

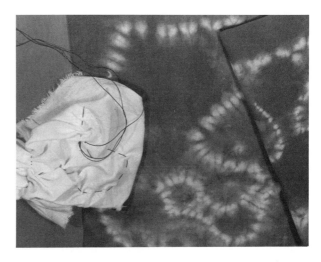

You can actually dye designs on fabric with the running stitch. Pull the thread tightly to gather the material before dyeing.

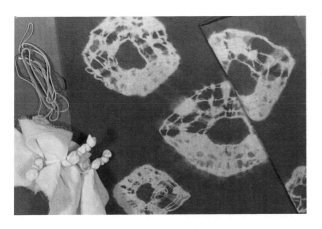

Pinch the fabric to form a point and wrap it tightly with rubber bands.

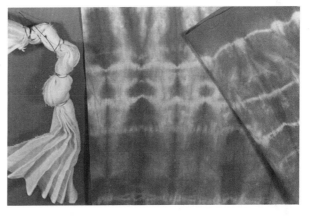

Pleat the fabric and wrap it with strong thread.

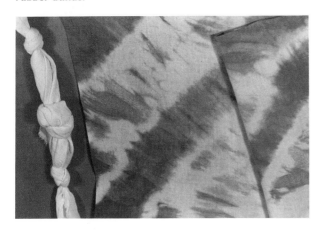

Tie knots in the fabric.

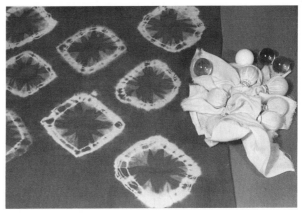

Bind around small objects such as these marbles.

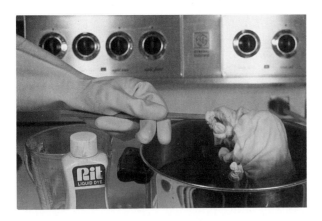

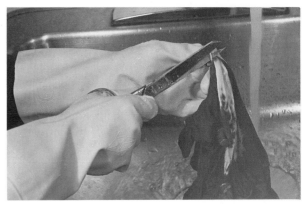

After all ties are made, emerse the fabric in the hot dye.

Rinse and remove the ties.

Dyeing

There are many types of dyes that may be used for tie-dyeing. Each possesses different qualities including the range and brilliance of colors, degree of colorfastness, compatibility with a specific fabric and the method of use. Household dyes are inexpensive and available at variety stores, drug stores and supermarkets. They are excellent for tie-dyeing. The directions for use are included in the packaging. **It is advisable to purchase household dyes in liquid, rather than powdered form to avoid inhaling the powder. Household dyes can be highly toxic when inhaled or ingested. Always wear rubber gloves when working with any dye and an approved dust mask when working with powdered dyes.**

Createx cold-water dyes are also excellent dyes. Their colors are brilliant and colorfast, and because they do not require heating, they are excellent for batiking as well as tie-dyeing. Since they come in liquid form, they are safer to use than powdered dyes. Createx dyes are simple to use and can be ordered by mail. (See Sources of Supply.)

Dye may be applied by dipping, brushing, squirting with dye-filled plastic squeeze bottles or by submerging the entire cloth in the dye. Household dyes are most effective when they are heated and when the fabric is allowed to remain in the dye for a sufficient period of time. It is therefore advantageous to submerge the fabric in a pot of simmering dye for the prescribed length of time. (See manufacturer's directions for specifics.) Do not, however, allow the dye to boil. Since dyed fabric will appear darker when wet, leave the fabric in the dye bath until it is darker than desired.

If you are using dye-filled squeeze bottles, fill them with undiluted dye and keep them warm in a pot of hot water. Colors that are squirted or painted on will be somewhat muted.

You may wish to work with several colors on a single piece of fabric. Small amounts of dye may be squirted onto the fabric before it is tied and dyed. Large areas may be protected while dyeing other areas, by covering them with plastic bags that are tied closed with a string or rubber band. After tying and dyeing once, additional ties may be made before dyeing a second time with a contrasting color. Work from lighter to darker colors. Cord that has itself been previously dyed in a contrasting color and left unrinsed will add color when it is allowed to bleed into the fabric that it is tying.

Rinsing and Untying

When you have completed your dyeing, rinse the cloth in cool running water until the water runs clear. This will remove excess dye and prevent it from bleeding into unbound areas when they are untied. After rinsing, open all bindings and rinse again. Set the dye by ironing the fabric when it is slightly damp.

Batiking

Like tie-dye, batik is a resist process for fabric decoration. However, rather than constricting the fabric with bindings, wax is used as the resist, setting boundaries through which the dye will not penetrate. Like the lead in a stained glass window, the wax acts as a border around the brilliantly colored patches of dye. When the batiked fabric is held up to the light, the comparison is even more striking.

The melted wax may be dripped, stamped, brushed or, most often, applied with a tjanting tool.

This ancient tool with its wax cup and tiny spout has not changed since its origin. With it, thin lines may be drawn in wax, and intricate, delicate pictures and patterns may be produced. Detailed Javanese batiked fabrics are a testament to this fine craft.

Batiked fabric is easily recognized by its characteristic crackled effect produced where the dye penetrates cracks in the wax. All of the wax is removed in the finished product, leaving the dyed and resisted design.

Materials. A large sheet of paper; pencil; dark marker; stretcher or picture frame; table covered with plastic sheeting or newspaper; cotton, linen or silk fabric; pushpins or thumbtacks; paraffin and

Ann Welch. **COSMIC VILLAGE. Incredible detail can be achieved with this process as demonstrated in this batik on silk.** Photo by Schecter Lee.

Harriet Berke. WATER LILIES.
Batik on silk. Repetition of
form, pattern and value echo
the movement of water in this
wall hanging.

Fabric is stretched on a frame and placed over the cartoon.

The design is traced in wax with a tjanting tool.

beeswax; tjanting tools and/or old paint brushes, other tools for applying wax such as a potato masher or spiral egg beater (optional); double boiler and temperature-controlled hot plate, or an electric frying pan; Procion MX series dyes; paint brushes for dye application; jar of clear water; urea; Ludigol (PROchem flakes); sodium hexa-metaphosphate; baking soda; plastic cups; jars with covers; rags; tablespoon or plastic lid; mild, neutral liquid detergent; newsprint paper; an iron; rubber gloves; dust mask.

Preparing the Fabric

After you have drawn your pattern and design full size on paper and retraced it with a dark marker, you are ready to begin your batik. Prepare the fabric by washing it in warm soapy water to remove any sizing. When cutting the fabric, consider the possible need for a border of undyed fabric if you intend to make a hem or seam when the dyeing is completed.

Stretch the dried fabric tautly onto the frame and secure it with pushpins or thumbtacks. Working on a stretcher rather than directly on the pattern enables you to wax and dye the fabric without ever touching the fabric to the pattern. Working with the fabric placed directly on the pattern affords less control over the placement of the wax and dye, since they tend to migrate via the newspaper.

Place the stretched fabric over the paper pattern for easy tracing in wax. Work on a table covered with plastic sheeting or newsprint paper.

Waxing the Fabric

Batik wax is made from approximately 70 percent paraffin to 30 percent beeswax. The beeswax makes the paraffin less brittle. However, paraffin alone may be used.

Wax is melted in a double boiler heated on a hot plate or, preferably, in an electric frying pan. **CAUTION: Do not overheat wax. Heat below the smoking point. Overheated wax produces harmful vapors and may explode. Do not melt wax in a pot placed directly over a flame. Work in a well-ventilated area.**

Wax is applied to fabric with a brush, stamp, such as a metal potato masher or carved wooden block, or tjanting tool. The tjanting tool comes in several sizes which allow different amounts of wax to flow, producing variations in line width. The tjanting tool's metal cup should be sufficiently warmed to keep the wax melted for a short time. Dip the bowl of the tool into the melted wax and draw on the fabric with the spout of the tool actually touching the fabric. A large tjanting tool must be moved quickly and some practice is necessary to master control of the tool.

The correct temperature for the wax may be gauged by observing the wax on the fabric. If the wax looks translucent rather than opaque, it has reached the correct temperature. Opaque wax is not hot enough to penetrate the fabric.

Although wax drippings are part of the process and may be used to your advantage, they may be controlled by using a tablespoon or plastic jar lid held beneath the waxing tool to catch drips. Excess

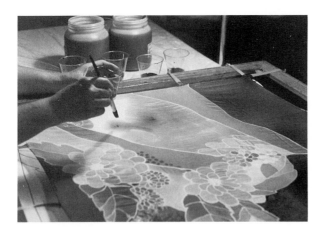

Dye is painted on the fabric. The wax borders prevent the colors from spreading.

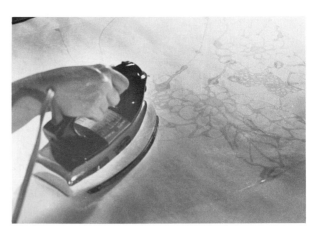

Wax is ironed out with the batik sandwiched between sheets of paper. The paper is discarded and replaced when it becomes saturated with wax.

wax may be remelted. Allow the wax to harden before proceeding to dye.

Dyeing the Fabric

There are many different dyes, and methods for dyeing fabric. The method presented here is one which yields a wide range of permanent, brilliant colors. The dyes used are Procion fiber-reactive, cold-water dyes. Cold water is a professional term for water at 70-80 degrees F. Water below 70 degrees F. is too cold for complete solution of dyes and chemicals and results will be erratic. These dyes are suited for dyeing cotton, linen or silk fabric. All of the ingredients needed for dyeing with fiber-reactive dyes may be purchased from PRO Chemical and Dye Inc. Other types of dyes may be used by following manufacturer's instructions.
Always wear rubber gloves when dyeing.

To prepare Procion dyes for use, a chemical water is first mixed, combining 1.5 teaspoons sodium hexa-metaphosphate (a water conditioner), 6.5 tablespoons urea, 1.5 teaspoons PROchem flakes (Ludigol) and enough warm water to make 1 quart of liquid. This chemical water may be stored in a covered jar and used as needed when mixing dyes.

When you are ready to dye, small amounts of dye may be mixed by combining the powdered dye with the chemical water in a ratio of at least $1/8$ teaspoon of dye per cup of chemical water. This ratio is highly variable depending upon the particular

dye and the desired intensity. Lastly, add baking soda in the ratio of 1 teaspoon per cup of dye liquid. Once the baking soda is added, the dye will last up to four days if stored in a closed container.

CAUTION: Avoid inhaling powdered dyes. A dust mask should be worn when preparing dyes.

Apply the dyes with a paint brush, dipping the brush in clear water and drying it on a rag between colors. Colors may be mixed together in a cup, blended directly on the fabric or thinned with the chemical water to produce different values or shaded areas. The dye will penetrate the fabric only where there is no wax or where the wax is cracked. After painting all of the colors onto the fabric, allow the dye to dry naturally, away from heat or sun. If possible, dyes should cure for 24 hours to develop maximum color. Covering the dyed fabric with plastic to slow down drying will also help the dyes to react completely. When dry, remove the fabric from the frame.

Crackling

If an overall crackled effect is desired, wax is applied over the entire fabric surface with a large brush. Be certain that the fabric is completely dry and that the wax is hot enough to penetrate the fabric. When cool, it is folded or crushed in the desired pattern. When working in a warm room, or on a hot day, cool the batik in a refrigerator for a few minutes to harden the wax and make it eas-

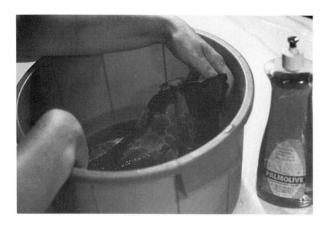

The fabric is washed and rinsed.

ier to crackle. You may wish to crackle some areas and leave others plain. After crackling, paint the cracks with a contrasting or darker dye. When dry, you are ready to remove the wax, leaving the completed batiked design.

Removing the Wax and Setting the Dyes

To remove most of the wax and set the dyes, place the dyed fabric between newsprint or any absorbent paper. Newspaper is not recommended since the print will transfer onto the fabric. Iron the wax out of the fabric and into the paper. The iron should not be so hot as to make the wax smoke. Change the paper regularly until all of the wax is removed. Do not use steam. Ironing with a medium hot iron for a few minutes will also set the dyes.

Rinsing

After the dyes are set by ironing, rinse the fabric in room temperature water to remove unfixed dye. Then wash in hot water and a mild, neutral detergent such as Palmolive or Woolite. Rinse several times until the water runs clear, and dry. Garments should be dry-cleaned before wearing.

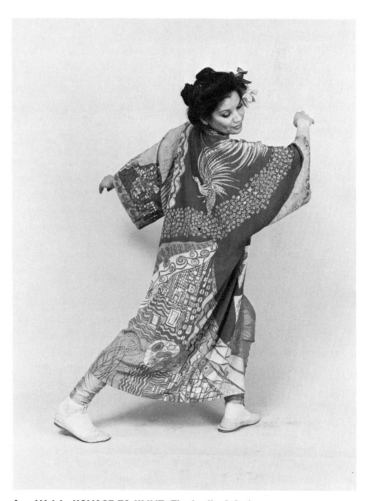

Ann Welch. HOMAGE TO KLIMT. The batiked design complements the fluid, graceful style of this kimono. Photo by Schecter Lee.

JUNGLE CAT. This student's composition is reminiscent of Henri Rousseau's *The Dream*.

Tie-Dye and Batik: Branching Out

✦ Design a soft sculpture in the form of a figure, animal, vegetable or inanimate object and use the batik method of dyeing to produce the image on the fabric.

✦ Create an article of clothing or home accessory by batiking or tie-dyeing the fabric. Dye the fabric before you do any sewing. This will prevent the seams from dyeing unevenly.

✦ Make a simple line drawing with pencil on fabric and sew a running stitch along the line. Gather the stitches tightly together and dye the fabric in the tie-dyeing technique.

✦ Batik an abstract or realistic composition and create a wall hanging. Quilt along some of the edges of the batiked areas to produce a three-dimensional effect.

✦ Using the batik technique, design a pattern that can be repeated to create "fabric-by-the-yard."

✦ Try using natural dyes for batiking or tie-dyeing (see Natural Dyeing).

Harriet Berke. Batiked eyeglass cases.

Constance Miller. ENTRANCE.
Handmade paper. 48" X 54".

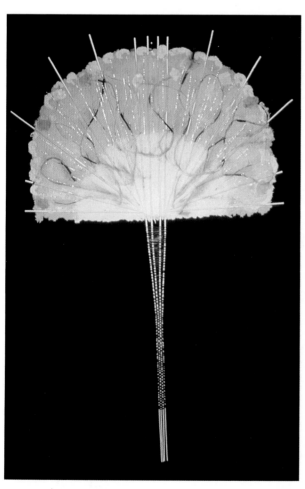

Constance Miller. PAPER FAN.
Handmade paper. 24" X 36".

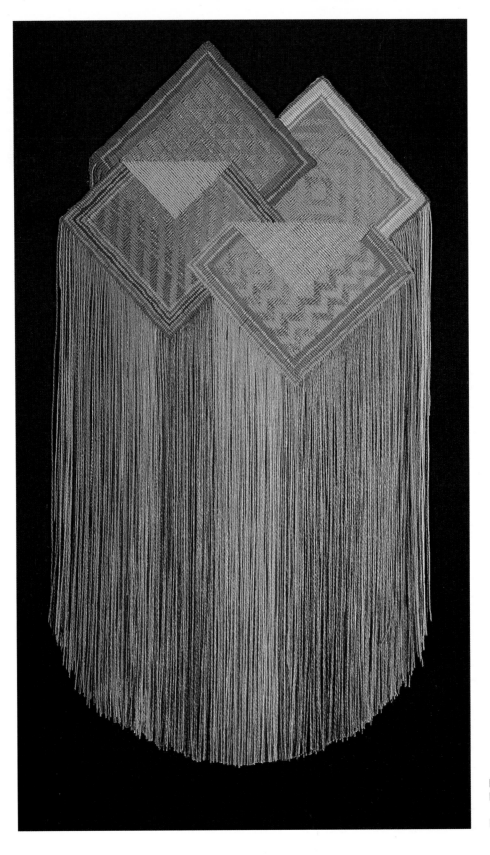

Diane Itter. QUILT QUARTET.
Knotted linen. 9" X 17".
1984.
Photo by David Keister.

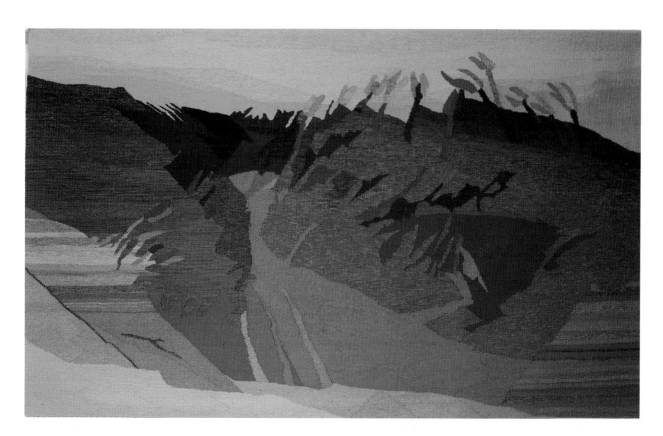

Michelle Lester. TRACKS.
Woven wall hanging.
7.5' X 4.5'. 1984.

Jane Sauer. CEREMONIAL
BASKET WITH STRIPES.
Knotted waxed linen and
linen. 1983.

Layne Goldsmith. **FAULT
ZONE I: WEST COAST RIFT.**
Wall hanging, felted wool.
1984.

Tafi Brown. **DEER KNOLL
DAIRY IV.** Cyanotype
(blueprint) on cotton. Quilted
wall hanging. 1982.

Ann Welch. **BIRD MARKET, JAVA.** Batik on silk. Photo by Schecter Lee.

Harriet Berke. Blouse. Batik on silk.

Nancy Baldwin.
SOUTHWEST III.
Earthenware vessel,
airbrushed glaze/slip.
7" high. 1981.

Randy Fein. MULBERRY HILL.
Handbuilt stoneware.

Marvin Bjurlin. SARABANDE.
Wheel thrown low fire
ceramic. 15" X 17".

Esther Knobel. Brooch of painted tin, stainless steel, elastic. 1984.

Lisa Gralnick. Fibula of sterling silver, ivory and cloisonné enamel. 1982.

Peggy Simmons. ANY ROOM ALWAYS. Neckpiece of sterling silver, 14-karat gold, cloisonné enamel.

Daphne Lingwood. BIRDS OF A FEATHER. Leather necklace constructed from one piece of cowhide.

Rhoda Goldstein. Scrimshaw.

**Ronnie Wolf. ST. CROIX.
Stained Glass.**

Stocking Figures

Since the Pop Art movement of the 1960s, which popularized soft sculpture as an art form, many artists have been creating sculpture from soft materials such as fabric, leather and plastic. Sculptors use traditional techniques like sewing, knitting, crocheting and weaving to create what are often very nontraditional sculptures. To create dimension and animate poses, these artists add stuffing and often an armature.

The relatively low expense, light weight, availability of materials and potential for large- and small-scale work contribute to making soft sculpture a vital art form. Most of the materials necessary for creating soft sculpture may be found in the home, there for the asking.

Stocking figures are an intriguing form of soft sculpture, appealing in their uncanny likeness to real life. The stuffed stockings provide a yielding yet suggestive substance from which characters are born. With a pinch here and there and then a few stitches to make it all permanent, you have a unique stocking figure.

The basic procedure for creating a stocking figure is to pinch and sew. The instructions below are a guide to show how the process is applied, rather than a set of rigid instructions. Enjoy experimenting and discovering how this medium can give birth to some very lively characters.

Materials. Stretch pantyhose, a needle and thread (preferably matching the stocking color); scissors; polyester stuffing; materials for making clothing and accessories, such as doll's or young children's clothing; fabric; yarn; fur; leather; junk jewelry; buttons; feathers; ribbons; lace and embroidery thread.

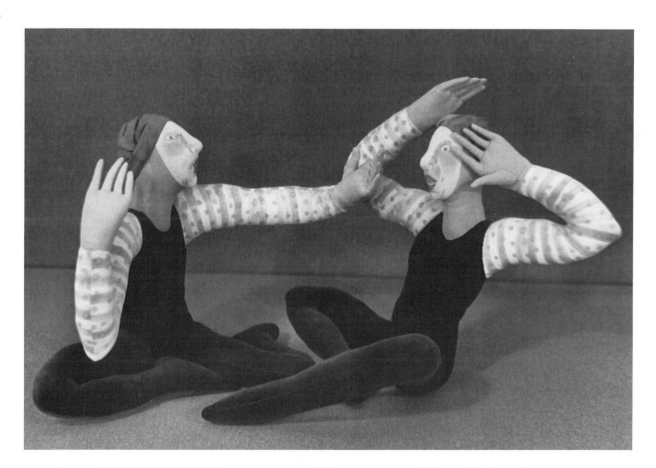

Lenore Davis. PAIR OF STORY TELLERS. Dyed, sewn and stuffed soft sculpture. 16" high. 1984. These dramatic figures seem to "speak" with their exaggerated postures.

Making the Head and Torso

Cut one leg off the panty hose approximately 8″ from the toe to form the head and torso. Stuff the leg with a few large pieces of polyester stuffing. Add a small lump of stuffing for the nose. Knead the stuffed stocking into shape, and experiment by pinching different expressions into the face. Try to make it as expressive as possible, for this medium lends itself to dramatic facial expressions.

To sew the expression in place, poke the needle from the back of the head to the front, drawing the needle out at the nose. Pinch a nose around the added lump of polyester and outline the nose in running stitches. When you have finished surrounding the nose with stitching, pinch and sew the eyebrows. Stitches that you do not wish to see should be hidden underneath the surface. Only stitches that are decorative or serve to define a feature should be visible.

After completing the eyebrows, travel under the surface so that the needle comes out in the eye area. Using the running stitch, sew an oval to form the eye. Repeat for the second eye. The eyes' centers may be sewn with a separate needle that is threaded with a triple length of thread. Sew the satin stitch to create the two irises.

To form the lips, pinch an upper lip and sew it in place with the running stitch. Repeat for the lower lip. Then tack the corners of the lips together. Insert a small lump of stuffing to mold the chin.

Now that the face is completed, the neck is formed by digging some of the stuffing away from the neck area, sewing the running stitch around the neck, and pulling the thread to draw the form inward.

The torso is completed when a knot is tied to close the bottom of the stocking.

Making the Arms and Legs

To construct the arms and legs, cut two sections of stocking in half lengthwise. Thus you will have material for two arms and two legs. Make the lengths appropriate for the size of your figure. Remember that they will stretch in both directions when stuffed. Sew each of the four limbs up the open side and across the bottom with the running stitch, leaving the top open for stuffing. Turn the

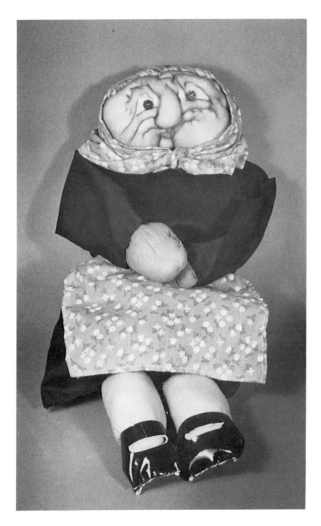

Student work. Stockings, fabric, leather.

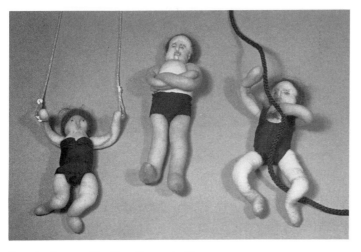

Dorothy Lazara. Stocking figure necklaces.

The stocking is filled with polyester stuffing and manipulated to shape.

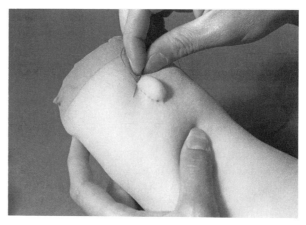

A lump of stuffing is added for the nose. The nose is held in shape with the running stitch.

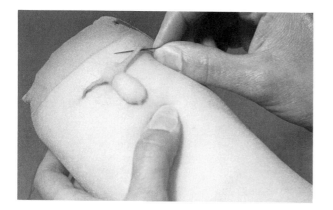

Eyebrows are pinched and sewn.

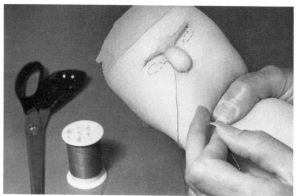

Running stitches are made to form the eyes.

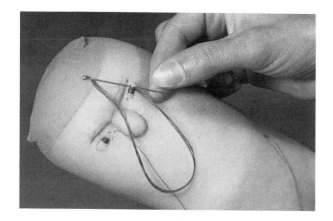

Triple thread is used to sew the eyes' centers.

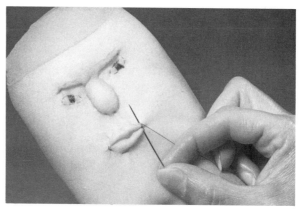

Lips are pinched and sewn, taking an extra few stitches at the corners to join the upper and lower lips.

sewn limbs right side out so that the seam is on the inside. Stuff them with one rather than several pieces of stuffing. After stuffing, close each limb by tying the end in a knot.

Next, press each arm and leg to the torso and sew it on with the running stitch, making sure to hide the knot at the top of each limb.

To form fingers and toes, sew a series of four parallel seams on each hand and foot.

Decorating the Figure

Here is your chance to become a hair stylist and a fashion or costume designer. Create hair by sewing or gluing polyester stuffing, yarn, steel wool, fur or any appropriate material to the head. A hat may be fashioned from leather or fabric, and eyeglasses from wire.

Add clothing to bring out the real character behind the figure. Clothing may be fashioned from doll clothes that have been altered to suit your character, or made from fabric to your own specifications. Craftsmanship in finishing, and the addition of subtle details is what will make your figure a true work of art.

Stocking Figures: Branching Out

✦ Create a stocking figure of a person that you know. Design the clothing and accessories to make the character as believable as possible.

✦ Make a life-size figure, and dress it in regular adult or children's clothing. Strong wire may be inserted within the figure and bent to support it in a specific pose. Groupings of figures may be created and props added to make an environment. This is an excellent group project.

✦ Create a hand puppet with stocking figure head and hands.

✦ Tiny stocking figure heads may be made and used as buttons, jewelry or ornaments.

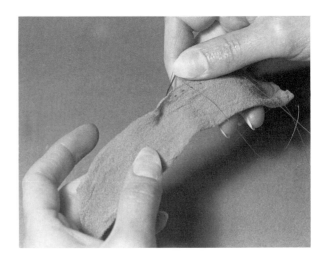

This will be a leg when the seam is sewn, turned right side out and stuffed.

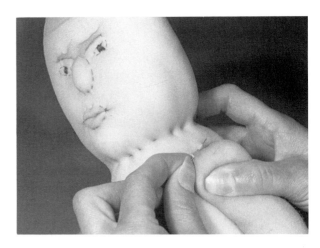

By pressing the stuffed arm to the torso, it can be easily sewn onto the body.

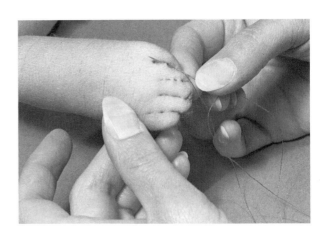

Four rows of stitching form the fingers.

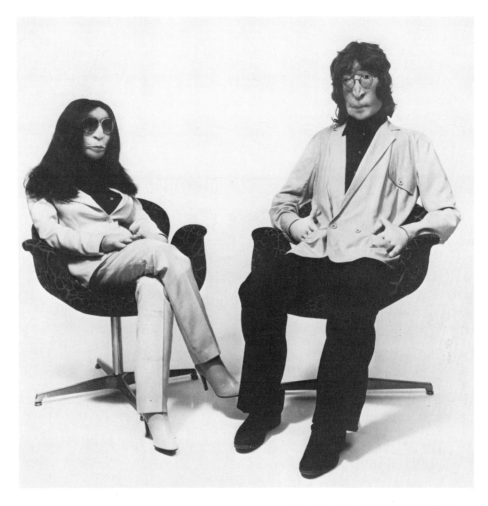

Dorothy Spiegel. JOHN AND YOKO.
Actual clothing from the Ono-Lennon personal wardrobe was used in making these life-sized portraits. The heads and hands were made from stuffed, sewn stockings.

Dorothy Lazara. BATHER. Careful choice of materials lends realism to this piece: smooth stuffed stocking for the skin; shiny satin for the bathtub; terry cloth for the towel, and coarse, unspun wool for the hair.

Tafi Brown. AIRY TIMBER FRAME. 48" X 48". 1984. The abstract pattern on this quilt was made by blueprinting an enlarged negative of a wooden building frame onto fabric pieces. The pieces were later arranged and stitched together.

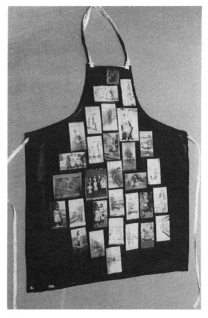

Margaret Casella. These aprons illustrate the use of blueprints on fabric: a) vegetables b) photographic negatives and c) vines.

Fabric Blueprints

Most people are familiar with blueprinting of architectural plans. The same process used to make these blue line drawings may be used by the craftsperson using fabric rather than paper, and images chosen for aesthetic rather than functional purposes.

Blueprinting involves coating fabric (or paper) with a mixture of two chemicals: potassium ferricyanide and ferric ammonium citrate. When objects, negatives or other masks are laid on the coated fabric and exposed to sunlight (ultraviolet light), the unprotected areas of the fabric (those not covered by objects) will turn blue. When the exposed fabric is rinsed in water, the light sensitive chemicals are washed out and the image is set. Thus, masked areas remain white while exposed areas turn blue.

Materials. Any objects may be used to produce an image. Opaque objects that make complete contact with the fabric will produce the sharpest, most dramatic results. Suggested materials include feathers, lace, leaves, tools, pressed flowers and photographic negatives. Transfer lettering or opaque paint may be applied to acetate and used as a mask. This allows you to write words and paint your own images. By making an experimental print of an object you can determine exactly how it will look.

In addition to objects, you will need the following materials: silk or pure cotton (the finer the weave of the cotton, the richer the blue of the print), rubber gloves, two light-proof bottles, ferric ammonium citrate (green crystals), potassium ferricyanide, a gram scale, distilled water, a measuring cup, glass or plastic jar, 2″ foam or bristle paint brush, newspaper, a blow dryer, plate glass, a board to support the fabric and objects, running water, bleach (optional).

Two solutions are combined to create the light sensitive liquid that will be applied to the fabric. The first of the two solutions is made by mixing 8 oz. of distilled water with 90 grams of ferric ammonium citrate. The second solution is made by combining 8 oz. of distilled water with 45 grams of potassium ferricyanide. A smaller quantity may be made by mixing 3.3 grams of ferric ammonium citrate with 1 oz. of water. When you are ready to use the chemicals, add 1.5 grams of potassium ferricyanide. These chemicals may be purchased at a chemical supply house. (Check the Yellow Pages of

Tafi Brown. DEER KNOLL DAIRY IV. Machine pieced, handquilted. 47" X 56". 1982. Horizontal bands of repeated photographic images create large patterns which complement the delicate patterns of the printed fabrics.

the phone book.) Each of these solutions should be stored in a brown bottle in a cool place. Do not allow the chemicals to come into contact with any metal other than stainless steel. **CAUTION: Wear rubber gloves when working with these chemicals. Label all chemicals. Do not use kitchen utensils that will be reused for cooking.**

Preparing the Fabric

Begin by combining the two solutions mentioned above in equal amounts, in a glass or plastic jar. If you are using the second formula (for a small quantity), add the potassium ferricyanide to the ferric ammonium citrate and water. Once these solutions are combined, they become light sensitive and should be used within a few hours.

Apply the light sensitive solution to the fabric in a darkened room. Although you may allow some light to enter the room so that you can see, the less, the better. A 15-20 watt red or yellow bulb may also be used. Lay the thoroughly dry fabric on newspaper and begin to brush on the solution. Apply the solution evenly over the entire surface unless you wish to produce a special effect. Then dry the fabric thoroughly with a blow dryer.

While you are still in a darkened room, arrange your objects on the fabric to create your composi-

tion. Work on a board so that the fabric with the objects may be easily transported outdoors. Cover light objects with a sheet of glass in order to press them flat against the fabric.

When everything is held securely in place, you are ready to begin your exposure. Move the setup into the sun without disturbing the objects. Since the exposure time is dependent upon the strength of the sun, it is highly variable and may take anywhere from 5 minutes to an hour or even longer. More time is required on overcast winter days than on sunny summer days. The sun is strongest between 10 a.m. and 2 p.m. You will know that your exposure is complete when the color of the chemicals changes from yellow-green to blue-grey. Then the fabric, with the objects still in place, should be brought back indoors.

Next, remove the objects in semi-darkness and rinse the fabric immediately for 15 minutes in running water. It is essential to rinse thoroughly.

If you wish to darken the blue further, dip the fabric in water mixed with a few drops of bleach. In a few seconds you will see the color change. Remove the fabric immediately and rinse thoroughly. Dry in a darkened area.

A blueprinted image may be embellished with embroidery, appliqué, quilting, machine stitching or hand coloring. It may be used to create images on clothing, a wall hanging or soft sculpture.

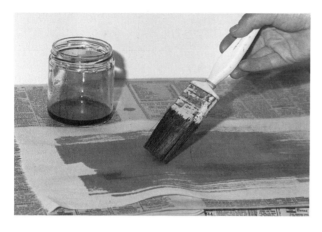

Brushing on the light sensitive blue printing solution in a darkened room. Photos of this process by Renee O'Brien.

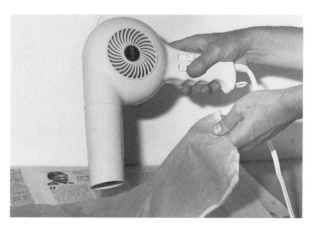

Drying the fabric.

After the objects are held securely in place under glass, they may be transported outside and exposed to the sun.

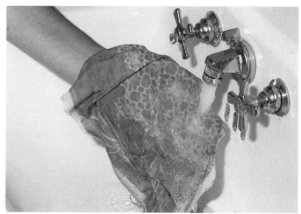

Rinsing the exposed fabric in semi-darkness.

The completed sampler.

Blueprinting: Branching Out

◆ Choose a theme and create a photo collection made from blueprinted photographic images. The collection may take the form of a fabric photo album or a quilt. Several people may contribute to this project.

◆ Combine xeroxed, blueprinted and original objects in one unified work. For example, make a blueprint and a xerox print of lace and sew the resulting images together with the lace itself.

◆ Create a soft sculpture by using the blueprinted image of an object to make a soft version of that object. For example, make a tool set by blueprinting each tool onto fabric. Then sew and stuff.

Color Xerox Transfers

One simple means of creating images on fabric is by using xerox iron-ons which are transferred onto fabric with the heat of an iron or dry-mount press. These transfers are easily made by taking the desired images or objects to a copy center that produces color xerox iron-on transfers. Within a few minutes a transfer may be produced to create a soft sculpture, T-shirt design, wall hanging, or any art object which incorporates the transferred image. On a single 8½″ x 14″ sheet, a number of images may be copied and cut out for use in several projects. The transfer may be used in conjunction with other materials such as acrylic paint, textile crayons, permanent markers, thread and fabric.

Materials. Two- or three-dimensional materials such as postcards, photos, magazine clippings, leaves, flowers, lace, yarn and small objects to be xeroxed; 8½″ x 14″ sheet of paper; cotton, polyester, cotton-polyester blends or any smooth fabric that will withstand the heat of an iron (a T-shirt may also be used); an iron or dry mount press; paper; materials for coloring such as markers, acrylic paints, textile crayons; and scissors.

Xeroxing

Plan your project including both the images to be used and the manner in which they will be organized. Arrange the images and objects on a sheet of 8½″ x 14″ paper, which is the size of the transfer sheet.

Next, take your materials to a copy center that makes color xerox iron-on transfers. Check the

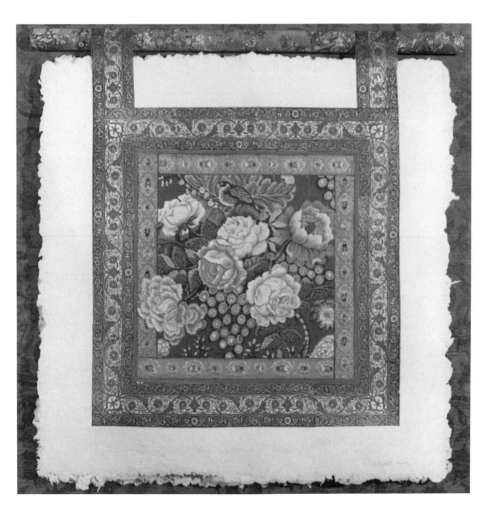

Charlotte Brown. PLUMB ROSE. 45″ X 42″ X 3″. Handmade paper is the background for this collage of heat-transferred images and actual fabric. The different materials are unified by their common floral motif.

phone book for centers in your area. Phone first to make sure that the iron-on transfer process is available.

Some copy centers will permit you to place the items on the copy machine yourself. This is preferable, of course, since it gives you complete control. In addition, it makes it possible to use a part of your body, such as your hand, in the composition and to move objects. Interesting effects may be created if an object is moved while being copied. Note that even black and white images must be color xeroxed and that all images are reversed when they are transferred. Words should therefore either be reversed on the original or a special reversal process should be requested. There is an additional charge for reversing transfers.

Once you have your xerox iron-on transfer, it can be transferred onto the fabric using an iron (for small transfers) or a dry mount press (for larger transfers). Place the transfer face down on the fabric and cover it with a thin sheet of paper to protect the iron (or press). Set the iron on the polyester or cotton setting (approximately 300–350 degrees F) and press for approximately 30 seconds. If you are using a dry mount press, preheat the press to 300 degrees F and press for approximately 30 seconds.

Try to remove the transfer paper immediately by holding the fabric down and slowly peeling off the backing. If it does not peel easily, heat for an additional 20 seconds and then peel.

If you wish to wash the fabric once the transfer is adhered, wash by hand, in lukewarm water and mild soap. Do not use bleach and do not iron over the transfer.

The transferred design may be embellished with any permanent medium such as permanent markers, acrylic paint, textile crayons or stitchery.

After the image has been xeroxed onto iron-on transfer paper, it can be cut out.

The iron-on transfer is positioned on the fabric and heated with an iron.

The paper is peeled off immediately, leaving the image on the fabric.

Ruth Struhl. Two separate images were cut out and ironed onto these handmade night shades.

Insert paper between the back and front of a T-shirt if you wish to protect the back from paint or other materials that may bleed through the front. If the work is not going to be washed, a non-permanent medium such as colored pencils may be used. Trimmings including feathers, beads, sequins and lace may be sewn on to embellish your creation.

Xerox Iron-On Transfers: Branching Out

♦ Take a photograph of a friend or relative, or find a magazine portrait of a well-known person and make an iron-on for the face of a soft sculpture.

♦ Make a pop art soft sculpture by using an iron-on to reproduce a familiar object in an unfamiliar material. For example, use a photograph of a book cover to make a "soft book" by applying

the photo transfer to the cover of a book that you have made out of fabric.

♦ Using one or several iron-on transfers, create a T-shirt organized around a theme. Some suggested topics include "Speak out for a good cause," "Advertise yourself" and "Publicize an event."

♦ Create a quilt made up of many squares of iron-on transferred images. The quilting stitches may follow the outline of the transferred images or may be independent of the transferred design. This is an excellent group project.

Charlotte Brown. A BOOK CONTAINED IN A BLACK BOX. 14" X 14" X 4". Xerox, 3M color process on handmade paper, wood and clay. Images can be heat-transferred onto paper as seen in this unusually packaged book.

Felting

Like paper, felt is a nonwoven material. Felting most likely preceded spinning and weaving and occurred naturally when sheepskin was worn against the body. The body moisture, heat and movement combined to create all of the ingredients needed to make felt. We too, on occasion, will felt wool accidentally (often to our dismay) when we machine wash a wool garment. Many a sweater has been miniaturized in this manner.

Felt is not a stranger to us in our everyday lives. We are familiar with felt hats, piano hammers, filters, boot liners and rugs. It exhibits an unusual combination of characteristics, displaying excellent insulating and cushioning abilities as well as being highly absorbent. Its softness is attested to by its use in the manufacturing of polishing pads.

Felt has no grain and will not ravel, can be molded, cut and sewn. Its surface may be embroidered or combined with almost any fiber surface treatment such as appliqué or painting. Individual felted pieces may be crocheted or knitted together to form a larger work.

The craft of felting has recently enjoyed a resurgence. Artisans are using this technique to create clothes, wall hangings and sculptures. Handmade felt bears little resemblance to the lifeless commercially manufactured felt used by hobbyists. Its warmth is both literal and implied, its surface rich and alive, yet dense and durable.

Fleece may be dyed any color. Several colors may be felted together to create stunning designs, all bound together by a seemingly mysterious process that transforms loose fibers into a resilient, tightly bound material known as felt.

Marleah MacDougal. CHASM. 5' X 5'4". Color, value and texture move the eye around this grid from one felted square to another.

Beth Beede. AGATHA'S
GARDEN. Felted wool. 1980.
This composition suggests
pressed and dried flowers.

Materials. Felt may be made from almost any animal hair; however, it is primarily made from wool. Due to the scaled surface of the wool fiber and the tendency of wool to shrink, the fibers become entangled when they are subjected to moisture, heat, pressure and agitation.

Although wool from any breed of sheep will felt, some felt more successfully than others. There are many factors which contribute to making felt; however, the crimp and fineness of the wool in particular will affect the quality of the felt. By felting small experimental squares, you will discover the felting capabilities of each type of fleece, and select those which suit your particular needs.

Felting is most effective when the fleece has been carded. Carding aligns the loose fibers and distributes them evenly to form what is known as a batt. Carding is done on a carding machine or by hand with two hand cards. If you are just starting in this craft, you may want to purchase precarded fleece from a weaving supplier.

In addition to carded fleece (assorted colors), you will need soap or detergent; a needle and thread; rubber gloves (optional); a sheet of thick plastic; cold, and hot or boiling water; a spray bottle filled with water; a reed mat, matchstick blind, or plastic screening; scissors; a disposable razor; materials such as yarn, string, ribbon, and small scraps of fabric to be incorporated into the felt.

Sharron Parker. Detail of a felted wall hanging showing the subtlety of texture and design possible in felting.

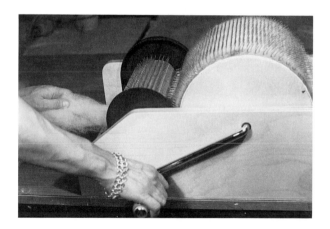

Carding the wool.

Sharron Parker. WATERFALLS. 54" X 38" X 1". Felted wool with inlaid yarn. Pattern and texture produce a strong shimmering effect.

Laying Out the Batts

The process of making felt is a highly physical one in which the felter rolls a stack of thin, loose layers of carded fleece until they become one dense layer. To begin, lay one layer of carded fleece (known as a batt) upon another, laying each perpendicular to the previous layer, until they are stacked to the desired thickness. You will need a minimum of three layers if you are making thin felt, and as many as you wish for thicker felt. The batts may be stacked as high as one foot (or even higher) if you wish to make very thick felt and have the determination and energy to work hard and long. When cutting the batts, remember the shrinkage (as much as 50 percent) that will occur during the felting process.

To create a design in the felt, several colors of dyed batt may be layered together, or small shapes of colored fleece or slightly felted wool may be added to the batt. These shapes may be arranged in a design between the top layers or directly on top of the batt stack.

Wool yarn, and even materials that will not felt, such as ribbon and cotton thread, may be incorporated into the work. Most of these additions will be trapped by the wool as it felts. To further encourage the entrapment of small materials, slits may be made in the top layer of the batt and the additions partially embedded before felting. To control the possible shifting of these design elements during felting, small additions may be basted down using a needle and thread. The basting stitches may be removed when the work is completed.

Wetting Out the Fleece

The completed batt stack should be compacted before it is felted. This will help hold the design in place as well as provide a better view of what the final work will look like. To compact the batt stack, spray or sprinkle water over the surface and add a few squirts of soap or detergent. The detergent will lubricate the fibers and encourage them to travel more freely.

Support your work on a reed mat or matchstick blind. The mat will prevent the fleece from shifting during the arduous felting process. Plastic screening or even an old sheet may also be used.

However, the reed mat is much more effective and will save a great deal of time and elbow grease. If screening or cloth is used, the batt stack should be encased in it. Spread a sheet of thick plastic under the mat, screening or cloth to protect the work area during this wet and soapy process.

Hardening

When the batt is thoroughly saturated with soap and water, you are ready to begin to felt the wool. During the first step, known as hardening, the batt is worked until it becomes a single layer of intertwined fibers. At the completion of this step, the fibers will no longer be easily teased apart.

The wool is hardened by rolling and unrolling the saturated batt in the mat. This is repeated over and over, flipping the batt and rolling it in every direction so that the entire piece is felted evenly. Smooth out wrinkles as they form and correct any shifts in the design elements. The longer you work, the harder and stronger the felt will become. Do not, however, be too agressive at the early stage of hardening. Rubber gloves may be worn to protect the hands.

Since agitation is what makes the fibers felt, the batt may also be slapped, stepped on (some felters work outside with a hose or in the bathtub wearing rubber boots), paddled or rubbed against a washboard.

In the first stages of hardening, when the wool fibers have just begun to interlock, the edges may be reinforced and straightened by folding them towards the center. As the felting proceeds, these folds will disappear as they become integrated into the felt. If you prefer, the edges may be trimmed with a scissors at this point or when the felting is completed.

When the batt is compacted into one unified, solid sheet of fibers that is not easily teased apart, you are ready to start the next step, known as fulling.

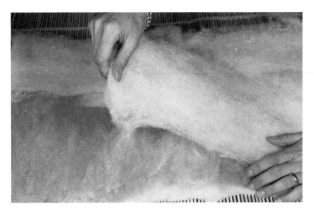

Stacking layers of carded fleece.

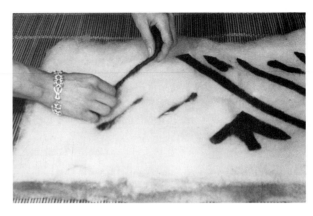

Shapes of slightly felted dyed wool are arranged on the fleece.

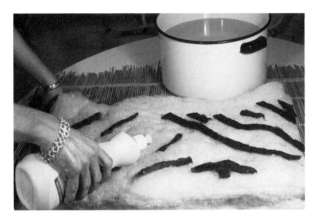

Water and soap are sprinkled on to help compact and lubricate the wool.

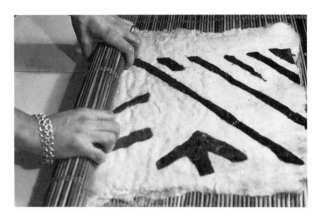

Rolling and unrolling the batt until it turns into felt.

Patience is a necessary ingredient.

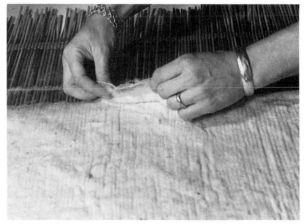

Folding the edges during the process of felting.

Fulling

The batt should now be an integrated mass of fibers. The purpose of fulling is to further interlock the fibers so that they create a stronger felt. The procedure is the same as for hardening, but in this stage the wool is shocked with hot (or boiling) water and then cold water as it is worked. Since hot water swells the fibers and makes them interlock more effectively, the hotter the water, the better.

As you work, you will feel the felt stiffening and becoming progressively more compact and resilient. Fulling may take an hour if you are working on a small piece or up to several days, depending upon the size of the piece as well as the conditions under which you are working. *Resist the temptation to quit too soon!* When you think that you have gone as far as you can go, go even further. Most novices stop well before the wool is truly felted.

When the felting is completed, wash the felt to remove the soap and thereby preserve the dyes. Then hang it out to dry.

Finishing Touches

When dry, the surface may be refined with a disposable razor. Shave off any unwanted fuzz or use the razor to bring out colors that lie beneath the top layer. The edges of your work may be left as is or cut with scissors.

Felting by Machine

Felting in a washing machine and dryer eliminates the physical effort that is such a time consuming and taxing part of felting by hand. There is, however, a loss of control over the process when felting is done in a machine. Although felting by hand is hard work, the felter has the satisfaction of being close to the process and "in touch" with the state of the material at any given moment. Thus, undesirable shifts in the fibers, and wrinkles may be corrected before they become a permanent part of the felt. As with any technique, felting by machine imparts its own qualities to the product — qualities which may not have been achieved by hand felting.

When using a machine to felt, encase the layers of carded wool in cotton cloth (a pillow case or sheet is excellent for this purpose) and baste through the sandwich with strong thread to secure the wool and prevent it from shifting in the machine. When the basting stitches cover the entire surface approximately every inch so that it looks like a quilt, place the bundle in the washer. Check it regularly by removing the stitching from one corner to see how the felting is progressing. When the batts have been hardened and somewhat fulled, they may be further fulled by hand or in the dryer. Redampen the felt if it becomes dry in the process. Since every machine is different, and the variation in temperature and agitation alters the rate of shrinkage, it is essential to make a test piece before committing your time and energy to a work.

Three-dimensional forms may be felted in a machine by wrapping carded wool around a mold such as a ball, foam rubber form or stuffed non-wool sock. Wrap the fleece in perpendicular layers around the mold. To felt this package, wrap it tightly in an ace bandage, stocking or cotton cloth. Wash it in hot water and soap, putting it through several cycles of the washing machine and dryer to accomplish the felting. This may even be done with your regular laundry. As the wool shrinks it will become matted and hard and will take the form of the core. The core may be removed at the completion of the felting.

Felting: Branching Out

- Experiment by making several small squares of felt in which different materials such as ribbon, thread, small swatches of fabric and natural materials are incorporated.
- Create a realistic composition by felting small pieces of colored fleece onto a background of solid-colored fleece.
- Experiment by stuffing carded fleece into a stocking, glove or other mold and processing it through the washing machine and dryer.
- Make an article of felt clothing or an accessory such as a bag, slippers or a vest.

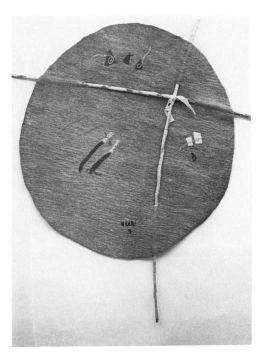

Anne Dodson. 6" diam. X 6" height. 1983. Layers of carded wool were wrapped around a foam rubber core, enclosed in pantyhose and put through several cycles of the washing machine and dryer to felt this vessel. Photo by Charles Dodson.

Anne Dodson. WARRIOR II. 36" diameter. 1983. Cords were felted into the layers of this piece and later removed, leaving channels into which sticks were inserted. The surface imagery is composed of previously felted wool and wool yarns. Photo by Charles Dodson.

Cynthia Boyer. Meandering linear elements are overlapped by a solid white panel in this hand-felted jacket. Photo by Mary Noble Ours.

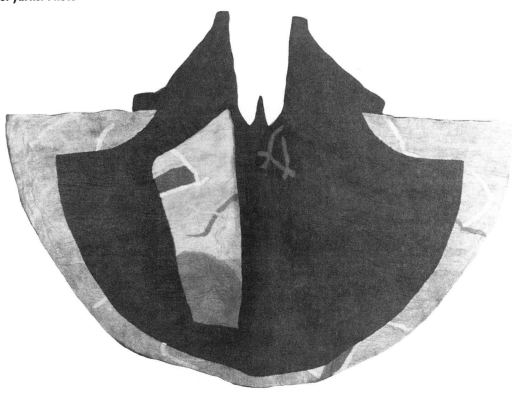

Layne Goldsmith. INSIDE OUT. 90" X 67" X 8". 1982. This cape-like form, felted in wool, sets off darks against lights in both symmetrical and asymmetrical contexts. Photo by George Williams.

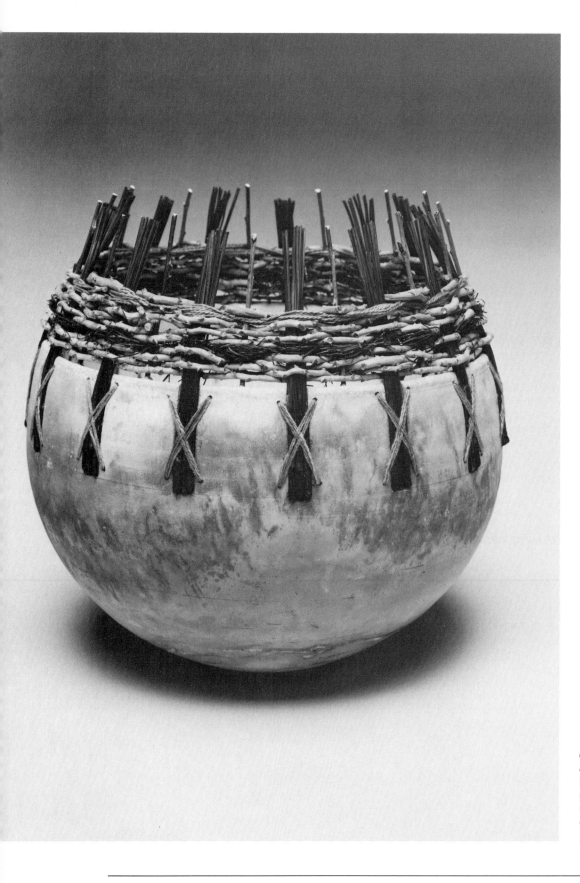

Christina Adcock in collaboration with potter Michael Adcock. Ceramic pot woven with dyed pine needles, willows, hand-dyed cotton, seagrass and date palm fruit stalks. 12" X 12".

Basketry

Virtually every culture practices basketry, one of the oldest crafts. Basket weavers have invented many weaves and techniques for working with their materials, and baskets come in every imaginable form and perform countless functions. Although contemporary basket makers have expanded their craft well beyond historical examples, the basic methods are essentially the same. Whether you create a traditional basket or an exotic form using basketry techniques, you are sure to find this craft challenging and exciting.

Twining

One of the simplest and oldest basketry techniques is twining. Twining involves weaving with two weavers (weft) around spokes (warp). The spokes form the skeleton of the basket. They define the basket's shape while the weavers fill in the form.

Materials. Baskets may be made from a broad range of materials including reed, bark, stems, vines, roots, grasses, leaves, branches, yarn, paper, wire, plastic or any flexible material that will withstand the weaving process.

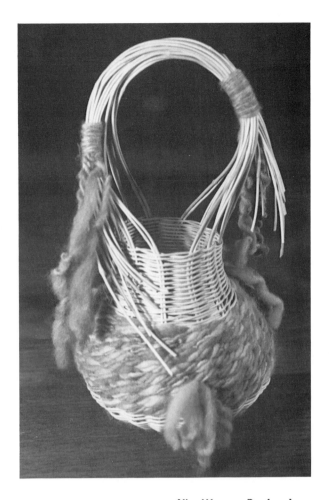

Alice Wansor. Reed and wool. Twined basket.

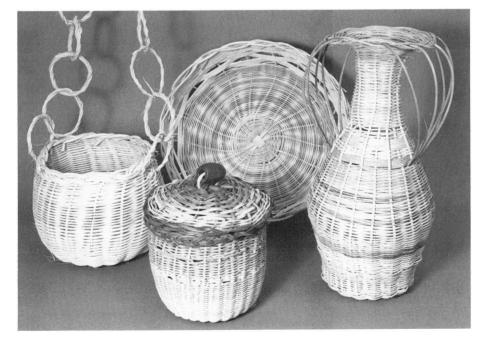

Twined baskets by students.

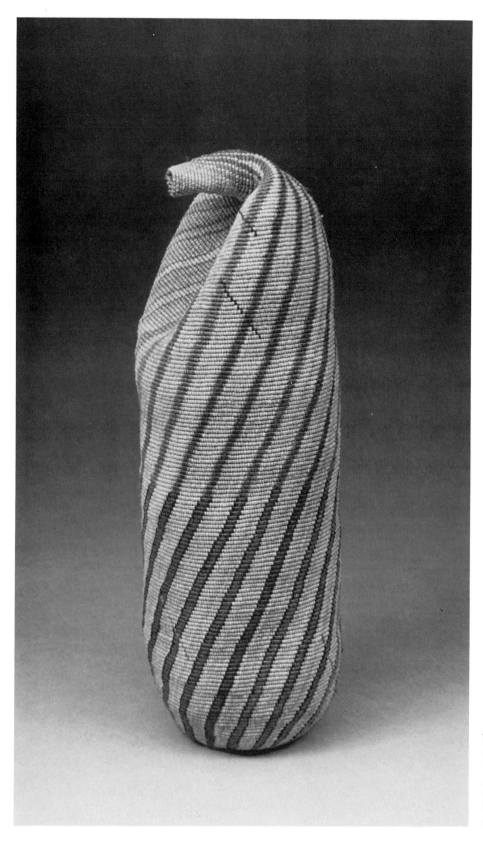

Jane Sauer. **PASSAGE
ENLIGHTENED. Knotted
waxed linen and linen.
10½" X 3½". 1983. The
spiraling lines on the
surface of this knotted
form accentuate its
organic shape.**

As a contemporary basket maker, you may wish to work as the ancients, with materials gathered from your natural environment, or you may prefer to use materials that have been purchased. Gathering materials may appeal to those who enjoy being involved in the entire process from start to finish. The fragrances, textures and colors presented by nature are there for the taking.

If you choose to gather your own materials, allow them to dry before use to prevent the shrinkage and warpage in the finished basket. Soaking the dry material before use will restore its flexibility.

Found materials may be appealing but are not always easily worked. Since it is easier to weave with smooth, straight, flexible, long materials, the novice should work with a more controllable material such as reed. Reed may be purchased in various thicknesses from a basketry supply house. Good sizes to begin with are **#2** reed for the weavers and **#4** for the spokes.

Small amounts of found materials may be integrated into the reed basket. Corn husks, for example, are easy to work with and readily available. Use the green leaves (or red leaves if you are working with Indian corn) closest to the cob. Lay them out to dry and dampen them before use. Use corn husks or other natural materials to add contrast to your work, or dye the reed itself any color.

In addition to the material from which the basket is made, you will need a tape measure, heavy duty scissors or shears, round- or needle-nose pliers and a soaking pail.

Preparing the Materials. Before you begin weaving, soak your materials in water for approxi-

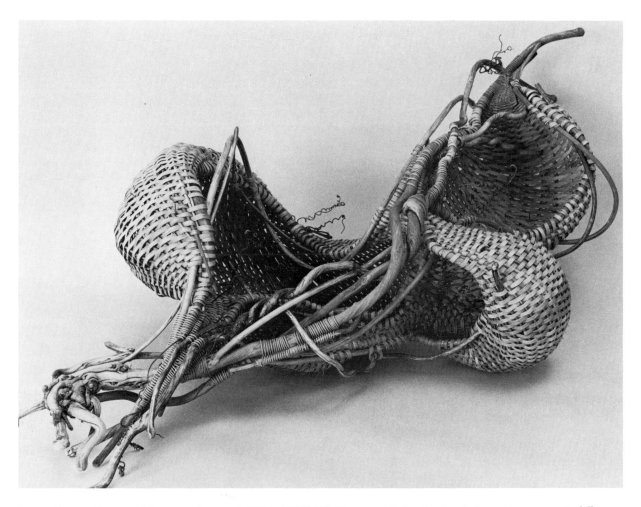

Jeanne Drevas. Honeysuckle, grapevine, reed. 36" X 18" X 20". These gnarled and twisted vines set up a wonderfully asymmetric framework for this sculptural basket. Photo by Charles Tompkins.

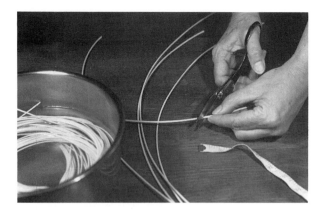

Reed is soaked and the spokes cut.

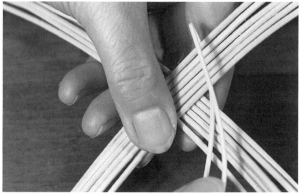

Bend the first weaver in half and around one of the four groupings of six spokes.

mately ten minutes. Different materials will require different soaking times depending upon their thickness, ability to absorb water and flexibility.

It is helpful to tie materials in coils or bunches before soaking, in order to prevent them from becoming tangled. Gathered materials should be tied in coils while they are still green and flexible. Then, when they are dry and ready to be rewet, they will be easy to handle. After the initial ten-minute soaking, the materials should be dunked in water for a minute or two whenever they become too dry.

Making the Spokes. Use thick, long spokes to make large baskets, and thinner, shorter spokes for small baskets. To determine the length of the spokes for a particular basket, measure an amount equal to the length of both sides and the bottom of the basket plus at least 10" for the basket's rim.

To make a small basket, begin by cutting with heavy duty scissors or shears twelve spokes from #4 reed. Divide the twelve spokes into two groups of six, intersecting the groups at midpoints to form a cross.

Weaving. Begin weaving with a well-soaked long strand of #2 reed bent in half. Bend this weaver around one of the four groups of six spokes. The resulting two weavers are then crossed over one another before passing over and under the next group of six spokes. Repeat this pattern, going around the groups of spokes and then crossing the weavers, until you have made two trips around the wheel. Be certain to cross the weavers in the same direction each time. This weave is known as twining.

Continue working around the wheel, but this

time twine around every *pair* of spokes. As you proceed, try to spread the spokes so that they become evenly spaced. Continue twining until there is enough space between the double spokes to twine around every *single* spoke. Spread the spokes evenly apart as you work.

Adding a Weaver. When you run out of weaver or should you wish to change the color or material that you are using, end the old weavers on the inside of the basket and begin the new weavers at the same spoke, also on the inside of the basket. Cross the two new weaver ends with the two old weaver ends behind two consecutive spokes. Thus there is no gap or change in the weaving pattern. Later, when the basket is complete, the loose ends may be cut short with a scissors, knife or shears.

Weaving the Side. Before the spokes are bent upward to create the side of the basket, they should be thoroughly soaked in warm water for approximately ten minutes. Use a pliers to compress the soaked spokes at the point at which they are to bend. Hold the basket with the inside facing away from your body. The contour may be widened or narrowed by directing the spokes outward or inward as you work.

Do not allow the basket to become too wide and cause the spokes to spread so far apart that it becomes weak. A wide basket requires the insertion of additional spokes when the spaces between spokes become too large. The extra spokes will provide the needed structural support.

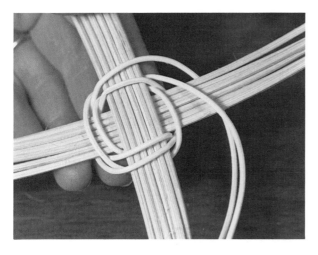

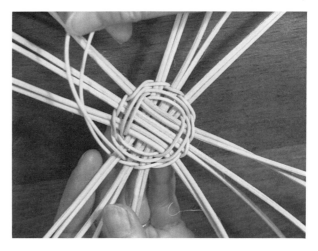

Cross the weavers between each grouping of spokes until you have made two trips around the wheel.

Then twine around every pair of spokes.

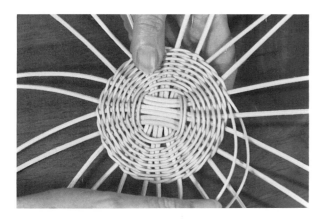

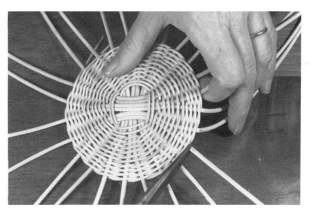

Twine around every spoke when there is enough space for the weaver to make the necessary twists. Space the spokes evenly as you work.

Use a pliers to compress the spokes at the point at which they will bend to form the sides of the basket.

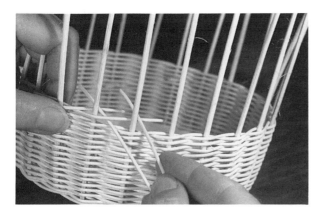

Add new weavers on the inside of the basket, at the same spoke where the old weavers end. Cross the new weavers with the old weavers.

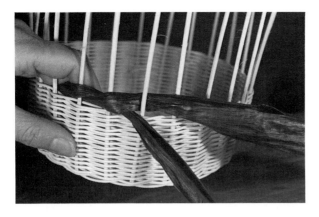

Other materials such as this corn husk may be woven into the basket.

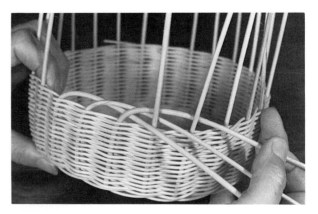

Begin the rim by passing each spoke to the inside of the basket, behind the two spokes to the right and then forward to the outside of the basket.

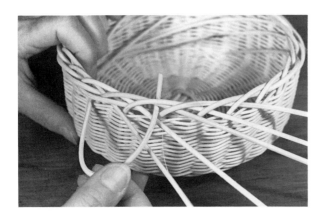

Then pass each spoke in front of the two spokes to the right and into the opening above.

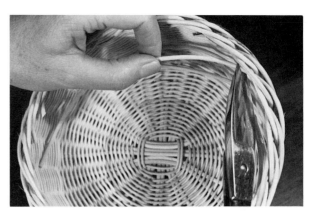

Trim all spoke ends to complete the basket.

Adding New Materials. After you have established the base and begun the side of your basket, you may wish to add new materials or weaves to your reed basket. Beads or metal washers may be threaded onto spokes. Add natural plant material either as a weaver or by using your weaver to lash the material to the basket. Stiff vines that cannot be woven between the spokes may be lashed on in this fashion. Additional weaves may be invented through experimentation or learned from the many books on basketry.

Weaving the Rim. It is important to make a strong rim to withstand abuse. There are many techniques for ending a basket. We will demonstrate one which is both simple and attractive.

You will need approximately 5" of spoke length to create this rim. Soak the spokes until they are flexible. Then pass each spoke to the inside of the basket behind the two spokes to the right and then forward to the outside of the basket. Proceed around the entire rim in this fashion. Do not neglect the last spoke which comes forward under the second spoke that has already been bent. All of the spokes should now be on the outside of the basket.

For the second step, pass each spoke in front of the next two spokes and into the opening above, to the inside of the basket. When you have traveled around the entire rim, the border will be complete. Cut the spoke ends (which are now on the inside of the basket), but not so short that they are in danger of pulling out of the weave. Trim any weaver ends left on the inside of the form to complete the basket.

Coiling

The coiling technique allows you to use flexible materials to make strong, fluid forms. Coiled structures may be complex or simple, geometric or organic.

This ancient technique uses continuous thick core, such as a rope, around which a thinner, more flexible weft material, such as yarn or raffia, is wrapped. Stitches are taken with the weft, at intervals, to join one section of the wrapped core to another. For tight, sturdy work, the stitches are taken close together at regular intervals. For loose work the stitches may be made wherever needed.

When making a traditional basket, the base is coiled in a spiral pattern. The sides are subsequently built upon the base with rows of coiling joined one atop the other. Virtually any form, be it functional or aesthetic, may be created using this technique.

Materials. You will need a tapestry needle; large scissors; wrapping material; and rope, clothes line or thick jute for the core. The core should be rigid enough to support the wrapping. If a thin material is used for the core, several strands may be wrapped simultaneously.

A variety of colored and textured yarns, raffia, string, wire, metallic thread or any material that will withstand the process without breaking may be used for the wrapping material. In addition, materials such as feathers and fleece may be trapped in the wrapping as you work. Beads, buttons, small metal washers or shells into which holes have been drilled may be threaded onto the weft and thus incorporated into the structure of the basket.

Making the Base. Begin by using scissors to taper approximately $1/2''$ of the end of the core. Begin wrapping the core $1/2''$ from the end and continue for $1''$. To do this, place the end of the yarn (or other wrapping material) parallel to the core and wrap around both the core and the yarn. Wrap tightly and evenly in order to cover them completely.

Next, bend the wrapped $1''$ of core in half and wrap around both the new core and the previously unwrapped tapered core for $1/2''$. With the yarn threaded in a needle, take a stitch into the center. This will anchor the core in a spiral.

Continue wrapping the core, and taking a stitch into the previous row of wrapping at intervals to join the coils. Thus a stitch will be taken approximately every $1/2''$. The closer the stitches, the stronger the work. This stitch is called the Lazy

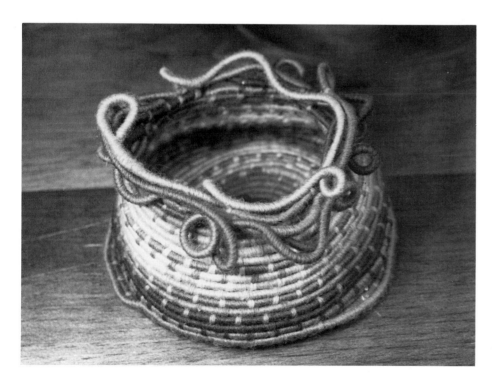

Alice Wansor. Coiled wool basket. The undulating rim treatment creates a definite serpentine effect.

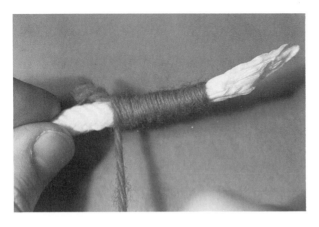

Wrap the tapered end of the core 1/2" from the end for 1".

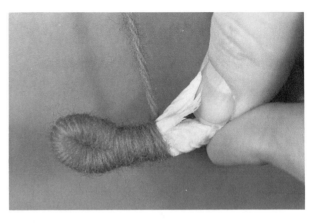

Bend the wrapped section in half and wrap around the new core and the end.

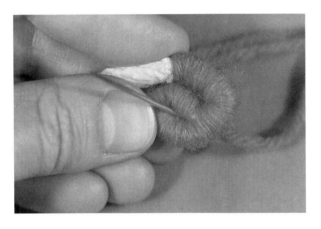

Take a stitch into the center to begin a spiral.

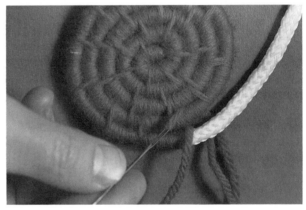

Continue wrapping, and taking a stitch into the previous row after every few wraps.

Splicing new core onto old.

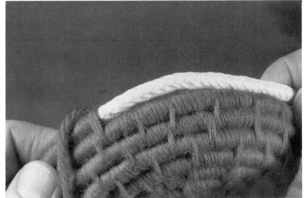

Shaping the side.

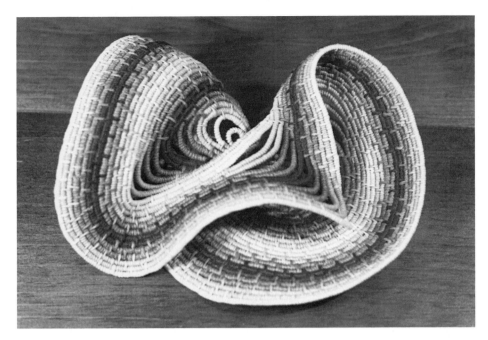

Squaw. Do not become too lazy and make the stitches far apart or your final form will be flimsy. Continue coiling until the base has reached the desired size.

Adding Core or Weft. It is quite simple to splice new core onto old when you have run out. To do so, taper both the end of the core that you have been working with and the beginning of the new core and overlap them so that they join without added bulkiness. These tapers should be at least 1" long. Wrap tightly over the join. There should be no visible evidence of the splice when you are finished.

To add weft, leave approximately 1" of the original weft and lay it, along with the same amount of new weft, parallel to the core. Both ends should now lie 1" down the core from the wrapping. Now, with the new weft, continue the wrapping, over the two ends and the core.

Shaping the Basket Side. After you have completed the base of your basket, build the side by laying new core on top of, rather than next to, the previous row. Laying the new core on top of and towards the outside edge of the previous row will cause the form to widen. Laying the core towards the inside of the previous row will cause it to narrow. Besides working in spirals and circles, the warp may be bent in zig-zags, scallops or any free-form that suits the design of your piece.

Finishing the Basket. To finish the basket,

cut off the excess core, leaving approximately 1". Using a scissors, taper the end and stitch it to the previous row until you have covered the core. This should create a smooth rim for your basket. On the inside of the basket, pull the yarn back under the last few wraps to secure the end. Cut off the excess weft to complete the basket.

Basketry: Branching Out

✦ Expand the concept of the basket beyond the vessel and create a realistic or abstract form using basketry techniques. You may wish to use a natural object such as a shell, gourd or animal as inspiration for your shape.

✦ Combine a minimum of four materials to create a basket. Choose from such materials as leather, reed, rope, yarn, feathers, shells, buttons, fleece, wire, movie film, raffia, beads, fur, corn husks, paper, bones and found objects.

✦ Using basketry techniques, create an object that performs a specific function such as a desk organizer, potpourri container, magazine rack, letter holder, tea strainer, piece of jewelry or sandals. When designing your work, consider how the form relates to the function.

✦ Combine basketry and weaving techniques to create a wall hanging.

✦ Create a mask using the coiling method.

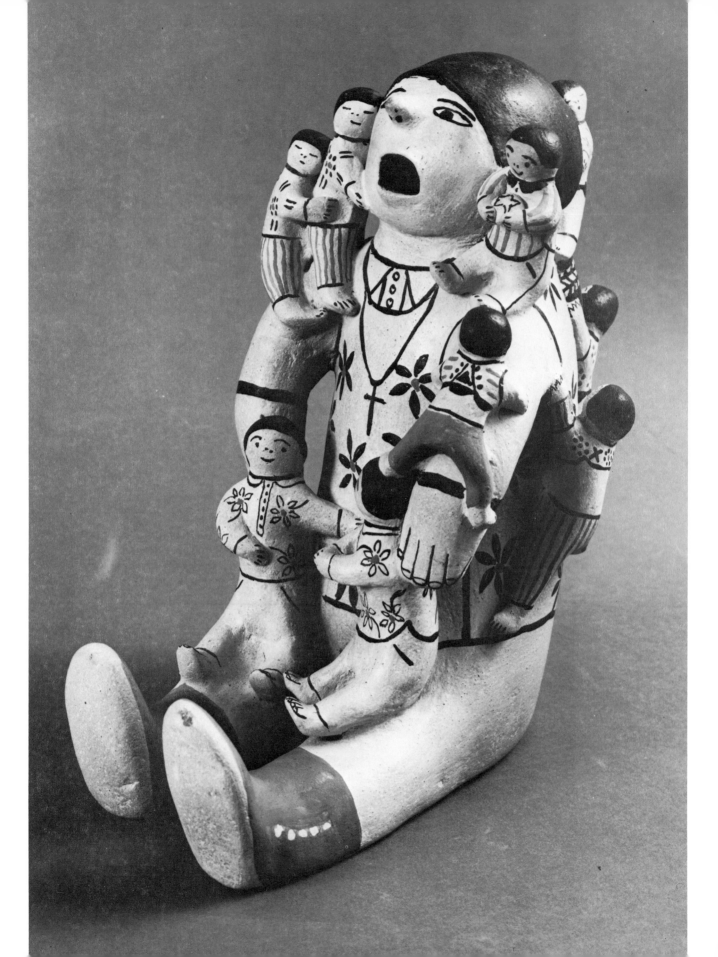

3 · CLAY

Clay is an abundant, inexpensive and versatile material that is the product of the disintegration of rock. It is made from fine-grained earth that differs in color, plasticity, rate of shrinkage, hardness and other qualities depending upon the components of the earth at a particular location.

In most areas, clay is easy to find, but it is often combined with impurities making it useless for pottery and sculpture. You may wish to experiment and dig your own clay, or purchase it at a ceramic or art supply store.

Clay takes many forms, be it a pipe, brick, sculpture or vessel. Plasticity is its most unique characteristic. Wet clay can be shaped into any form and will harden into that shape when left to dry. It can be rolled into slabs or coils, thrown on a wheel or simply pressed and pinched to shape. When made into a liquid suspension called *slip*, it can be poured and cast, or applied to the surface of clay as decoration or to change color.

Preparing the Clay

Before forming clay, it must be wedged not only to achieve a uniform consistency but also to remove air bubbles that will expand and possibly explode during firing. Wedging is done on a plaster slab if you wish to remove moisture from the clay, or on a canvas or burlap covered surface if the clay is already of the desired consistency.

In wedging, clay is kneaded like dough; however, it is never folded or in any way made to trap

Helen Cordero. (Cochiti Pueblo) STORY TELLER. 1970. Earthenware. Photo courtesy of the U.S. Department of the Interior, Indian Arts and Crafts Board.

Clay is wedged to make it consistent and free from air bubbles.

The wedged clay is sliced open with a thin wire to check for unwanted air pockets.

air bubbles. Rather the clay is compressed upon itself. As you wedge, test the clay for air bubbles by cutting it with a thin wire and checking the cut surfaces. Smooth consistent surfaces indicate that you have wedged the clay well.

After the clay is fully wedged, it may be stored in an airtight plastic bag to maintain its plasticity until it is used.

Clay that is left open to the air will gradually harden. By soaking it in water, hard unfired clay may be reconstituted. A plastic garbage pail is an excellent container for holding clay and water for recycling. When the clay is fully saturated, excess water may be poured off. To further thicken the clay, it may be spread on a plaster bat which will absorb water until the clay dries to a workable consistency. Then the clay may be wedged.

Stages in Working With Clay

Clay goes through many changes in the processes of wedging, forming, firing and glazing. A dry, unfired clay piece is called *greenware.* Greenware is

Cora Wahnetah, a Cherokee potter from North Carolina, is shown pinching a pot that has been initially formed with coils. Photo courtesy of the U.S. Department of the Interior, Indian Arts and Crafts Board.

fragile and should be handled as gently and as little as possible.

Once fired in a kiln so that the clay is hard and can be handled easily, it is called *bisque*. Any fired, unglazed clay is called bisque. In firing, the clay shrinks and undergoes a color change. The degree of shrinkage in both the drying and firing processes varies with each kind of clay and is significant. It should be taken into account when planning your work.

The application of glaze to the surface of bisque will impart color and design, as well as waterproof the piece. After glaze is applied, the piece must be fired a second time and is called *glazeware*.

General Rules for Working in Clay

✦ Wedge thoroughly to homogenize the clay and remove air bubbles.

✦ Never add wet clay to dry clay. Clay must dry uniformly or it will crack.

✦ When assembling pieces of clay, score and slip all leather hard surfaces to be joined.

✦ Store unfinished pieces and unused clay in an airtight plastic bag to prevent them from drying out.

✦ Do not allow clay to exceed 1/2" in thickness. Thicker forms should be hollowed.

✦ Dry clay slowly, uniformly and thoroughly before firing. Use a damp cloth or thin plastic to retard the drying of thin areas such as handles, until the rest of the clay has "caught up."

✦ ✦ ✦ ✦ ✦ ✦ ✦ ✦ ✦ ✦ ✦ ✦ ✦ ✦ ✦ ✦

Pinch Pots

The simplest, most immediate method of forming clay is by pinching. A clay pot can be pinched to shape with no tools other than your hands.

Starting with a ball of clay, use one hand to pinch the walls gradually thinner. Pinch as evenly as possible. Use your other hand to turn and support the clay. With patience and care, delicate walls may be pinched to eggshell thickness. Pinching and coiling may be combined to create larger forms that cannot be easily made by pinching a single lump of clay.

✦ ✦ ✦ ✦ ✦ ✦ ✦ ✦ ✦ ✦ ✦ ✦ ✦ ✦ ✦ ✦ ✦ ✦ ✦

Slab Construction

Structures with straight walls may be constructed by the slab method. Sheets of uniformly thick clay are rolled, cut to shape and assembled when they are dry enough to support themselves. Decorative textures or designs may be stamped, scratched or otherwise applied to the surface of a slab.

Materials. Well-wedged clay; two sticks or dowels of a thickness equal to the desired thickness of the slabs; a rolling pin or thick dowel; hard working surface covered with canvas or burlap; small cup to hold slip; water; a fettling knife; straightedge; pin tool or fork; wood, rubber or metal rib. Optional: grog, cardboard, scissors, T-square, stamping tools, waxed paper cups, plaster casting materials (see One-Piece Plaster Molds), a paddle such as a wooden spoon.

Randy Fein. SOHO BUILDING. 1983. This clay wall relief is constructed from slabs. The meticulous detail is added with texturing stamps.

Rolling the Slab

To make a slab, begin with a lump of well-wedged clay that has been partially flattened with your fists. It is advisable to use pre-grogged clay or to purchase grog and wedge it into your clay. Grog is simply clay that has been fired and ground. Its purpose is to minimize shrinkage and warpage. It also imparts an interesting texture to the clay surface.

Work on a hard surface that has been covered with burlap or canvas to prevent the clay from sticking. To create a uniformly thick slab, place a wooden stick or dowel of the thickness that you wish to make the slab on either side of the clay. The larger the finished piece, the thicker the slabs should be. Jewelry, for example, may be made from $1/8''$ slabs, while a large pot or sculpture may be constructed from walls as thick as $1/2''$. $3/8''$ slabs are an average size. Use a rolling pin to roll the clay flat until the pin rests on the two sticks. Flip the slab and roll on each side to help prevent warping. Work from the center out. The clay will eventually conform to the thickness of the sticks.

Slabs that are to be cut and left flat should be allowed to dry to a leather-hard state before being cut. This prevents distortion and creates a crisp edge. Clay is said to be leather hard when it is partially dry. At this point it is stiff enough to be handled without collapsing but can still be carved and cut without crumbling.

Slabs for draping and slumping over or into a mold should be formed when they are soft. In this state they will be flexible enough to conform to the mold.

Lois Hirshberg. The artist used this simple slab form as the stage for her expressive brushwork.

A slab is rolled out between two sticks, with a rolling pin.

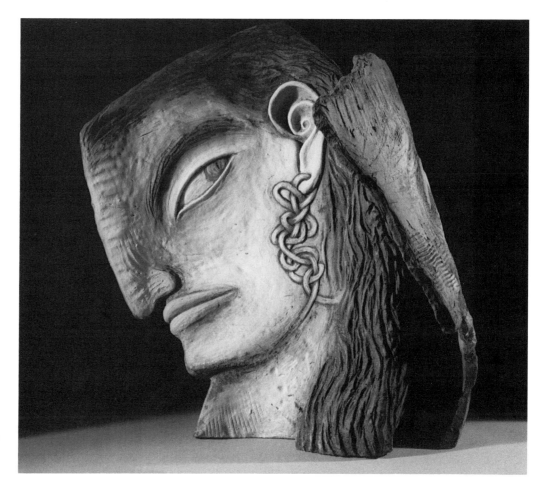

Judy Moonelis. SISTERS II. 29" X 26" X 28". 1984. Slabs can be modeled and textured to create a rich surface, here dominated by curves, ovals and spirals. Photo by Doug Long.

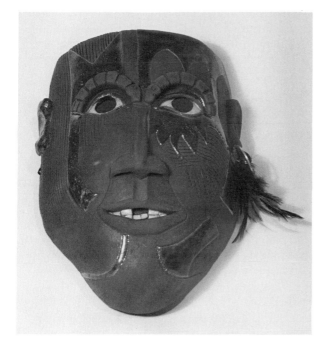

TRAIN. Student work. Strongly geometric components dominate this slab-built miniature train.

Donna Lasky. MASK. (After a Northwest Coast American Indian design.) A slab was draped over crumbled newspapers to impart dimension to this mask, thus forming the base on which the decorative features were fashioned.

Practically anything can be pressed into a slab to create a unique texture.

A knife is drawn along a straightedge to cut the slab into the desired shape.

Decorative Stamping

While the clay is still soft, texture may be stamped into the surface of the slabs. Stamps may be made from found objects such as a piece of wood, jewelry, a fork, meat tenderizer, wire potato masher or shells. Rubber or metal letter or design stamps, normally used in printing, are perfect for decorating clay. Impressions may be pressed from materials such as textural cloth, lace, a leaf or screening.

A stamp of your own design may be carved from a piece of plaster. A waxed paper cup makes an excellent mold for casting the plaster. The plaster is easily carved with a small kitchen knife. Both ends of the plaster may be carved to create differently sized and designed motifs. Stamps may also be fashioned from clay that is bisque fired.

Wind chimes, trivets, tiles and jewelry may be made by cutting shapes from the slabs and decorating them with stamps. Holes needed for hanging or attaching these clay elements may be poked with a pin tool or wire of the appropriate thickness. Make the holes large enough to compensate for shrinkage in drying and firing.

Cutting the Slabs

It is advisable to work with a cardboard template that has been cut to the correct dimensions for each element of your piece. Cut the individual shapes from the clay slabs by tracing your pattern with a knife. A template is not necessary for simple angular forms. Simply draw the knife along a straightedge placed over the clay. A T-square is helpful for creating right angles. Be certain to hold the knife perpendicular to the surface, or if you wish to bevel the ends to be joined, cut them at a consistent angle.

Making Cylindrical Forms

Cylinders made from slabs may be formed around pipes, dowels, tubes or other cylindrical cores, or they may be shaped without a form. The clay must never be allowed to dry completely over a form. Clay shrinks as it dries and will crack when constricted by the non-shrinking form beneath it. A few layers of newspaper wrapped around the core are sometimes used to solve this problem by providing the needed cushion for the contraction of the clay.

Attaching Slabs

After the slabs have been cut and the desired stamping applied and cylinders formed, the slabs may be joined to create three-dimensional forms. Before assembling the slabs, allow the clay to dry to a leather-hard state. Slabs must be carefully joined to avoid cracking while drying and firing. They may be joined to create simple forms or intricate angu-

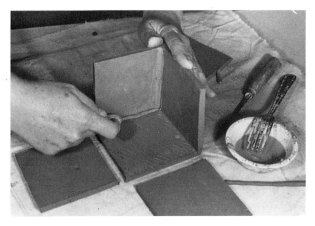

Slabs are attached after scoring and adding slip. A tiny coil may be blended into each joint to further secure the juncture.

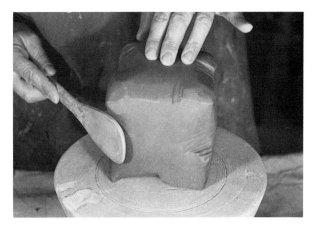

A slab cube may be paddled, sliced with a thin wire to form a lid, and decoration added.

lar structures. Slab ends may be cut at any angle to create other than right angle junctures.

Before you join two pieces of leather-hard clay, it is essential that the surfaces be scored and coated with slip. Score with a knife, fork or pointed tool so that the surfaces are thoroughly chopped up. Slip is then added to glue the pieces being joined. Slip is made by mixing clay with water to the consistency of yogurt. Press the pieces of scored, slipped clay firmly together, so that no gaps remain. Blend thin coils of clay into joints to further secure the slabs. When the entire structure is assembled, use a wood, metal or rubber rib to refine the shape and surface and to remove excess clay.

Allow the completed work to dry slowly and uniformly. Never speed up drying by placing the clay work on a heater. Drape a sheet of plastic loosely over a piece, allowing some air to circulate and the work to dry slowly. Wrap thin areas in thin plastic to prevent them from drying prematurely.

When bone dry, the work is ready to be bisque fired. Drying may take anywhere from one day to several weeks, depending upon the thickness of the clay as well as the ambient temperature and humidity.

Making a Paddled Slab Box

Slab forms may be precise and angular, draped and formed loosely, or they may be altered with a paddle after construction is completed. A sculptural

The completed paddled slab container.

box may be created by using the slab method to construct an airtight hollow cube. The air trapped within will prevent the walls from collapsing when the box is paddled. Paddle the cube until the form is pleasing, being certain to keep the bottom flat.

To cut the box cover away from the base, draw a line to mark the division. Then cut along the drawn line with a knife. An irregular cut including a notch will prevent the lid from slipping off when the piece is completed. When the lid is fully separated from the base, refine the inside of the box with clay tools or your fingers.

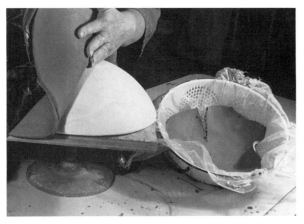

Slabs may be formed over or into a cast plaster mold or a found mold such as this colander.

A foot is added to complete the basic structure of the bowl.

Potter Barbara Karyo puts the finishing touches on her slab vase. She uses a variety of clay modeling tools to sculpt its surface in low relief.

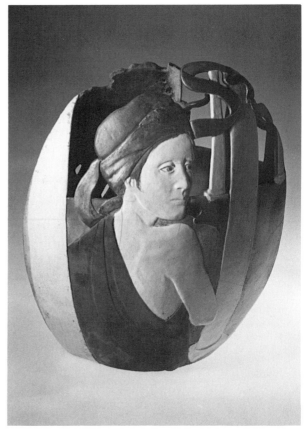

Barbara Karyo. CERAMIC VASE. The delicately carved surface of this vase gives the illusion of great depth in the figure. The pierced walls add further depth.

Draping and Slumping Slabs Over or Into a Mold

A slab of clay may be formed over or into a found mold, or you may wish to make your own mold from plaster (see One-Piece Plaster Molds). A slab is gently coaxed to conform to the mold, thus shaping the clay. Clay is draped *over* a hump mold, while it is pressed *into* a slump mold.

Shallow kitchen bowls or other containers make excellent drape or slump molds if the form is such that the clay is not required to stretch beyond its capacity in order to fill the mold. Cheesecloth or a thin plastic sheet such as a dry cleaning bag may be used to line the mold. The liner keeps the clay from sticking, easing removal of the clay. After forming, the slab may be lifted with the fabric or plastic providing support. If you are working with a plaster mold, the cloth or plastic sheet is not necessary.

When draping and in particular when slumping a slab, folds may develop in the clay. When this occurs, simply cut a dart where appropriate and rejoin the clay. Gently pat and coax the clay, particularly over a hump mold, to make it conform. When the clay has been molded to the desired shape, use a rib to smooth the surface and a knife to trim the excess clay.

To remove the clay from the mold, allow it to stiffen on the mold until it may be removed without distortion. Remember that clay shrinks when it dries. If allowed to dry too much over a hump mold, it will crack.

After removing the clay from the mold, use a rib to smooth seams or unwanted marks on the side that was against the mold. Handles, rims, a foot or decorative elements may be added at this time. Several forms taken from the same or different molds may be joined to create an exciting piece.

Slab Structures: Branching Out

✦ Create a horizontal or vertical structure from several different slabs.

✦ Make a cookie cutter-type die from a strip of thin sheet metal, and use it to cut shapes from a thin slab of clay. Use these shapes as dangles or linked forms combined to make a piece of jewelry, a mobile or wind chime.

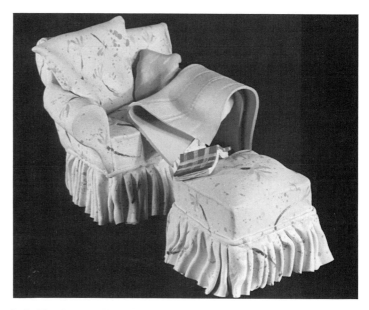

Judy Hirschmann. Thin slabs were bent, folded and draped to create this finely detailed miniature ceramic furniture. Clay is a good imitator of the qualities of other materials.

✦ Construct a large clay vessel from a combination of cylinders and box forms.

✦ Drape slabs into or over a plaster mold to create multiples of a single form. A set of dishes, for example, may be made in this manner.

✦ Design a teapot and matching cups that are constructed from slabs.

✦ Combine a slab structure with a wheel-thrown form.

✦ Create a mosaic mural or table top by combining many differently textured clay slabs of a designated size. This is an excellent group project.

✦ Press mold a form and add it to a slab container that you have constructed. The molded form may be used as a base, handle or simply to decorate the inside or outside of the box. For example, you might cast your hand in plaster, press a clay slab into the mold and use the resulting clay hand as the handle for a box.

✦ Make small, shallow press molds that may be used to create production jewelry or to make small ornaments.

One-Piece Plaster Molds

By casting into a plaster mold, multiples of a form may be created simply and inexpensively. The model may be a found object, or an original model may be sculpted in clay. A plaster mold is cast around the model. When the plaster sets, the model is removed, leaving the negative mold. The mold is then filled, creating a positive cast identical to the original model.

One-piece plaster molds may be used for many purposes including casting paper, wet forming leather or molding clay. Small molds (no larger than 1½" x 1½") may be used to cast pewter. Plaster molds may even be used for slumping glass, however they crack easily when subjected to extreme heat and are usually good for one firing only.

Materials. To make a mold you will need an object to cast; petroleum jelly; a retaining wall made from aluminum flashing, wood or a sheet of linoleum; masking or duct tape; a smooth and nonporous working surface; plaster of Paris; a plastic bucket; water and a plaster file, rib or hacksaw blade.

Choosing or Creating a Model

The model from which the plaster mold is cast may be a found object such as a lightbulb, ball or doll's head, or an original form may be sculpted in oil or water-based clay. Found objects should be thoroughly coated with a layer of petroleum jelly so that they may be easily separated from the plaster mold when completed. Be certain to apply a thin layer of the petroleum jelly or the excess will appear as texture on the completed mold. Use paper towels to wipe off any excess.

If you are making a clay model, sculpt the clay into the desired form, using clay modeling tools or small kitchen knives to refine the form and model areas that fingers cannot reach. Good craftsmanship is essential since plaster casts in excellent detail.

Avoiding Undercuts

In making a one-piece mold, avoid casting models that have undercuts. A model with undercuts would be impossible to separate from the mold. When plaster sets, it becomes rigid and traps wide portions of the model which cannot pass through

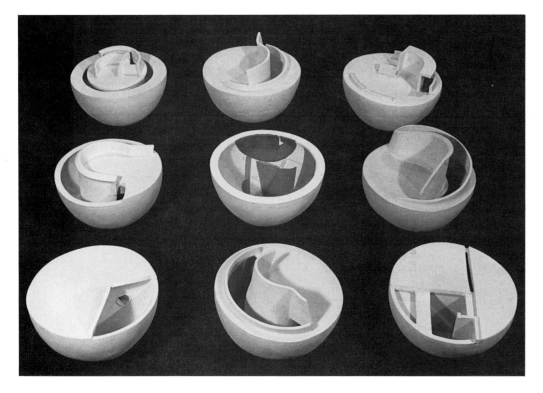

Rose Krebes. DIRECTIONS. 5' X 5'. These variations on a theme were created by adding slabs to the basic hemispheric elements. The original hemispheres were fashioned from slabs draped into a clay mold.

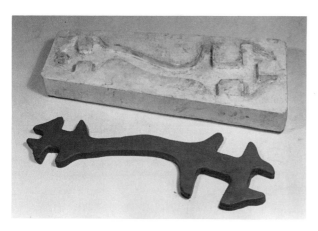

A wrench was cast in plaster to produce a one-piece plaster mold from which the clay form was reproduced.

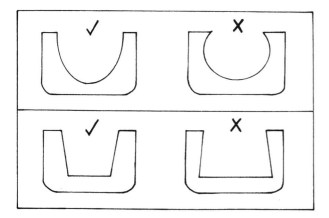

Slabs pressed into the checked forms contain no undercut areas and would be easy to remove. The two molds marked with an "X" do contain undercuts and would therefore trap the clay, making removal impossible.

A mold is made from this glass light fixture by first embedding the base in clay so that all undercuts are covered, and then making a retaining wall that will hold the plaster when it is poured.

more constricted areas when the model is being separated from the mold. A lightbulb, for example, may be submerged lengthwise in the plaster to its midpoint. If the bulb is sunk beyond this point, it would be impossible to remove without breaking. Even if you break the bulb, the cast impression, which cannot be broken, would not separate from the mold.

If a model does contain undercuts, a rim of clay may be built up around the model to cover the undercuts, thus exposing only the areas that do not contain undercuts.

Preparing for Casting the Mold

To make the mold, the model is placed on a smooth, nonporous surface such as a Formica table and is embedded in clay, if necessary, to eliminate undercuts. The model is then surrounded by a retaining wall made from aluminum flashing, wood, linoleum or any nonporous material that will contain the plaster. Aluminum flashing is an excellent material for this purpose and may be reused to make several molds. The flashing is placed around the model leaving at least a 1" space between itself and the model at all points so that when the plaster is poured, it is never thinner than 1". Too thin a mold will be vulnerable to breakage, and a thick mold is cumbersome and wasteful.

When the flashing is in place, tape the ends closed. Use clay to seal the seam where the flashing meets the base. This will prevent the plaster from leaking out. Apply a thin coat of petroleum jelly to all porous or textured surfaces that will come in contact with the plaster.

Casting the Plaster Mold

Since making plaster involves a chemical reaction, it is important to follow the correct procedure for mixing. Always add plaster to water — never the reverse. Begin by sprinkling plaster into a bucket of warm water. You will know that you have added enough plaster when it no longer settles but rather forms small islands on the surface. When you have added the proper amount of plaster, use your hands to gently mix the plaster. Remove all lumps. Do not mix too vigorously or you will create air bub-

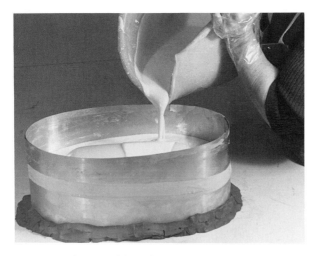

The plaster is poured into the casting box.

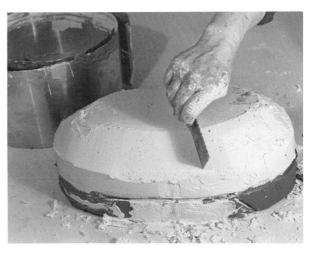

The flashing is removed and the shape of the mold is refined with a plaster rib.

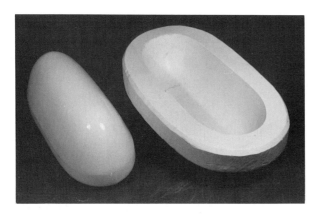

The finished mold alongside the original model.

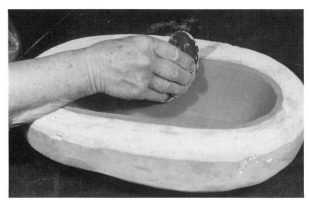

The slab is formed inside the mold.

bles. It is not wise to add plaster after mixing, for this will weaken the plaster when it is set.

As the plaster sets, it will begin to thicken and emit heat. When it is still relatively thin, pour it into the casting box, at least 1" above the model. As the plaster thickens, excess plaster that is thicker than 1" may be removed to lighten the mold. A plaster rib or hacksaw blade may be used to refine the shape of the mold.

When the plaster is firm, remove the flashing (or other retaining wall) from around the plaster and continue to refine the outside of the mold. Round the outer edges to prevent chipping. Do not, however, touch the inner surface unless you wish to change the newly formed mold form.

Allow the plaster to set until it is hard and cool before carefully removing the model. **CAUTION: Do not pour plaster down the sink drain. Rather, wash hands in a plastic bucket and allow the plaster to settle before pouring off the water. Dispose of the settled plaster or other unwanted plaster in the garbage. Do not use clay that has been in contact with plaster for ceramics.**

Coiled Forms

Well before the invention of the potter's wheel, people were making pots using coils. Huge vessels, some even large enough to hold a person, were created by this simple yet versatile method. Virtually any shape, from intricate, organic forms such as a hollow animal to stark, symmetrical forms, may be constructed using coils. Coiled forms have a unique quality resulting from the process by which they are constructed. The most successful products of coiling will most likely be those which exploit rather than attempt to disguise this process.

Materials. Well-wedged clay (preferably grogged); a plaster bat; plastic, wooden or metal ribs; a fettling knife; thin plastic sheet; slip. Optional: a banding wheel.

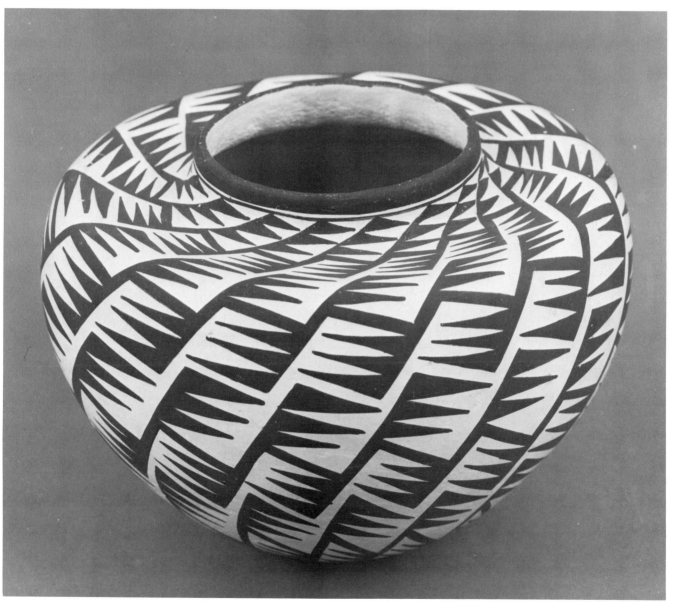

Lucy Lewis. (Acoma Pueblo) JAR. 1965. The painted saw-tooth surface design interrupts the smooth flow of the rounded sides. Photo courtesy of the U.S. Department of the Interior, Indian Arts and Crafts Board.

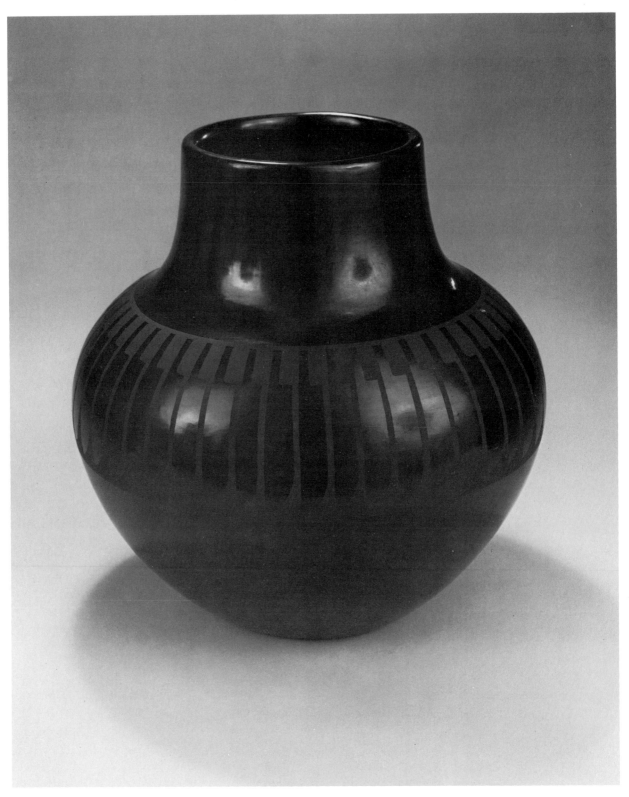

Maria Martinez and Popovi Da. (San Ildefonso Pueblo) JAR. 1960.
Photo courtesy of the U.S. Department of the Interior, Indian Arts and Crafts Board.

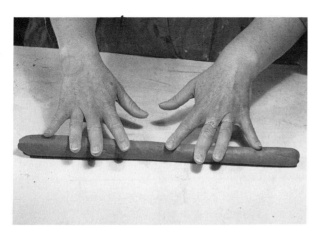

Clay is rolled to form a coil.

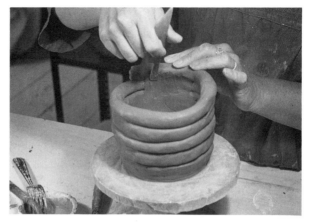

Coils are built up, and welded together on the inner surface to form the wall of the pot. The outer surface may also be made smooth if so desired.

Making Coils

Begin a coiled vessel with a ball of wedged clay flattened to an even thickness to create a slab base. Use a thick base for large pieces and a thin base for small work. It is advisable to build your pot on a plaster bat that is supported on a banding wheel so that it may be easily turned. A plaster bat may be cast in an aluminum pie pan.

The coils are rolled from a cylindrical lump of clay. Work from the center outward, and use your fingers to produce a uniformly round and thick coil. The clay should be soft enough so that it does not crack and is easily formed, yet not so soft that it has no body.

Building With Coils

Attach the first coil to the slab base and continue to add coils, spiraling upward, to form the walls of the vessel. As you overlap, coil upon coil, pay careful attention to the contour of your vessel. Lay a coil over the outer edge of the coil beneath it in order to widen the form and along the inner edge to narrow it.

After approximately three rows, the coils should be welded together on the inside of the vessel. If the clay is soft, it is not necessary to score and slip the surfaces being joined. Blend the coils with your fingers or a tool, and then smooth them out with a rib. It is important to blend the inner

surface thoroughly or your work will fall apart when dry. Be careful not to thin the walls too much in the process of blending. If needed, extra clay may be added while blending. The outside of the pot may be left as is or may also be welded and made smooth.

If you wish to exploit the textural pattern of the coils, you need not be limited to this upward spiraling pattern of coiling. Coils may also be cut and placed vertically, wrapped in undulating patterns, or flattened balls may be integrated into the design. Many short coils concentrated in one section will create an organic shape. The rim may be unified whenever necessary with a long, horizontal coil. Do not feel that you must maintain a level rim. It is perhaps more interesting to work with the organic flow to which this method lends itself so well.

If you are working on a tall pot, the structure may begin to sag after a while because of the weight of the clay. At this time you must stop work for enough time to permit the lower portion of the vessel to firm up. Cover the top coils with thin plastic sheeting so that they do not dry out. Remember that you cannot add wet clay to dry clay. If the rim is not as soft as it should be, score and slip before adding another coil. Never permit the work to harden completely until you have completed the entire piece.

As with any completed work, allow the clay to dry slowly, evenly and thoroughly. When bone dry, you are ready to bisque fire the vessel.

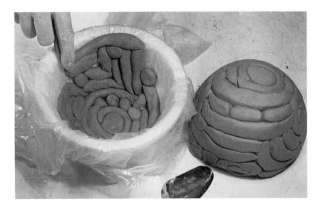

Laying coils into a mold such as this kitchen bowl, will yield exciting results. Be certain to blend the coils on one side of the wall. The rubber rib shown in the foreground is a useful tool for blending.

Coiling into a Mold

Coils may be shaped in a form such as a bowl. Before placing the coils into the mold, line it with thin plastic sheeting. This will make removal of the clay easier. After you have laid down your coiled design, blend the clay with a rib on the exposed (inner) wall. Remove the coiled form when it is dry enough to be handled without distortion, and admire your results.

Coiled Forms: Branching Out

◆ Create a multi-necked coiled vessel.

◆ Use coils to create a mask. Spiraled coils may be used for the eyes, undulating coils for hair, and whatever you can invent for the rest of the features. Be sure to blend all coils together on the reverse side of the mask.

◆ Experiment by twisting, winding, spiraling, cutting and attaching coils to create a container with as many variations as you can invent.

◆ Study the pottery of pre-Columbian America and, using the coiling technique, make an animal or figurative vessel in this style.

◆ Create a strand of beads by slicing a coil and making a hole through it. You may wish to work around a wire to create the holes in the beads. Be sure to remove the bead from the wire before allowing the clay to dry.

◆ Have a contest to see which team can build the tallest coiled structure within a specified time.

Wheel-Thrown Pottery

Although throwing a pot on the wheel looks easy in the hands of a seasoned potter, it is a skill that requires practice and some patience. However, the thrill of watching and feeling the clay transform into a pot between your fingers makes it well worth the effort.

The potter's wheel has been in use since ancient times. Ancient Egyptian hieroglyphics depict people using wheels not too different from those of today.

The wheel lends itself to making symmetrical forms. The fast spinning clay is formed equally at all points as it passes through the stationary fingers. As the hand slowly moves inward or outward, the contour narrows or widens. Once off the wheel, thrown forms may be altered, elements such as handles added and textures and designs applied.

The technique of throwing can best be learned from a teacher who can demonstrate the process and then correct hand positions as you work. Although there is no single correct way to throw a form, it is difficult to teach yourself how to work on the wheel without the assistance of someone who is proficient.

Materials. An electric or kick wheel, well-wedged clay; a pin tool; wire end tool; small natural sponge; container of water; cutting wire; plaster bat or wooden board. Optional: potter's ribs.

Preparing the Clay

Begin by wedging several balls of clay. Very small balls are difficult to throw so it is advisable for a beginner to work with clay the approximate size of a grapefruit. Take time to wedge the clay thoroughly since the slightest inconsistency or air bubble will throw your hands off center and most likely ruin your work. The clay should be relatively soft. Working with improperly prepared clay will prove frustrating.

Have several balls ready so that you can continue working if the clay collapses or if you have completed a pot and wish to begin anew. Do not attempt to reuse clay that has collapsed unless it is rewedged.

**Nancy Baldwin. Aegean III.
1984. 19½" h. Earthenware
wheel-thrown vessel,
airbrushed and brushed
glaze/slip. Photo by
Mary Dougherty.**

Centering

All work on the wheel is done with centered clay. This is accomplished by gently throwing a clay ball onto the center of the pre-moistened wheel head or a plaster bat that has been anchored, with clay, to the wheel head. Throughout the throwing process, elbows should be braced on the wheel or against your body. In this way, your steadied hands will force the clay to conform rather than allowing it to have a mind of its own. Always keep the surface wet by squeezing a wet sponge over the clay.

With the wheel spinning counterclockwise, and elbows braced, use the heel of your right hand to press the clay in and down. Simultaneously your left hand is placed on the opposite side and used to push towards the center. You are striving for a beehive form that is perfectly centered. When you can feel the clay passing evenly through your hands and when the clay looks stationary on the

Jeanne Drevas. Stoneware vessel with grapevine, honeysuckle and reed handle. 14" tall. This handsome vessel demonstrates the perfect marriage between two crafts: basketry and pottery. Photo by Charles Tompkins.

spinning wheel, remove your hands slowly. Jerky movements at any time will tend to throw the clay off center.

There are several variations of hand positions for centering as well as subsequent steps in throwing a pot. Experiment to discover what works best for you.

Opening

Next, the beehive is opened with the fingers braced on the outside surface and both thumbs pressed into the center of the clay and pulled slightly apart. Be certain to leave enough clay at the bottom for the base of the pot. A pin tool may be used to determine the thickness of the base.

Raising a Cylinder

In order to raise a cylinder, the fingers of the left hand are held on the inside wall of the pot just above the right hand knuckle or finger tips which are held on the outside wall. The two hands should interlock for stability whenever possible. With the hands held in this position at the base of the pot, slowly raise them so that the clay wall is thinned as it passes through the constricted area created by the fingers. The excess clay will be forced upward, thus raising the wall. Keep the hands a consistent distance apart as they move up the entire wall. Repeat this step until a cylinder of the desired height and thickness is formed. Typically it takes about three passes to thin the wall.

An uneven rim may be leveled by inserting a pin tool below the top edge and, with the wheel spinning, removing a ring of clay.

Most wheel-thrown pieces begin as a cylinder which is subsequently shaped. To vary the shape of the cylinder at any point, press out from the inside while the outer hand gently supports the clay. Press inward with the outer hand to narrow the cylinder. Realizing that the bottom fingers shape the pot, press in with the outer fingers below the inner fingers for a concave form. Reverse the hand positions for a convex form. A potter's rib is a useful aid for shaping and smoothing. Remember to approach the pot gingerly. Sudden moves may destroy a perfect form.

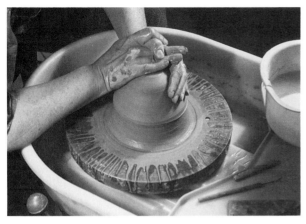

Center the clay by pressing with the heel of your right hand while pushing towards the center with the left hand on the opposite side. Keep hands steady by bracing your elbows against the wheel or your body at all times.

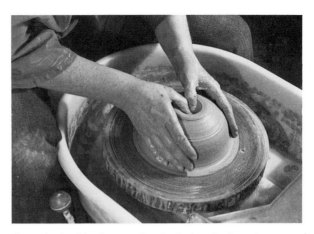

Open the beehive by pressing both thumbs into the center of the clay.

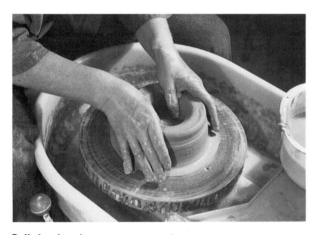

Pull the thumbs apart to open the center.

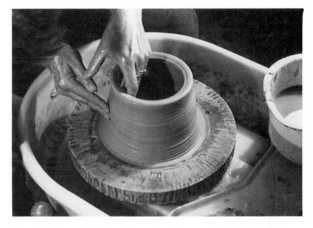

To raise the cylinder, place the fingers of the left hand on the inside wall just above the fingers of the right hand which are on the outside wall. With the hands in this position, raise the hands from the base of the pot, up the wall. The clay wall will thin and the excess clay will be pushed upward, raising the wall.

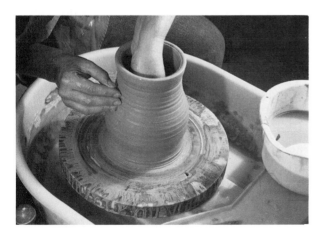

Shape the contour of the cylinder by pressing inward with the outer hand to narrow the form, and pressing outward with the inner hand to widen the form.

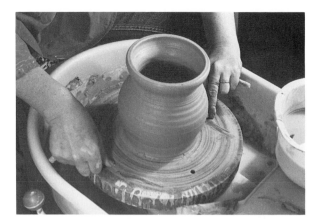

Detach the thrown piece from the wheel by drawing a thin wire under the base. The pot is then lifted off the wheel.

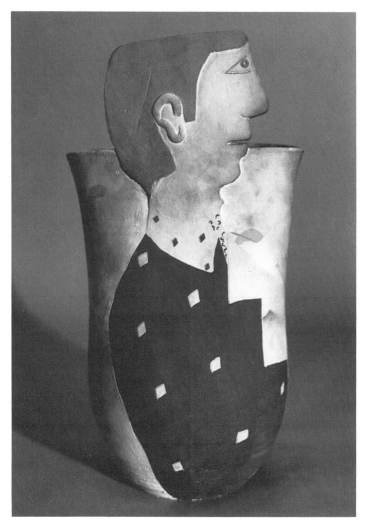

Dave Williamson. Red earthenware. Two techniques, handbuilding and wheel throwing, are incorporated to create this whimsical pot.

Removing the Pot

Before you take the pot off the wheel, sponge out the water that has collected in the base. While the wheel is turning, hold the sponge against the bottom. This will remove the water and smooth the base.

Next, cut the pot free from the wheel with a taut wire that is drawn under the base. Lift the pot gingerly off the base and allow the clay to dry until the base and rim are leather hard. Now it is ready for trimming.

Trimming

Excess clay at the base of the pot is trimmed in order to fashion a finished foot. Center the pot upside-down on the wheel and fasten it with three small wads of clay. With the wheel spinning, use a wire end tool to shape the base. To complete the pot, trim the foot, working from the center outward, leaving a raised ring upon which the pot will rest.

Wheel-Thrown Pottery: Branching Out

✦ Experiment by throwing a variety of sized and shaped spheres, cylinders, bowls, knobs and tubes. Do not concern yourself with producing a perfect piece. You may find it liberating to destroy these forms as you work so that you may be free to experiment rather than constrained by the fear of loosing what you have.

✦ Throw several cylindrical forms and combine them to create a functional vessel.

✦ Throw a number of identical forms such as a set of mugs. Use a caliper to help you measure for uniformity.

✦ Try altering a wheel-thrown form. Use your hands or a wooden paddle to flatten, poke, dent, expand or otherwise change the symmetry of the piece.

✦ Create a combination wheel-thrown and coiled pot. Begin by throwing a cylinder to create a base. While still on the wheel, hand build a coiled design onto the rim. Next, allow the base to dry for a short time so that it can support additional clay. Then score, slip and add a thick coil of clay. Turn on your wheel and continue throwing from the coil that you have just added.

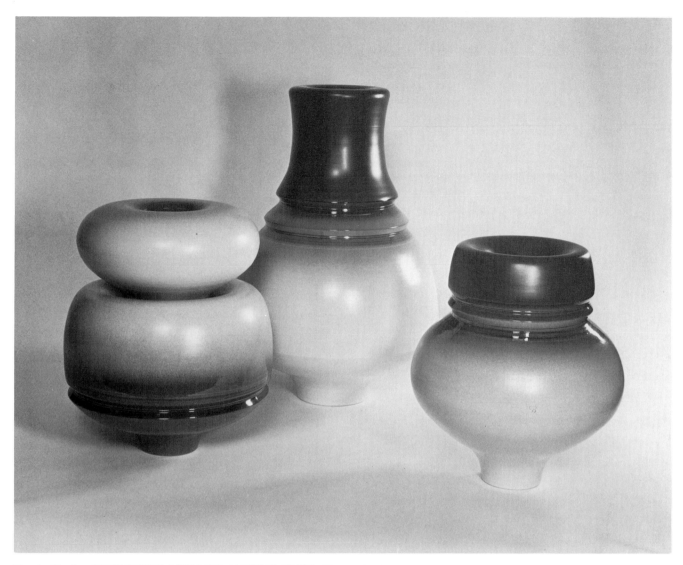

Marvin Bjurlin. OCEAN WAVES, SOLILOQUI, ALONE/ TOGETHER. These wheel-thrown vessels are double-walled, creating an ambiguity between inside and outside.

Glazing

Glazing involves the application of what is essentially a layer of glass over the clay surface. Glaze functions aesthetically, imparting color, texture and design, and it also has a practical function. It not only strengthens the clay but also makes it nonporous and therefore capable of holding liquids. The challenge of glazing is to integrate the glazed surface design with the sculptural form of the clay. A pot is like a shaped canvas — the glaze is the paint. Each should complement the other.

Glaze is made from silica (the main ingredient in glass), flux, which lowers the melting temperature of the silica, and alumina which, among other things, makes the glaze more viscous so that it will not slide off the walls of the pot. Other ingredients may be added to produce qualities such as color and opacity.

Glaze is rich and extensive in its range of textures and colors. It can be matt, glossy, metallic, pearlized, transparent, opaque, opalescent and textured. The color range is infinite.

Commercially prepared glazes as well as glaze ingredients for making your own glazes may be purchased at ceramic supply stores. Studio-prepared glazes may be mixed to satisfy personal taste and the specific requirements of your clay and kiln. Many books on ceramics include glaze recipes. Each glaze matures at a specific temperature. A glaze must be suited to your particular clay body as well as the temperature at which it will be fired.

CAUTION: Use lead-free glazes, especially for vessels that will be used for food or drink.

Although glaze may be applied to greenware, it is recommended that work be bisque fired before glazing. Bisque is stronger than greenware and is nonsoluble in water, although it remains porous. Glazing errors may be washed off bisque.

Since glaze will fuse to whatever it touches, it is necessary to avoid applying glaze to surfaces that will come into contact with kiln shelves. Liquid wax may be applied to areas such as the foot of a pot, to resist the glaze, or glaze may be sponged off contact surfaces before firing.

Glazes are unpredictable. Some factors which influence their appearance are ingredients, firing temperature, the thickness of application, method of firing, placement in the kiln and the clay body

The pot may be dipped into the glaze.

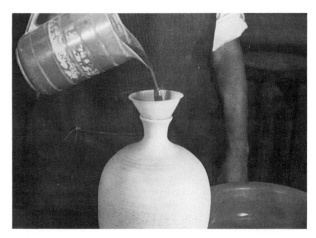

A simple method of glazing the inside of a pot is to pour glaze into the pot. The pot is then turned until the glaze coats the entire surface.

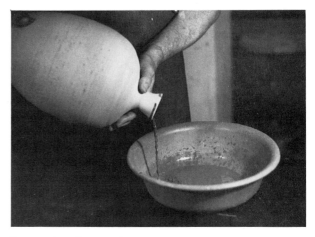

Excess glaze is poured out.

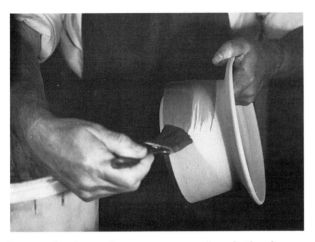

Or treat the clay surface as a canvas and apply the glaze with brushes.

Here a spray gun is used to apply glaze to the bisque.

on which they are applied. Glazes may, however, be tested on small bisque-fired tiles under the same conditions that you propose to fire the actual piece.

Glaze Application

Just as there are no hard and fast rules for painting on canvas, glaze may be applied in any manner that achieves a desired effect. The following are four conventional methods of glaze application.

Dipping. A quick and easy method for applying glaze is by dipping the pot into a bucket of glaze. For dipping, a comparatively large amount of glaze is required. If more than one glaze is applied in this manner, be certain to allow the first glaze to dry before dipping into the second. Colors may overlap for exciting effects. Hold the piece so that your fingers are as unobtrusive as possible. Metal tongs may also be used to hold the pot. Use a brush to touch up any missed spots.

Pouring. Glaze may be poured or dripped over or into a pot. A pitcher is used to hold the glaze for pouring. To glaze the inside of a pot, pour an ample amount of glaze into the pot and gradually turn the pot as you pour the excess into a bowl. When you have turned the pot completely around, the entire inner surface should be glazed. A funnel is helpful for directing the flow of the glaze when pouring it into a narrow-necked pot. When pouring the glaze over a pot, catch the excess in a bowl. Glaze the interior before the exterior.

Brushing. Entire pots may be glazed with a brush or brushed decorations may be applied directly to the clay or over a layer of glaze. Use a wide brush to apply an even coat of glaze over a large area. For decoration, varying widths of hard or soft bristled brushes will create delicate or bold strokes. Tools other than brushes may be used to apply glaze. A sponge, for example, can be dipped into glaze and its surface printed onto the clay.

Spraying. Spraying is a method best used to achieve an even coat of glaze and gradual gradations of color changes. The fine mist of glaze that settles on the clay is more subtle than a poured or brushed surface. The spray gun should be held at the proper distance from the pot and moved slowly and evenly so that the glaze does not build up too rapidly. When too much glaze is applied too quickly, it will begin to flow. **CAUTION: To avoid inhaling the toxic glaze mist, spray in a spray booth with an exhaust fan. In general, when working with glazes, take the appropriate measures so as not to inhale or ingest these toxic materials.**

Nancy Baldwin. PINK DESERT (SOUTHWEST IV). 1982. Earthenware vessel. This atmospheric glazed effect was applied with an airbrush.

Firing

Clay is fired in a kiln. Different types of kilns use different heat sources such as electricity, gas and wood. Some primitive kilns are simple to make. Books are available that deal solely with ceramics and kiln construction and provide instructions. Each kiln requires specific firing techniques and produces unique effects. **CAUTION: Indoor kilns should be situated under an exhaust hood to prevent inhalation of harmful fumes.**

If you do not own a kiln, kiln space may often be rented from private, educational or commercial institutions.

Clay is usually fired twice. The first firing produces what is known as bisque. In this firing the clay becomes hard and non-soluble in water. Glaze is applied to bisque and fired a second time to fuse the glaze to the clay surface.

The temperature in a kiln may be measured by a pyrometer (temperature gauge) or by pyrometric cones. Each cone has a number that corresponds to the temperature at which it begins to sag. The temperature at which a specific clay body or glaze matures is indicated on the packaging. When the cone is placed in the kiln, situated so that it may be viewed through a peephole, it will alert the potter as to the temperature inside. The kiln is turned off when the desired temperature has been reached. Generally, three different cones are used for each firing. The first will bend and thus warn that the kiln is approaching the proper temperature (the second cone). The third cone will remain straight unless the kiln has been overfired. When a cone is used in an automatic shut-off device, the kiln will shut off automatically when the cone heats to the correct temperature.

In the bisque firing, greenware may be stacked for economical use of space. In a glaze firing, however, surfaces should not touch or they will fuse. Kiln furniture such as shelves and shelf supports may be used in stacking a kiln. Coat shelves with a layer of kiln wash before using. Stilts may be placed under pots in a glaze firing so that they are lifted off of the shelves.

To avoid disappointing accidents when firing, be certain that the clay is bone dry. Damp clay will explode. Firing should be done gradually, over several hours. Specific instructions are included with each kiln.

Nothing quite compares to the thrill of opening a kiln after firing and admiring the products. Each firing is unique. The rich colors and subtle variations are a wonder to view.

Helen Gagne. WOMAN ON A PIG, 16" X 12". Bulbous, curving shapes dominate the form of this ceramic sculpture.

4 · GLASS

Glass has been around since lightning first struck a patch of sand. As far back as 1500 B.C., the Egyptians were manufacturing glass. Today, glass is used to make functional items such as windows, eyeglasses, bottles, lightbulbs, kitchenware, mirrors and fiberglass curtains as well as a host of crafts including enamels, stained, fused and blown glass.

Among glass's varied properties are its capacity to be transparent, opaque, clear, colored, delicate, strong, smooth, textured, thick, thin, shiny, frosted, ovenproof and fireproof. It can resist a flying bullet and, at the other extreme, be spun as thin as hair. Glass is a stable material and will not deteriorate with age.

For the craftsperson, glass offers many possibilities. It can be cut, molded, fused, blown, etched and ground into a powder for enameling. Although we have learned to fear its fragility and sharpness, this should not be a barrier to finding a comfortable working relationship with glass. It is a beautiful material which is safe to work with if a few simple rules are followed.

Fusing and Slumping

Glass begins to melt when it is heated in a kiln to the proper temperature. This property allows us to fuse and to slump glass.

Fusing glass involves heating it to the temperature where two pieces melt together to become a single piece of glass. Materials may be laminated between two sheets of window glass before they are fused, trapping the decorative materials inside the glass. Enamel may also be applied to a piece of glass and fired until the powder has fused to it.

Slumping is similiar to fusing in that it involves heating glass to a high temperature. In slumping, however, the glass is placed in or over a mold. As it begins to melt, it takes the form of the mold. If textured molds are used for slumping, they will impart texture to the glass. The techniques of fusing and slumping may be combined.

Glass is temperamental about just how it is heated. Temperature variations within a piece produce stress points as different areas expand and contract at different rates. Thus, glass that has been heated is vulnerable to fracturing. This problem is alleviated by heating and slowly cooling the glass at specific temperature ranges. The process of slowing down the rate of cooling is called annealing. Glass that has not been annealed may look solid when taken from the kiln; however, it will only be a matter of time before the brittle glass fractures.

Linda Ethier. Three techniques (fusing, slumping and stained glass) are used to create this multi-layered, multi-faceted portrait in glass. Photo by Roger Schreiber.

Fusing

Materials. In choosing your glass, be aware that the pieces of glass must be compatible to fuse successfully. Choose your glass carefully since incompatible glass will crack when fused. Sheets of glass that are compatible may be purchased from manufacturers such as Bullseye. These sheets are specifically labeled for compatibility. Glass from different manufacturers or even glass that has been taken from separate sheets made by the same manufacturer may not be suited for use in the same piece. Uniformity in the thickness and number of layers of the glass makes for more successful fusing. Test firings should be made by fusing small pieces of each color onto the base. Window glass fused onto itself will produce pleasing results for the beginner and will not present the problems of compatibility posed by using a variety of colored glass.

The materials needed for fusing are: window glass, stained glass (preferably labeled compatible), glass cleaner, paper towels, flux with an atomizer or airbrush applicator, electric kiln with a pyrometer, kiln brick or shelf and kiln wash. Optional: 18 gauge wire, wire cutter, dry leaves, baking soda, metal screening and ceramic fiber paper.

Preparing the Glass. To fuse, or laminate glass, cut the glass as described in the section of this book on stained glass. It is important to clean all glass with glass cleaner and paper towels before fusing. Next, arrange the pieces on a sheet of clear glass. When working on small fused projects, it is not necessary to laminate the pieces of glass to a base sheet. The pieces must, of course, overlap if they are to fuse together.

Since window glass is compatible with itself, lovely work may be created by fusing several pieces of window glass together. Window glass is available for little or no cost, especially since scraps may be used. Materials such as leaves, thin wire and wire screening may be sandwiched between two sheets of clear glass. A small amount of baking soda trapped between two sheets of glass will produce bubbles. Enamel powder may be fused to the surface of a sheet of glass to create a colored design or picture. A wire loop may be partially sandwiched between two pieces of glass so that the exposed portion of the wire protrudes beyond the edge. The finished work may be hung from this loop.

Fluxing. Although not essential to the fusing process, it is highly recommended that flux be applied to the surface of the glass before it is fused. The flux is sprayed onto the glass so that it covers the surface with a light coat of "snow." The glass should be visible through the flux. The flux will impart a glossy finish to the glass when it is fired. If you use too much or too little flux, the surface of the glass will acquire a matte finish.

Firing. When all of the glass has been cleaned and fluxed, transfer the work to a kiln shelf or kiln brick that has been coated with kiln wash to seal the surface. A ceramic fiber paper is available that may also be used as a surface on which to place the glass. This material is supported on a kiln shelf and may be used for one firing only.

Place the work on the kiln shelf, brick or fiber paper in a cold, well-ventilated kiln. The kiln should be appropriate for the size of the piece in order to minimize cost. An enameling kiln is fine for small work and for testing the compatibility of glass.

Next, turn the kiln onto low and, with the kiln door left slightly ajar to allow the gases and moisture to escape, heat the piece slowly. When the temperature reaches 1000° F, close the kiln door. Because of variations in kiln construction, size and the kind of glass used, it is impossible to state standard firing times or precise temperatures. The glass should be checked from time to time after it reaches 1300° F. When the edges of the glass become rounded, fusing temperature has been reached, and it is time to turn the kiln off. Do not overheat the glass.

Annealing. With the heat turned off, the temperature in the kiln will gradually drop. When it has dropped to 1000° F, it is important to maintain this temperature for approximately 1 hour. This is the crucial temperature for annealing. It may be necessary to turn the kiln on low if the temperature drops below 850° F. within the hour. After one hour, the kiln may be left to cool. Only when the glass is cool enough to be handled in your bare hands is it time to remove the work from the kiln.

Each glass piece is cut with a glass cutter, and positioned on a sheet of clear glass.

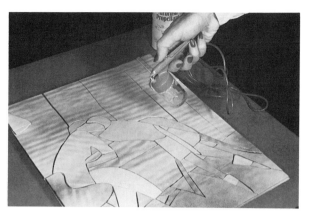

Flux is sprayed over the surface of the glass.

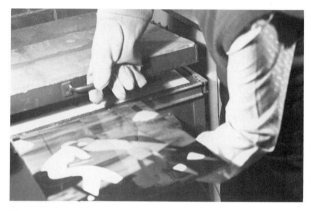

The glass is transferred into a cold kiln and the firing process is begun.

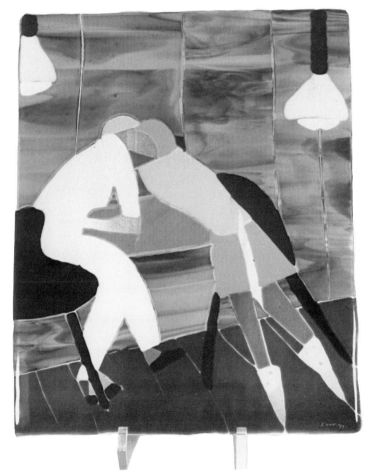

Ronnie Wolf. The completed fused piece.

Tim O'Neill. Slumped bowls. Photo by Roger Schreiber.

Slumping

Following the same firing procedure, a sheet of glass may be slumped into a mold made from ceramic or firebrick. Place the glass over the mold and heat it until the glass has slumped to conform to the mold. Follow the above procedure for annealing as the kiln temperature descends.

Branching Out: Fusing and Slumping

✦ Experiment by laminating different materials such as wire and pressed leaves between two sheets of clear window glass.

✦ Create a design with powdered enamels on a sheet of window glass.

✦ Fuse small chunks of glass together to create glass jewels. Use these jewels in a stained glass piece or for making jewelry.

✦ Cut many small pieces of window glass and fuse them together to create several fused pieces that can be combined to create a wind chime or mobile.

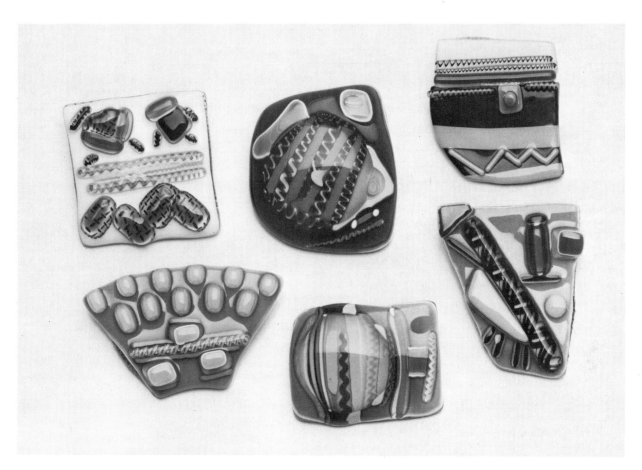

Dari Gordon and Bruce Pizzichillo, Que Pasa Pins. Spiral DNA-like elements are the dominant motifs in these miniature abstractions of fused glass. Photo by M. Lee Fatherree.

Ronnie Wolf. A glass disc that has previously been fused is placed in a ceramic mold. When fired in a kiln, the disc will slump to conform to the shape of the bowl-shaped mold.

Stained Glass

Nothing can match the vibrant colors of illuminated stained glass. You need only enter a Gothic cathedral or look at a Tiffany lamp to see for yourself. The jewel-like glass and brilliantly colored light contribute to making this craft as popular as it is.

The color in most stained glass is actually added in the molten state and not, as the name implies, to the surface. The sheets of glass may be handblown or machine-made. They are available in a variety of colors, degrees of opacity, textures and thicknesses and are often works of art in themselves.

The art of making stained glass windows first blossomed with the development of Gothic architecture in the Middle Ages. Architects of this period invented a means of creating lofty cathedrals. They opened the expansive walls to light by creating huge windows. Because only small pieces of glass could be produced in this period, they needed a means of combining many small pieces of colored glass to create large windows. The problem of joining the glass was solved by using lead came to surround each piece. The came provided surfaces which, unlike glass, could be soldered together.

In the 19th century, an American artist, Louis Comfort Tiffany, devised a technique for working with pieces of glass too small to be joined by lead came. By surrounding the glass with strips of thin copper foil rather than the more cumbersome lead came, he was able to create more delicate and intricate work. Tiffany's studio produced stunning lamps and windows executed in the Art Nouveau style. Today, many stained glass artists are choosing this method for their creations.

Stained glass by students.

William Barash, Imagine Stained Glass. The copper foil method was used to create this kaleidoscopic image.

The Copper Foil Method

Materials. Glass cleaner and paper towels; thick paper such as oaktag; tracing paper; pencil; flat surface covered with stiff paper or cardboard; scissors or a razor knife; double-sided tape; sheets of stained glass; glass cutter with a ball end; straight edge; hand broom; kerosene in a small jar; combination pliers; carborundum stone; adhesive-backed copper foil tape; flat wooden stick or burnishing tool; soft solder flux with a small brush; 100 watt soldering iron; 50/50 or 60/40 solid core wire solder; damp natural sponge; goggles; patina for copper.

Preparing a Pattern. Although working with stained glass is not nearly as difficult as it may seem, it is advisable for the beginner to start with a design utilizing a few simple shapes. Straight lines and gentle curves are the easiest to cut. Cutting glass with a glass cutter does take some skill, but it can be easily mastered with practice.

Begin by making two full-scale copies of your sketch on oaktag or any stiff paper. Use tracing paper to trace the first copy so that a second copy may be cut using the traced copy as a guide. The first copy is used to assemble the glass after it is cut. The second copy is cut into pieces and used as a pattern when cutting each section of glass. Cut the pieces of the second copy slightly smaller to allow for the thickness of the copper tape that will surround each piece of glass. Number each section on both copies. Double-sided tape may be used to tape each pattern piece onto the glass.

Cutting the Glass. It is advisable to practice cutting on clear window glass since it is less costly than stained glass and will make the inevitable mishaps of first attempts less painful. Work on a flat surface covered with stiff paper or cardboard. From time to time, the paper may be swept over a garbage basket to remove slivers of glass that can be dangerous if left on the working surface. **Safety goggles should be worn at all times when cutting glass**. Clean the glass with glass cleaner before you begin cutting.

A glass cutter is used to score the surface of the glass. The wheel of the cutter should be stored in kerosene when not in use and lubricated by dipping it in kerosene between each cut. This will prolong the life of the cutter.

To score, hold the cutter perpendicular to the glass, with the handle between your index and middle fingers and your thumb pressing against the underside of the cutter. Working on the smooth side of the glass, trace along the paper pattern. Score in one continuous motion, starting as close to the edge as possible without actually touching the edge. Apply enough pressure so that you can hear the wheel cutting but not so much that you produce a ragged cut. Only through practice will you learn the proper amount of pressure to exert. Work towards or away from your body and do not retrace scored lines or stop in the middle of a cut. Cut along one side of the pattern at a time, scoring from one edge of the glass to the opposite edge. Most pattern pieces will require several cuts. A straight-edge may be used as a guide for the cutter when scoring straight lines. Do not score more than one line before breaking.

The scored line does not actually cut through the glass but rather provides a groove at which point the glass may be broken. The glass must be broken immediately after being scored. If you wait even a short time before breaking, you will not produce a clean cut.

To break the glass after scoring, grasp the glass on both sides of the scored line, between your thumbs and the rest of each hand. Applying even pressure, snap the pieces apart with a downward and outward motion. When cutting off a small piece of glass that cannot be easily grasped with your hand, use a glass pliers to grab the small piece of glass approximately 1/2" from the end of the cut and right up to the scored line. Hold the larger piece in your hand as described above and snap the glass apart.

Some cuts are not as cooperative as others and require additional coaxing. The metal ball at the end of the glass cutter may be tapped gently against the underside of a scored line starting approximately 1/2" in from the edge of the glass. If you cannot see the scored line, hold the glass up to the light and trace the line with a marker. After tapping, snap the glass apart as described above. Any irregularities in the edge may be nibbled (grozed) away with a pliers. Rub a carborundum stone across the edges of the glass to smooth out any rough spots. Hold the stone at an angle to avoid chipping the glass.

Two copies of a stained glass pattern are made so that one can be cut out and traced to shape each glass section, and the other can be used for assembling the cut pieces.

Scoring the glass.

The glass is grasped on either side of the scored line and snapped in a downward, outward motion.

Glass pliers are helpful for grasping small pieces of glass.

Tap gently on the underside of a scored line to help break the more resistant pieces.

A carborundum stone is rubbed over the glass to smooth rough edges.

The edge of each piece of glass is covered with copper foil tape.

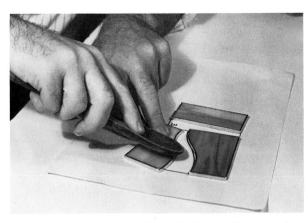

A wooden spoon is used to burnish the tape firmly against the glass.

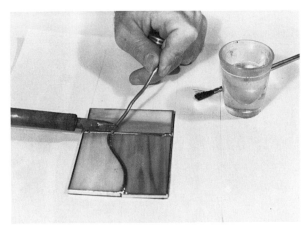

Solder is melted onto the copper tape to join the sections of glass and completely cover the foil.

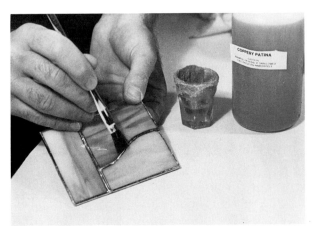

A patina may be brushed over the solder to give it an antiqued effect.

Applying the Copper Tape. When all of the pieces in your design have been cut, you are ready to apply the copper foil tape to the edges. Rolls of foil tape with an adhesive backing are available in several widths to accommodate different thicknesses of glass. 1/4" tape is a good size for most glass. Remove the protective backing as you work and avoid touching the adhesive.

Position the glass edge on the center of the tape and wrap the tape around the entire piece, overlapping 1/4" where the ends meet. The tape may be cut with an ordinary scissors. Next, fold the tape neatly over both edges of the glass to provide a small, even overlap. When you reach a corner, take a small tuck in the tape so that it will lie flat. For better adhesion, burnish the foil with any flat, smooth tool. A wooden spoon is excellent for this purpose. As you finish wrapping each piece, assemble it on the paper pattern.

Soldering. The tip of a new soldering iron should be coated with a layer of solder. This is known as tinning the tip. A soldering iron with an iron-clad or iron-plated tip is already tinned when it is purchased. An iron with a copper tip should be tinned by brushing soft solder flux onto the tip and coating the heated tip with solder. A copper tip should be filed clean and retinned when necessary. With use, either type of tip will need to be wiped clean on a damp natural sponge.

It is essential that you use the proper solder for stained glass work. 50/50 or 60/40 solid core wire solder contains the proper ratio of tin to lead and

will make soldering easy. Note that the first number in the ratio refers to the amount of tin and the second to lead content.

To solder the assembled pieces together, begin by coating the copper foil with flux on the points to be soldered. This will clean the foil and encourage the solder to flow. Now tack adjacent sections at strategic points until the entire work is held together with solder. Clean the iron tip on a damp sponge from time to time.

Next, flux the rest of the copper tape. This time, coat the entire surface of the foil with solder, thus joining the pieces and filling in all gaps. Make a raised, rounded solder line by pressing the solder against the iron tip. Move the tip along the foil at a speed that will leave the desired amount of solder on the foil. When the first side is completely soldered, flip the piece over and solder the second side. Complete the soldering by drawing the iron along the outer edges of the work. Now all of the copper tape should be coated with solder.

If desired, a patina may be applied to the soldered lines to darken or antique them. Brush the patina on with a clean brush.

Clean the entire piece with glass cleaner or detergent.

CAUTION: Work in a well-ventilated area, preferably with local ventilation. Wash hands after working with lead solder and do not eat while working.

Stained Glass: Branching Out

 ✦ Create a sun-catcher to be hung in a window. Solder on a copper or steel wire loop from which the piece may be hung.

 ✦ As well as working flat, try soldering glass pieces in three dimensions to create a sculptural stained glass work.

 ✦ Design a stained glass belt buckle. Solder on a copper or steel wire hook and slide to accommodate the belt.

 ✦ Create a mirror or picture frame from rectangular strips of glass. A straight-edge may be used to aid in the cutting of the glass.

 ✦ Design a stained glass box and incorporate another material, such as a shell, into the lid.

 ✦ Sandwich dried flowers, a photo, collage, or lace between two pieces of clear glass. Use wide copper foil to accommodate the greater width.

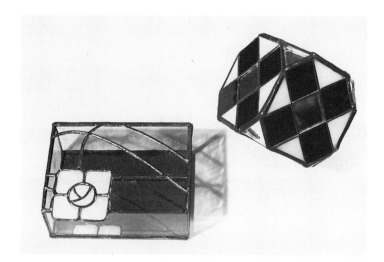

William Barash. Paperweight and box. The paperweight was weighted with sand before soldering the final side of the cube in place. Mirror was incorporated into both of these functional pieces.

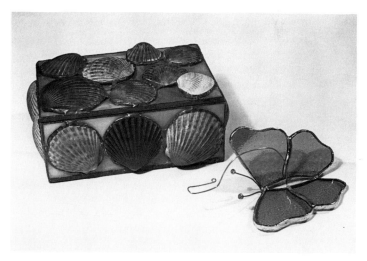

William Barash. Shells were edged with copper foil tape and soldered to the glass to make this box. The butterfly is ready to be hung in a window.

Enameling

Enameling opens the exciting world of color to the metalsmith. Although there are numerous techniques for coloring metal, none is as extensive as enameling. An infinite range of colors may be produced when enamel is fused layer upon layer to the metal surface. The enamelist can "paint" intricate designs that will endure, unchanged, forever.

The potential of this rich medium has been explored by civilizations throughout history. From ancient Greece to Byzantium and the Orient, techniques have been invented to exploit this wonderful art form. In this book we will present beginning explorations in enameling, using the limoges, stenciling, sgraffito and cloisonné techniques. For the enthusiast who wishes to go beyond, there are several books available that deal solely with enameling and offer additional techniques.

Enamel is a glasslike substance. It may be purchased in lump or, most popularly, powdered form at craft stores as well as jewelry supply houses. Enamel can be transparent, opaque, opalescent, matt or glossy.

The most popular metals for enameling are copper, fine (pure) silver and a special alloy of gold made for enameling. Other metals such as brass, bronze and sterling silver are not recommended. Because of the low cost of copper, it is popular with beginners. It does oxidize, however, becoming discolored when heated to enameling temperatures. If precautionary procedures are followed, this drawback may be overcome.

Pre-enameled metal tiles may be purchased in many sizes. These tiles come from the manufacturer already enameled on both sides, thus eliminating the preliminary steps in the processes discussed below. (See Sources of Supply.)

Since enamel is essentially a glass coating, the metal base must remain rigid. A bracelet that requires the wearer to bend it to get it on, for example, would be an impractical surface for enameling. The enamel would inevitably crack. Enamel is generally applied to metal sheet that is at least 18 gauge. Thinner metal may be used when working on small pieces or if the work is going to be set or mounted onto a backing.

Hard soldering cannot follow enameling because of the dramatic heat changes involved,

Lisa Gralnick. Brooch of sterling silver, gold, ivory and enamel. 1981. Linear elements transect the irregular planar surface in this animated work.

and pre-soldering must be done at very high temperatures to withstand high kiln temperatures. It is, therefore, advisable for the beginner to design work that may be worn or mounted without soldering. Findings may be attached through drilled holes. All drilling and sawing must be done before the metal is enameled.

Enamel is fused in an electric enameling kiln. Although a large, front-loading kiln will handle large pieces and provide more consistent temperatures, a small, inexpensive kiln is fine for smaller work. For less predictable results, enamels may be fused directly with a torch. **CAUTION: Kilns should be vented with a canopy hood.**

Materials. 18 or 20 gauge sheet metal (copper; fine silver or gold) cut or sawed to the desired shape; scouring powder or powdered pumice; steel

Lisa Gralnick. Brooch of sterling silver, ivory, gold foil, wood and enamel. 1983. Repetition of shape and pattern unify this unusual combination of materials.

Student work. COUNTRY CAT. Limoges technique.

wool; Scalex and small paint brush (if you are working with copper); paper; 80-mesh powdered enamels; hard (high firing) enamel flux; small cups; Klyrfire; water; a fine brush; small spatula or dental tool; sifter; an electric enameling kiln; a firing rack; firing fork; trivet; and thick leather gloves. Optional: a 200-mesh sifter, an eyedropper, atomizer, tweezers and paper towels.

Limoges

Limoges is a method of enameling named after a city in France where it first flourished. It is the simplest, most direct of the enameling techniques. Limoges is made by building layer upon layer of opaque and/or transparent enamel on the surface of the metal. The piece may be fired many times between enamel applications, until the desired colors and composition are achieved.

Cleaning the Enamels. Attention to cleanliness is very important when enameling. The enamel powders are easily contaminated by the slightest speck of dirt. The powders themselves must be purified by washing before use. Transfer the desired amount of enamel into a small, clean

container that is filled with water. Swirl or stir the mixture, allow the enamel to settle and pour off the water. Most of the enamel will remain at the bottom of the container. The water will be cloudy at first. Repeat this procedure several times until the water is clear. It is particularly important that transparent enamels be thoroughly cleaned.

Preparing the Metal. To prepare the metal for the enameling, scrub all surfaces with scouring powder or powdered pumice and then steel wool. Do not allow the steel wool to get into the enamels. After the metal is cleaned, avoid handling the surfaces since oil from your fingers will transfer to the metal and prevent the enamels from adhering well. If you are working with copper, use a small brush to coat any unenameled surfaces with a layer of Scalex. Scalex inhibits the buildup of oxides when the metal is heated. Scalex must be reapplied each time the piece is fired if areas still need protection. Do not allow Scalex to contaminate the enamels. Scalex is not needed when fine silver or gold is used.

It is also recommended that the metal be domed slightly to reduce warpage in firing.

Counterenameling. Because metal expands and contracts at different rates from enamel during firing, it is necessary to counterenamel work to prevent warpage and consequent cracking of the enamel. Counterenameling involves sifting on an equal thickness of enamel to the underside of the metal as you have applied to the top. Thus warpage in one direction will be counteracted. When the counterenameled surface will not be visible in the finished piece, leftover enamel that has been discarded from previous work is often used.

Applying the Enamel. Enamel may be applied in wet form with a fine brush or small spatula, or in dry form by sifting. A limoges piece is usually begun by sifting on a layer of either hard transparent flux or hard opaque white as a base coat. On gold or silver, a transparent enamel is used rather than flux or opaque white. Before sifting on the first layer of enamel, spray or brush Klyrfire diluted in a ratio of 3 parts water to 1 part Klyrfire onto the metal surface. This will help the powdered enamel adhere to the surface. Klyrfire may be sprayed on with an atomizer.

Sift the enamel on evenly to cover the entire surface. If you work over a clean sheet of paper, excess enamel may be returned to its original container. Contaminated enamel may be saved in a separate container and used for counterenameling for pieces where the backs will not be visible. Allow the enamel to dry thoroughly before placing it into the hot kiln. The piece may be placed on top of the kiln to promote drying.

Firing. When firing, the piece is held on a trivet so that the enameled surface does not come into contact with the firing rack. To fire, carefully place the dry work, held on a trivet, onto a firing rack. **CAUTION: Wear protective gloves to avoid getting burned when loading and unloading the kiln.**

Slide a kiln fork under the rack and lift to transfer the work into the preheated kiln. Although some heat loss is inevitable, this may be minimized by moving quickly and smoothly.

Most enamels fuse at just under 1500° F. The chamber of the kiln will be bright orange at this temperature. Only through experience will you learn the precise temperature at which to fire a particular color. Firing time is dependent upon the size of the piece and the size and construction of the kiln as well as the enamel used. In most cases, firing takes only a minute or two. It is therefore important to observe carefully to avoid under- or overfiring.

Remove the piece when the surface is no longer rippled, but rather smooth and shiny. At this point it is said that the enamel has reached its maturing temperature. You may wish to fire preliminary firings to just under maturity to save time and avoid possible overfiring. Note that a hot piece, when taken from the kiln, will appear to have undergone a color change. Cooling will restore the enamels to their true, brilliant colors.

Do not attempt to speed up the cooling process. It is tempting to quench the work in water for instant cooling. However, this will only result in cracked enamel.

Wet Application. Since enamel does not flow when fused, it is possible to lay down adjacent colors as would a painter and maintain control over the design. If your powdered enamels are wet enough to hold together, yet dry enough so that they do not spread after being applied, you will be able to create lines and shapes in surprisingly subtle detail. Water, or water mixed with Klyrfire in a ratio of 3 parts water to 1 part Klyrfire, may be added to moisten the dry enamels. An eyedropper may be used to add the liquid to the enamels. Excess liquid may be absorbed from

Cleaning the enamel.

The metal should be cleaned with pumice and then steel wool before it is enameled.

Scalex is applied to any unenameled surfaces of copper to inhibit the buildup of firescale in the firing process.

Enamel is sifted onto the metal.

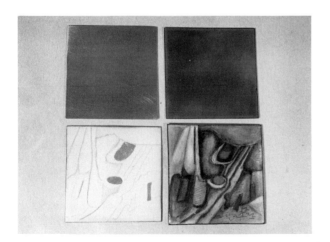

The stages in making an enameled piece using the limoges technique: the metal is cleaned, counterenameled, a base coat of enamel applied, and the colored enamels built up, color by color, between firings.

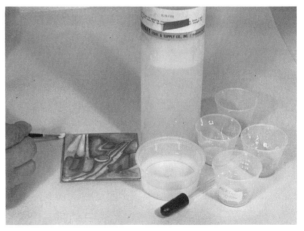

Enamels are mixed with a Klyrfire/water solution and applied with a brush.

wet enamels with the tip of a paper towel. To control this process to an even greater extent than you would using 80-mesh enamels, sift the 80-mesh enamels through a 200-mesh sifter. The resulting powder is finer and, when mixed with water or the water/Klyrfire mixture, acts more like paint than the coarser powder. Thin layers of this fine enamel may be built up to create delicate, subtle effects.

Apply the wet enamels with a fine brush, small spatula or dental tool. Dry enamels thoroughly before firing or they will jump around and rearrange themselves in the kiln. You may fire as many times as required to build up one color upon or next to another. Transparent colors, in particular, show their true beauty when they are layered rather than built up in thick applications. Shading and layering opaques and transparents together will demonstrate some of the extreme versatility of this medium. Experimentation is essential to discover the many effects possible when enamels interact. Testing enamels on scrap metal is well worth the effort. Label all tests for future reference.

Foils. Gold and silver foils added to an enamel will produce the beauty of precious metals at a fraction of the cost. Foil is a very thin, fragile form of metal. To prevent it from falling apart, foil is handled and cut sandwiched between two sheets of thin paper. Do not use gold or silver leaf for enameling. Leaf is too thin and will burn during firing. Foil may be applied on any enamel base and must be covered with several coats of transparent enamel.

Begin by brushing pure Klyrfire onto the area where you wish to apply the foil. Use a fine brush to transfer the foil onto the enamel. It is often convenient to cut the foil into small squares for easy handling. Larger pieces should be pin-pricked to allow air to escape and prevent air bubbles from forming. You may wish to overlap squares of foil to ensure complete coverage. Smooth the foil against the enamel with a spatula.

When the foil is in place and dry, the piece is ready to be fired. Fire just long enough to allow the foil to adhere to the enamel. After firing, the foil should be burnished with a small spatula or knife. If some of the foil flakes off while burnishing, the piece has been underfired and should be repaired and refired. If the foil burnishes smooth and adheres well, you are ready to cover the foil with transparent enamel.

Stenciling

In addition to "painting" wet enamels onto the metal, a stencil may be used to mask areas and create a design. Work over a coating of fired enamel that has been sprayed with the water and Klyrfire mixture (3 to 1). The stencil may be a found object such as a leaf, or it may be cut from thin paper or a paper towel. A wet stencil will adhere better to the metal. Lay the stencil over the metal and dust on a layer of enamel. When you remove the stencil by hand or with a tweezers, only areas that were exposed will be enameled. Several stencils may be used on a single piece, and the enamels fired between applications.

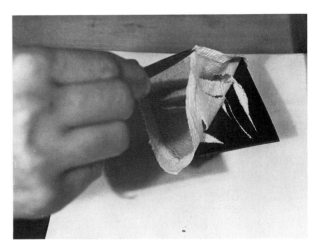

The stencil in this photo was cut from a paper towel. Enamel was sifted over the surface. After the paper is removed, the enamel will be fired in an enameling kiln.

Sgraffito

Another simple method of creating an enameled design is by scratching through a layer of unfired enamel to the bare metal or to a contrasting fired base coat of enamel. For example, a black coat of enamel may be sifted over a fired base coat of white. The black powder is scratched into, exposing the white below, and fired. Any sharp instrument, or even your finger, may be used to draw in the powdered enamel.

This sgraffito technique may be combined with the limoges technique discussed above, by applying thin layers of 200-mesh colored enamels to the exposed white areas.

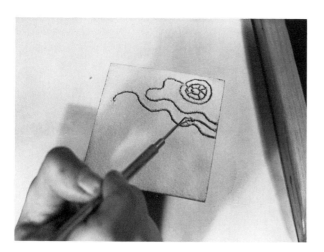

Sgraffito. A dental tool is used to scratch into the powdered enamel surface to expose the fused enamel base coat below.

Cloisonné

As stained glass windows are made from glass partitioned by strips of metal which juxtapose line and shape, the cloisonné technique similarly combines enameled shapes separated by thin strips of metal.

Additional Materials. 18 x 30 gauge fine silver or gold cloisonné wire; a small scissors; tweezers; medium carborundum file; #400 wet and dry paper; a toothbrush or glass brush; ammonia and water.

Making the Cloisons. Cloisonné wire is a thin, flexible, flat wire. Although cloisonné wire may be purchased in copper as well as the suggested silver or gold, copper oxidizes and presents

Lisa Gralnick. THE MONOMYTH, detail. Cloisonné. The fluid forms emanating from a central focal point show how freely one can "paint" with enamel.

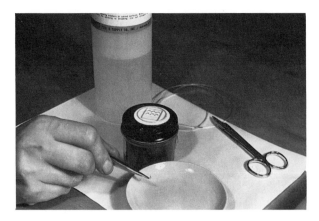

The cut cloisonné wire is dipped into Klyrfire and positioned on the enamel-coated metal.

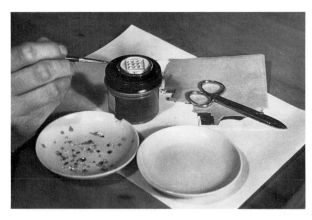

Gold foil is applied after the enamel has been coated with a layer of Klyrfire. Metallic foil must be covered with several coats of transparent enamel.

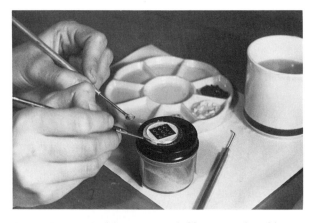

Each cell is filled with wet enamel. After several packings and firings, the enamel will be even with the top of the wires.

The dry piece is fired in an enameling kiln.

A carborundum stone is used to stone the surface flat. After stoning, the piece may be flash fired to restore the glossy finish.

problems that do not occur when silver or gold are used. Gold or silver wires may be used quite successfully on a copper base.

The wires are bent to the desired shapes and cut to the proper lengths with a small scissors. Use tweezers to lay the wires on the metal base that has been covered with a layer of fused hard flux or hard opaque white enamel. First, dip the wires in undiluted Klyrfire to help adhere them to the base. Do not use a straight wire, for inevitably it will fall over in the kiln. When the wires are in place, fire the piece until the enamel is just soft enough to hold the wires. Do not overfire or the wires will sink too far into the base coat. After firing, the wires should be held solidly in place.

Filling the Cloisons. With the wires in place, the cells are filled with wet enamel. A fine brush or spatula may be used to apply the enamels and pack them into the cells. The enamel will sink when fired. Although some enamelists like the effect of the concaves of enamel, the cells are usually filled and fired several times until they are level with the wires.

Finishing the Piece. To create a smooth surface in which the enamel and wires are level, the surface may be stoned and sanded. Begin by filing with a medium carborundum file, always holding the work under running water as you file. The water will wash away dirt and keep the surface clean. When the enamel is level, #400 wet and dry paper is used to further refine the surface. Scrub the sanded surface clean with a glass brush or toothbrush. To truly clean the enamel, it is advisable to soak it for a half hour upside-down in a solution of ammonia and water. The matt finish may be left as is, or the piece may be flash fired in a hot kiln to restore the glossy finish.

Carefully file and polish exposed metal edges as explained in the section of this book on polishing metal. File in a direction away from the enamel to prevent chipping.

Peggy Simmons. SOUTHERN BELLE. Brooch of silver, 14-karat gold, cloisonné. 1982.

Enameling: Branching Out

✦ Explore the potential of enamels by making a series of tests on scrap metal. Observe how the base color as well as the order of layering effects the results. Note the effect of "overfiring" enamel. You may find it pleasing. Keep a written record of your experiments.

✦ Create an enameled plaque that illustrates a scene. Build up the composition in the limoges technique.

✦ Experiment by adding tiny scraps of metal as well as chunks of enamels and observe the effects produced when they are fused into a base coat of enamel.

✦ Try using several leaves as stencils over a base coat of enamel. Dust the enamel over each leaf, firing between colors.

✦ Make a pierced pendant (see Sawing and Piercing) and enamel it using one or several colors.

✦ Create a cloisonné pendant in which the cloisonné wire takes the form of a figure or portrait.

✦ Use the sgraffito method of enameling to create a line drawing in enamel.

✦ Add small shapes cut from gold and/or silver foil to a base coat of black enamel.

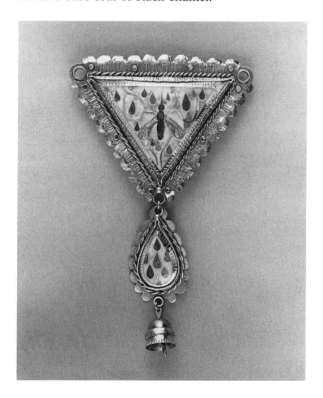

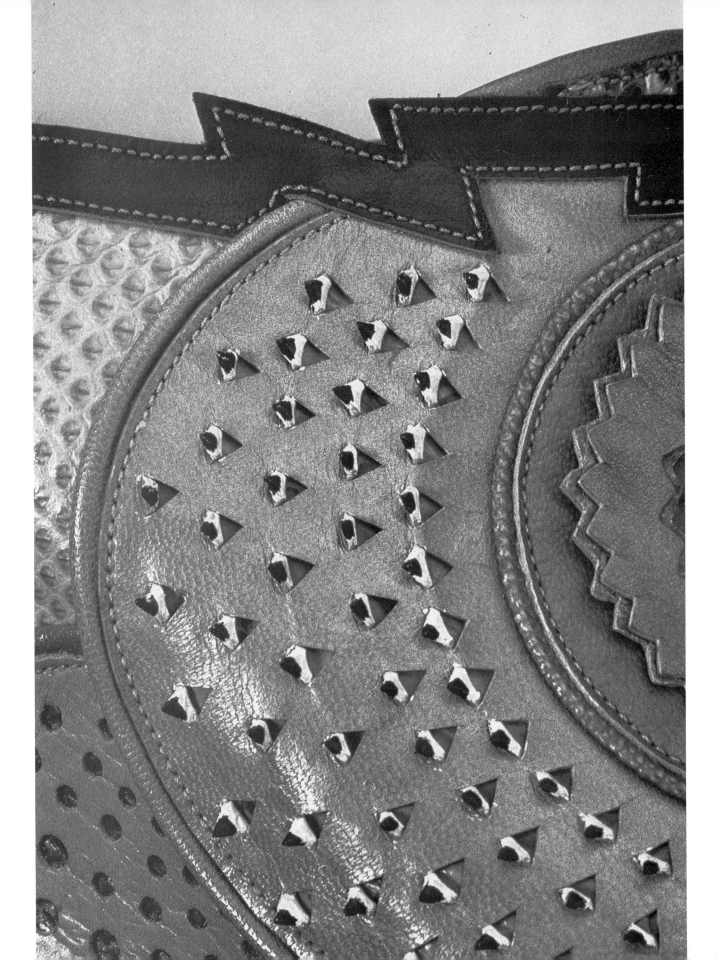

5 · LEATHER

From our beginnings as a species to the present, we have exploited leather for numerous purposes. Its qualities are unique and varied, making it a functional as well as aesthetic medium. Leather is used in making such items as saddles, bookbindings, bags, balls, boxes, furniture, shelters (the tepee), drinking vessels, sculpture and clothing. Leather's toughness can find symbolic expression as a motorcycle jacket or, at the other extreme, its natural suppleness and delicacy are well suited for an American Indian ceremonial dress.

Leather is made from the skin or hide of an animal. The term "skin" refers to the skin of small animals such as pigs and goats. "Hide" is used when referring to the skin of large animals such as cows and buffalo. Untreated animal skin or hide is called rawhide. In this natural state it is soluble in water, weak and unsuited for most purposes. In order to make rawhide into leather, it must be tanned. The tanning process makes the hide stronger, more flexible and prevents it from decaying. Vegetable and chrome tanning are two processes most often used to tan leather.

There are many approaches to leathercraft. Molding, carving, stamping, sewing and tooling are among the techniques often employed. Different kinds of leathers are appropriate for different techniques. Among the skins and hides used for leatherwork are calfskin, goatskin, pigskin, sheepskin, steerhide and cowhide. Cowhide is most commonly used because of its availability. Many

Daphne Lingwood. INSECT. Cowhide, dye and acrylic paint. The unique texture of leather mimics the chitonous shell of an insect making this piece thoroughly realistic.

exotic leathers are no longer in use because they are made from endangered species.

Different leathers possess different qualities depending upon the animal source as well as the manner in which they are tanned, cut and finished. Qualities such as size, strength, thickness, grain and color should be considered before choosing the leather to meet your particular needs.

Leather is sold by the full or partial skin, or by the square foot. Scraps may be purchased by the pound. Each skin is unique and has imperfections and inconsistencies. It is advisable to take your pattern along when selecting your leather.

Gaza Bowen. NEVER SAY NEVER AGAIN. RIGHT, DEN? 1986. Leather over wood with inlay, overlay and foldbacks. Courtesy of the artist.

Student work. INDIAN. Wet formed leather.

Marcia Lloyd. NECKPIECE. Cowhide lined in skiver. Airbrushed with textile dyes. 1985. Wet formed ruffels add dimension to this unusual neckpiece.

Wet Forming

With the technique of wet forming, leather reaches its maximum potential as a sculptural medium. Because vegetable tanned leather is flexible when wet and rigid when dried, it is possible to form leather for saddles, jewelry, masks, containers and sculpture. It is surprising to see the depth that can be achieved by wet forming a piece of flat leather.

Forming may be done by manipulating wet leather with your hands or by molding it over or into a mold. The mold may be a found object such as a bottle or wooden hat form or a mold made specifically for forming leather. The mold may be carved from a block of wood or plaster, or a plaster impression may be taken of a found or sculpted model (see One-Piece Plaster Molds). Plaster molds should be shellacked before they are used to wet form leather. Anything that will withstand the pressure necessary to coax the leather snugly around a form or into a mold may be used as a mold.

Materials. Only vegetable tanned leather is suitable for wet forming. To determine whether leather is vegetable tanned, soak a scrap in warm water. Vegetable tanned leather will become limp when it is wet and rigid when dried.

Kip (approximately 2 oz.) is excellent for wet forming small pieces that are made by hand without a mold. This lightweight leather is easy to manipulate. When working larger or when using a mold, 3 oz. to 6 oz. leather is recommended. The lighter weight (3 oz. to 4 oz.) will pick up greater detail; however, it does not become as rigid as thicker leather. The thicker leather (5 oz. to 6 oz.) is usually reserved for large work. You will find that a form with many folds will be structurally stronger than a flat form.

In addition to leather, you will need the following materials: a paper pattern; pencil; sharp knife such as a utility knife; cutting surface such as neolite, hardwood or masonite; plastic pail with warm water; absorbent towels; clothespins and a hairdryer. The following items are optional: modeling tools; straightedge; spray bottle; a mold or form over or into which leather may be molded; leather dye, drawing ink, markers or wax shoe polish; plastic gloves; rags; petroleum jelly or a leather finish and beeswax.

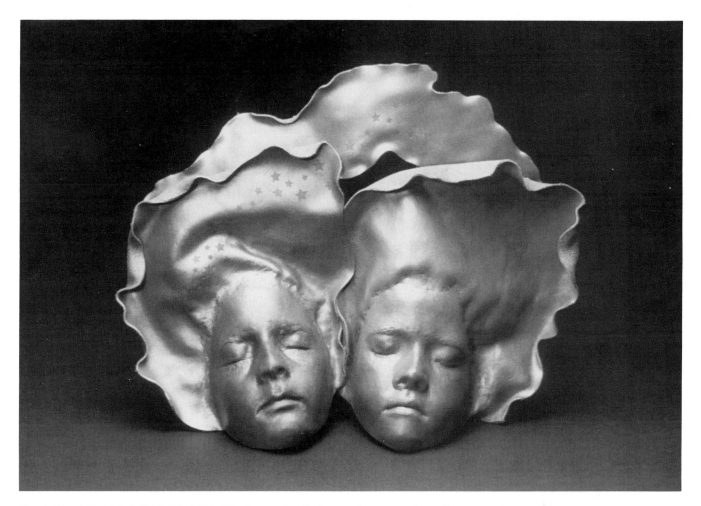

Marcia Lloyd. DANIEL AND SASHA. 1986. This impressive dual portrait was wet formed over a mold.

Cutting the Leather

After a paper pattern has been made, it is traced onto the leather with a modeler or pencil. The leather is then cut on a cutting board with a utility knife. A metal straightedge or steel square is used as a guide for the knife when cutting straight edges.

Wetting the Leather

Soak the leather in warm water until it becomes limp and slippery to the touch. Some hides will soften more quickly than others. Squeeze the leather to increase the amount of water that is absorbed. Remove excess water by pressing the leather between paper towels or any absorbent cloth.

Forming the Leather

The leather may be formed by hand or in a positive or negative mold. To form the leather without a mold, simply pinch, fold, stretch, compress or otherwise work the leather into the desired form. A blow dryer set on high heat will dry one area permanently in place so that your hands are free to work another area. Be careful not to burn the leather by keeping the heat too close for too long. Clothespins will hold the folds in place until the leather is dry.

To form the leather into a shallow negative mold, lay the wet leather, smooth (grain) side down, over the mold. Use the appropriate modeling tools with a flat, pointed or balled end to gradually coax the leather to conform to the mold. You may find it advantageous to remove the moisture gradually with a blow dryer as you pick up more and more detail. Although very wet leather will form easily into large concaves, excessively wet leather will not hold as much detail as drier leather. Work from the center outwards.

Working over a positive mold is similiar to working into a negative mold. However here the leather is being stretched over a form, making it more difficult to hold in place as you work. Lay a piece of leather that is larger than the mold, rough (flesh) side down, over the mold. Use your fingers and then modeling tools to stretch and compress

the leather. Always work from the center towards the edges. Blow dry finished areas as you proceed. Rewet sections that need additional work with a spray bottle filled with water. Although you will get less detail from a positive mold, it enables you to see exactly what you are doing, since you are working with the grain side up.

Finishing

The leather may be left in its natural state or it may be colored with dye, markers, drawing ink, wax shoe polish, thinned acrylic paints or almost any coloring agent. Dye is usually applied with a rag to dampened leather. It may be applied either before wet forming, producing a less intense color caused by dilution in the water, or after forming, when it becomes more difficult to coat the leather evenly. Be certain to wear plastic gloves when working with dyes.

A final coat of petroleum jelly or a leather finish may be rubbed into the leather to protect and keep it supple. Beeswax may be rubbed along the edges and then burnished with a rough cloth.

Wet Forming: Branching Out

◆ Wet form leather around a bottle and sew up the seams to create a leather container. The bottle may be left in the leather so that it may be used.

◆ Wet form a piece of leather into a low relief mold and use it as one of the pattern pieces in a functional item such as a pocketbook or briefcase.

◆ Experiment with wet forming small scraps to create leather flowers or jewelry. Impress details onto the damp leather with a pointed modeling tool.

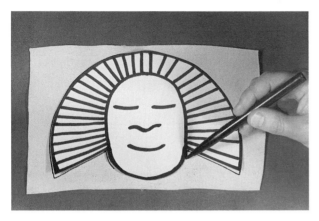

The pattern is traced onto the leather.

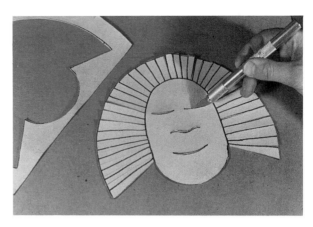

A sharp knife is used to cut the leather along the guidelines.

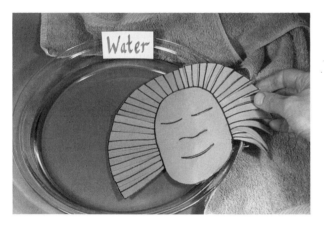

Soaking the leather will make it pliable and easy to mold to shape.

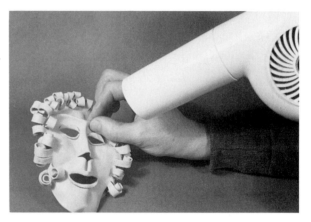

Hot air will stiffen the leather permanently once it has been molded in place by hand.

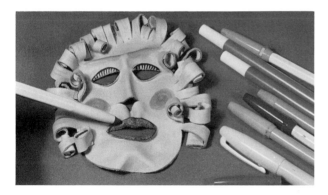

Markers, ink, paint or wax may be used to add color to the formed leather.

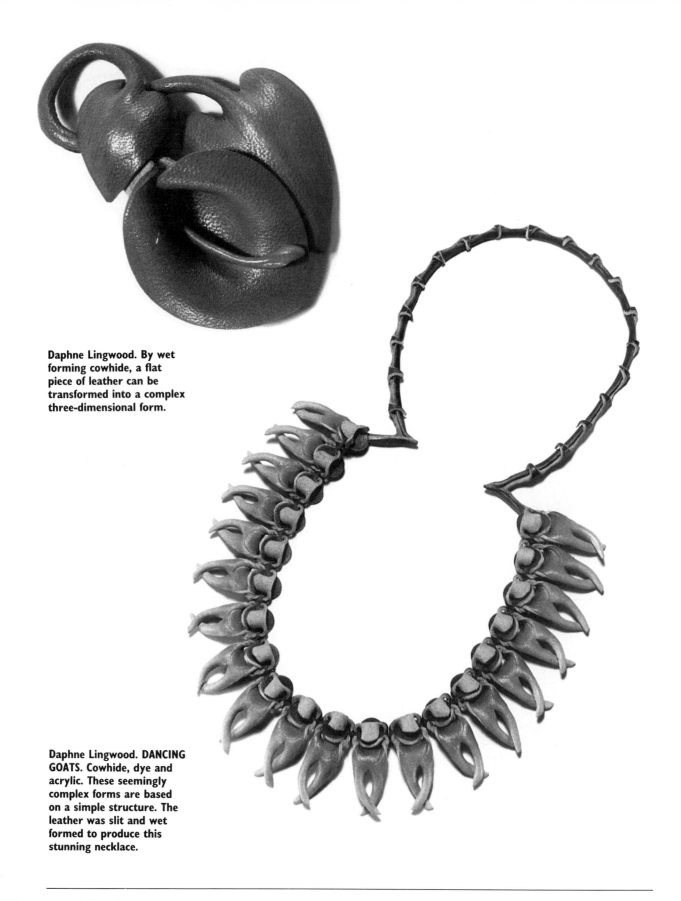

Daphne Lingwood. By wet forming cowhide, a flat piece of leather can be transformed into a complex three-dimensional form.

Daphne Lingwood. DANCING GOATS. Cowhide, dye and acrylic. These seemingly complex forms are based on a simple structure. The leather was slit and wet formed to produce this stunning necklace.

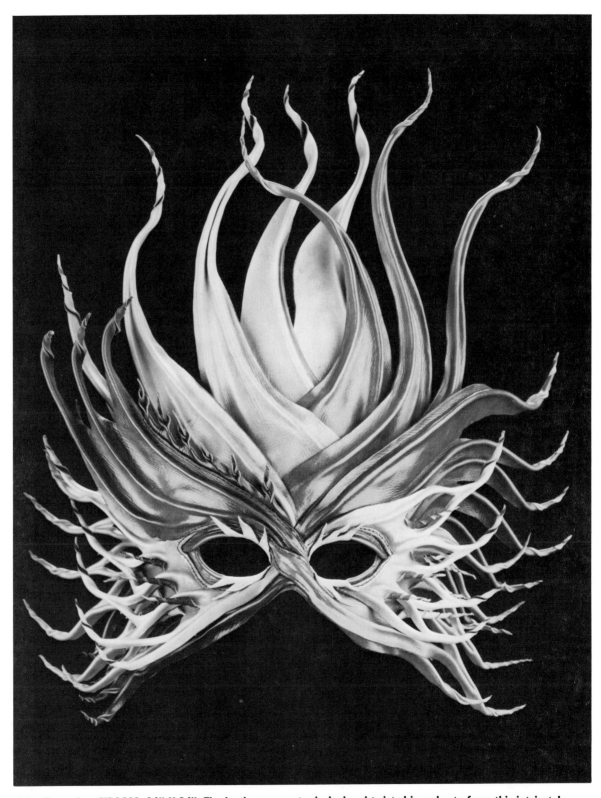

John Flemming, SIROCCO. 26" X 24". The leather was cut, pinched and twisted in order to form this intricately crafted wet-formed mask. Photo by Will Crocker.

Sid Garrison. SYNCOPATION. 1984. Deeply incised outlines and textures emphasize the design in this elegant sculptural leather vessel. Photo by Mike Carlisle.

Tooling

Various tools may be used to compress the surface of leather in order to create designs. Stamping tools made from metal rods with a designed or textured end will leave an impression in damp leather when hit with a mallet. Modeling tools with pointed, balled or flat ends may be rubbed over leather to compress and sculpt its surface. In addition to sculpting the leather, compressed leather is darker and therefore provides an element of contrast to the natural color of the leather.

When creating a relief in leather by stamping or modeling, consider the play of light over the tooled surface. Subtle variations in depth as well as sharp contrasts create the illusion of great depth, even in as thin a material as leather.

Materials. Vegetable tanned leather; a mallet; modeling tools; stamping tools; a clean sponge; bowl of water; hard, flat surface such as masonite. Optional: spray bottle, printing press.

Stamping

The impression of a rigid stamp may be transferred to damp leather by stamping. The stamp may be one of many commercial leather stamps or a found or studio-made stamp. Tools such as hammers and screwdrivers may be used, as well as stamps made from copper pipe or large-headed nails that have been filed to create a design on the head. The image is impressed into the grain side of the leather with a mallet.

Before you begin to stamp, dampen the leather with a wet sponge or water-filled spray bottle. Wet the flesh (rough) side and then the grain (smooth) side. The leather should be wet to the extent that it does not ooze water when pressed. Leather that is too dry or too wet will not hold a deep impression. If the leather dries after a period of time, it may be remoistened. Work on a smooth, hard surface.

Stamps may be superimposed, combined, repeated in a pattern or border, or used singly. Experiment with scrap leather to explore the variety of effects possible with just a few stamps.

Sid Garrison. METRO. Leather box with lid. The architectural structure of this box is enhanced by the abstract geometric composition on its surface. Photo by Mike Carlisle.

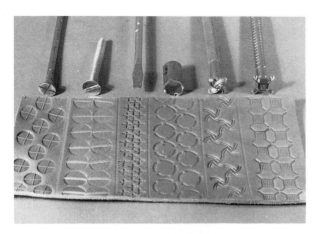

A filed nail, screw, screwdriver, filed copper pipe, and commercial stamps are just some of the tools that may be used to texture leather.

The image is stamped into the moist leather with a mallet.

A printing press or vise can also be used to make impressions. The press will transfer images from a wood or linoleum block, as well as from thin objects such as paper clips, lace or anything that will not cut the leather or damage the press. Be certain to protect the press with thick felt pads. Make tests on scrap leather to determine the proper amount of pressure for each situation.

Modeling Tools

Modeling tools are pressed by hand into pre-moistened leather to create free-form designs. Designs may be first outlined with a thin modeling tool, or cut part way into the leather with a swivel knife. The leather around the impressed or cut lines is then modeled with differently shaped modeling and stamping tools that compress and shape the leather. Realistic pictures and intricate designs may be drawn in this manner. To create a deep impression, go over a section several times, making it deeper with each pass. The thicker the leather, the greater the depth that can be achieved.

Tooling: Branching Out

+ Create a signature stamp from a thick metal rod that has been filed to shape with metal files. Use this stamp to identify your leather creations.
+ Carve a design or picture into a linoleum block and use a printing press to impress it into the damp leather. Hand color the printed image and use the resulting leather relief as part of a functional object such as a book cover.
+ Use modeling tools to create a large drawing in leather. Add texture with stamping tools, and color with inks, dyes or paint. Mount the work for hanging.
+ Create a belt that includes designs made with found stamps.

Russel Maxfield. Stamped leather belt (detail).

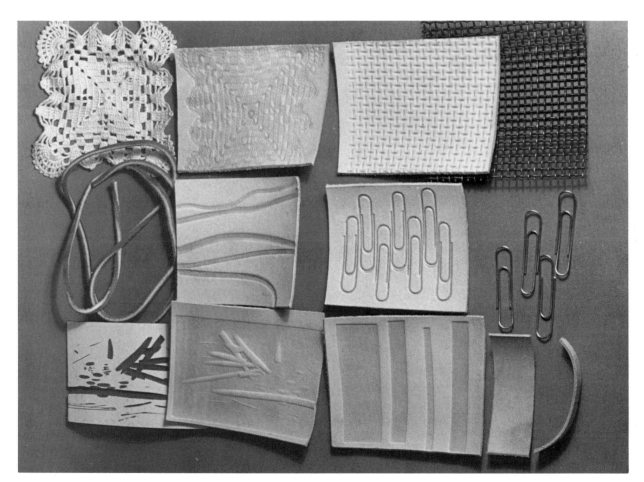

A printing press may be used to make impressions in moist leather. Prints of lace, wire mesh, a leather strip, paper clips, carved linoleum and leather scraps are shown here.

Lacing and Stitching

Leather may be joined by lacing or stitching. Lacing is made of thin strips of leather, approximately 3/32" wide. Wider lacing may be used for large projects or for decorative purposes. Waxed thread, usually linen or nylon, is used to stitch leather. The wax waterproofs and strengthens the thread and keeps the stitches from slipping. Both lacing and stitching attach leather to leather and can be used as a design element.

Materials. Paper pattern; leather; leather shears or sharp knife such as a utility knife; divider; awl, single and multi-pronged thonging chisels, or rotary hole punch; ruler; tape or paper clips; mallet; lacing and a lacing needle, or waxed thread with two harness needles; rubber cement.

Punching the Holes

Stitching or lacing becomes a simple process when holes are precut. Holes are made with an awl, thonging chisel or rotary punch and should be evenly spaced and properly aligned. A paper pattern may be drawn including the spacing for the holes, or marks to indicate hole placement may be drawn directly on the leather after the pattern pieces have been cut out.

To make a paper pattern for symmetrical work, simply fold the paper in half, draw one half of the pattern, and cut out the two halves at once. In this way the piece will be perfectly symmetrical and the holes will be even in number. Use leather shears or sharp knife such as a utility knife to cut the leather. Paper clips or tape will hold the pattern to the leather, and the holes can be punched directly through both.

A guideline for making the holes may be drawn directly on the leather by using a divider set to the distance between the edge of the leather and the holes. One point of the divider is drawn along the edge of the leather while the other point marks the distance along which you wish to make your holes.

Small holes for stitching may be made with an awl. Use a ruler or divider to mark the distance between holes along the guideline. If you are making holes in thin leather, push the awl through by hand. To make holes in thick leather, use a mallet to hit the awl.

Holes of various sizes may be punched with a rotary hole punch. The punch is squeezed at marked intervals to create round holes. Holes made in this manner are larger than holes made with an awl and are generally used for lacing.

A thonging chisel may be used to make several holes at one time. Thonging chisels come with different numbers of prongs variously sized and spaced. Choose the right chisel for the size of your project as well as the thickness of your thread or lacing. Use a mallet to hit the chisel along the guideline made by the divider. Since the chisel itself spaces the stitches evenly apart, there is no need to pre-mark each hole.

After making the first set of holes, insert the first chisel prong into the last hole and punch the new set of holes. By overlapping one prong each time a new set of holes is punched, even spacing between holes will be assured. Punch hard-to-reach corners and curves with a single-pronged chisel. Holes that are punched with a thonging chisel may be used for stitching or lacing.

A divider that has been set to the desired distance may be drawn along the edge of the leather to mark a guide line for punching or poking holes.

Small holes for stitching may be made with a mallet and awl.

A rotary hole punch will cut large holes in leather.

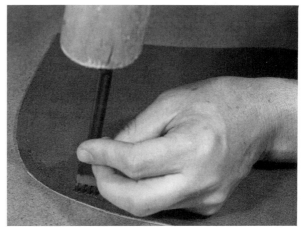

Several slits are made simultaneously with a thonging chisel.

Lacing

Lacing is usually made from leather, purchased by the spool or by the yard, or studio-made. Use leather shears (for thin leather, a sharp scissors will do) to cut your own lacing. Cut along the edge of a straight piece of leather or in a spiral pattern. Cutting in a spiral will make one continuous, long piece of lacing from a relatively small piece of leather.

If the lacing is stiff enough, it may be tapered to a point at one end so that a needle is not needed. Use a lacing needle for more flexible lacing, or apply glue to reinforce the lacing point.

There are a great variety of lacing stitches, from the simplest running stitch to more complex stitches that require several steps to create a single stitch. Following are a few simple examples. You may wish to experiment and invent your own stitches.

Lacing may be begun and ended by concealing approximately ½" under 3 or 4 stitches. An alternative method for starting thick lacing is by slitting a hole in one end, taking a stitch and threading the other end through the hole to lock it in place. Never begin or end lacing on a corner.

Hand Stitching

Harness needles and waxed thread are used for stitching. The saddle stitch is a popular stitch because it is simple, neat and strong. To make a saddle stitch, first thread a long piece of waxed thread through two needles, one at each end of the thread. Draw one needle through the first hole and both needles through each succeeding hole. The two needles pass through each hole simultaneously from opposite directions. Backstitch through the last two holes to complete the stitching. Cut the threads flush with the leather. The finished stitching will not show any spacing between the stitches.

Lacing and Stitching: Branching Out

◆ Use a pattern that you have designed to create a leather garment, handbag or wallet that is hand stitched or laced.

◆ Lace or stitch small pieces of leather onto a leather background. These appliquéd designs may be made from different colors and types of animal skins to form an abstract or realistic design.

◆ Use a variety of sewing or lacing stitches to connect scraps of leather. Create a functional object from the resulting patchwork piece.

◆ Use the running or saddle stitch to draw a design in leather. Contrasting thread will make the design stand out.

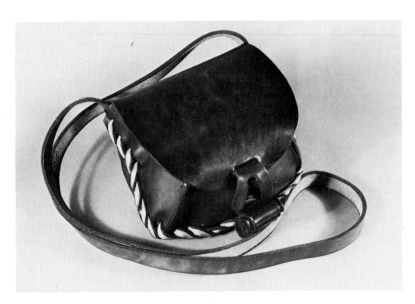

Russel Maxfield. The lacing on this bag performs both a utilitarian and decorative function.

Lacing may be cut with sharp shears.

Running stitch.

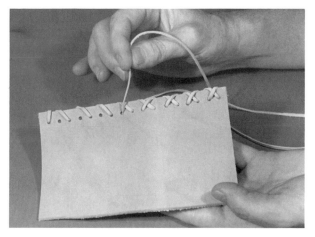

Cross stitch.

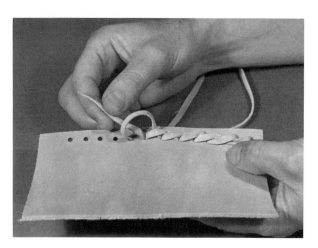

More complex stitches can be quite decorative.

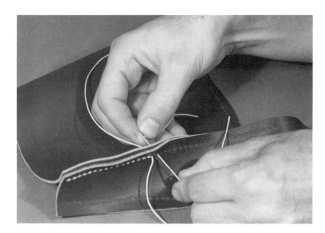

Saddle stitch.

Machine Sewing

In some ways it is even easier to sew leather than fabric. Since leather is a non-woven material, it will not unravel. A fringe may be cut and left unbound, and hems are generally glued rather than sewn. Leather is intrinsically beautiful and is best shown off in a simple garment. Ordinary fabric patterns, if suited for thick materials, may be used as is or altered. You may wish to create your own pattern on brown kraft paper. Avoid designs with bulky details such as tight gathers or many seams.

Materials. Light- or medium-weight leather, tape or pins, a pattern, sharp scissors, sewing machine, cotton-wrapped polyester thread, rubber cement, rawhide mallet.

Cutting Out the Pattern

Patterns may be marked on the leather with chalk, or taped or pinned in place and then traced. Pin only in areas that will not show in the completed garment since pins make permanent holes. Leave a 3/8″ seam allowance. Since leather does not unravel you may get away with a smaller seam if you are just shy of the amount of leather needed. Cut out the leather with a sharp scissors or a leather shears.

Sewing

Any light- or medium-weight leather may be sewn on most modern home sewing machines. A #11 wedge-point needle is recommended for light-weight and a #14 for medium-weight leather. The stitch size should be set at no more than twelve stitches per inch. Too many stitches in a small area will create perforations which will weaken the leather and cause it to tear. Always test the stitch size and thread tension on a scrap of leather before working on the actual garment. Tie thread ends together rather than backstitching to avoid piercing too many holes.

Nick Swearer. Eagle created from leather scraps and a suede glove. Courtesy of Robert Campbell.

Finishing

After a seam is sewn, it may be glued open and flat with rubber cement. Use a rawhide mallet to flatten bulky areas. Cut notches into seams along curves before glueing to help ease the leather flat. Be careful not to cut across the seam stitching. Glue rather than sew leather hems.

Machine Sewing Leather: Branching Out

◆ Use a commercial pattern that you have modified to create your own unique leather fashion.

◆ Appliqué leather onto a background of leather and create a fashion accessory such as a handbag, belt or tie. Be sure to sew the appliqué before attempting to sew the pattern pieces together.

◆ Sew your leather scraps together to create a leather patchwork creation.

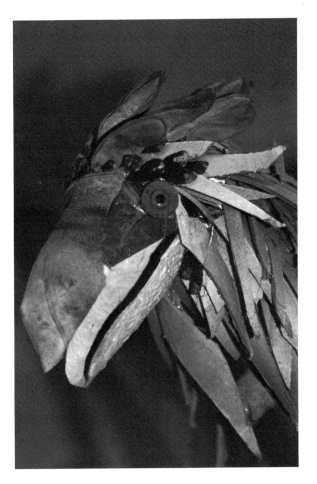

Transferring the pattern onto the leather.

Cutting the leather.

Machine sewing the leather.

Rubber cement is used to glue the sewn seams open.

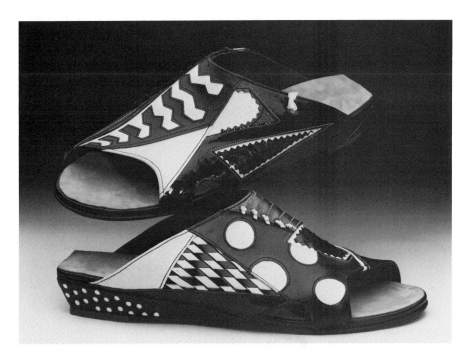

Gaza Bowen. SATURDAY FUNNY PAPERS. 1983. Leather with plaitings, inlay, overlay and knotting. Courtesy of the artist.

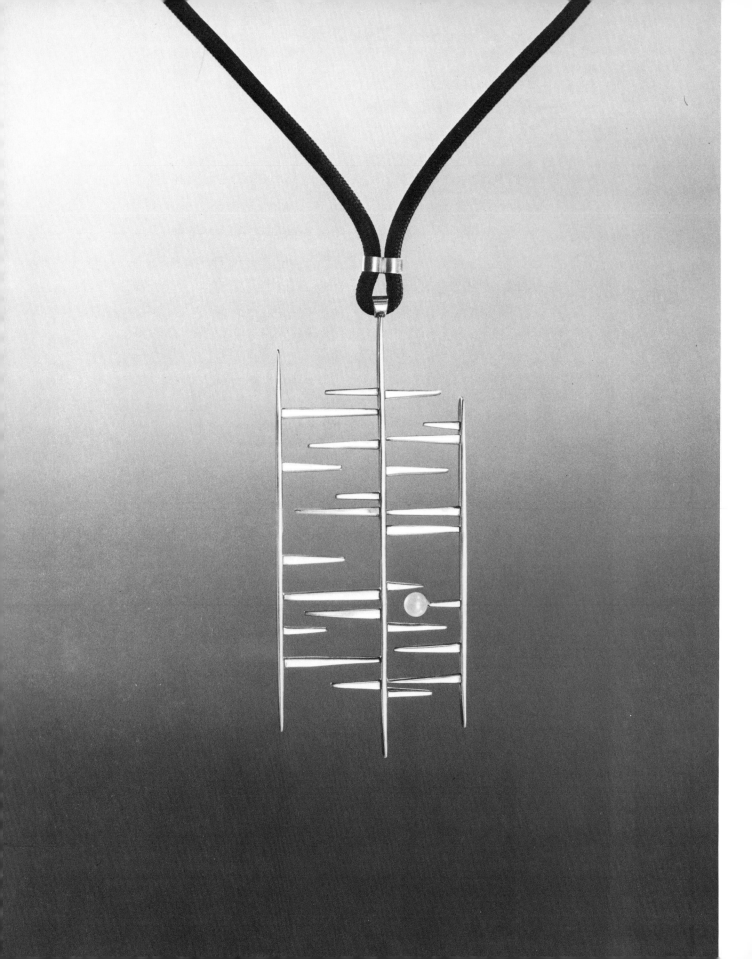

6 · METAL

Metal evokes many images, from the romantic knight in shining armor to the richness of the golden egg and the strength of a steel-girdered skyscraper. Its diverse qualities make metal a highly functional and aesthetic material. It has been used since prehistoric times. Today metal surrounds us in numerous forms, be it a coin, nail, knife, piece of jewelry, airplane, electrical wire or sculpture. Although other materials such as plastic have replaced metal for some functions, it is still a prized material.

Metals comprise much of the earth's substance. Most metals that we use exist in nature in the form of ores. Metal is extracted from its ore and manufactured into useful forms including sheets, wire, tubing, grain and ingots. It can be cast into any shape as well as soldered, twisted, bent, stretched, compressed, woven and textured.

Metals are so varied that it is hard to categorize them. Each metal reacts differently when subjected to heat, hammering, bending, polishing, sawing or other factors and operations. Metals may have high or low melting points. They may be brittle or malleable. Some are scarce and in great demand, while others are abundant and inexpensive.

Two or more metals may be combined to create a new metal with some of the desirable qualities of both. Such a combination is called an *alloy*. Brass, bronze, pewter, sterling silver and nickel silver are examples of alloys.

You do not need elaborate tools or expensive metal to make exciting metal jewelry or small sculptures. The projects in this chapter are designed to teach the techniques of working in metal without requiring a large investment in tools and materials. Copper, brass, sterling silver and gold are all suited for jewelry making. They are available in sheet, wire and tube form. These metals, as well as jewelry making tools, may be purchased at a jewelry supply store. The less expensive metals, brass and copper, are also available at most hardware stores.

Sheet metal is supplied in different gauges ranging from the thinnest foil to thick sheets. The higher the gauge, the thinner the metal. 20- or 18-gauge sheet metal is recommended for most jewelry projects. A thinner gauge is more suited for jewelry, such as earrings, where the strength afforded by thicker metal can be sacrificed for lightness and lower cost.

Wire is also available in different gauges as well as shapes. Square, rectangular, round and half round wire may be twisted, bent, coiled or used as a line element in a design.

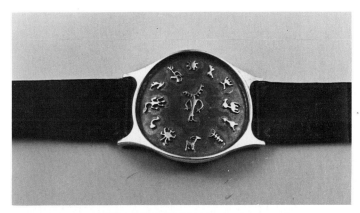

Julian Wolff. The horizontal and vertical linear elements in this classic piece were joined by butt soldering. Photo by Charles Uht.

Harold O'Connor. PETROGLYPH TIME. This timeless watch is made from sterling silver and 18-karat gold.

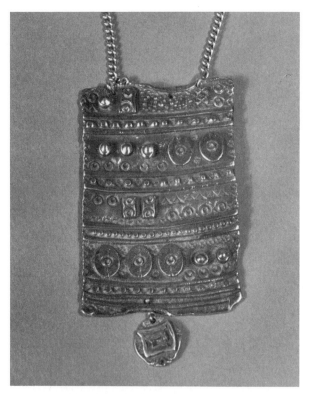

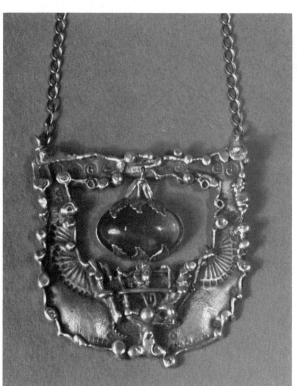

Texturing Metal: Stamping

A simple method of texturing metal is to stamp patterns, textures and designs into sheet metal. Metal stamps made specifically for this purpose are available at most jewelry supply stores. Some stores carry a large selection of stamps, particularly in Southwestern United States where American Indians use many stamped motifs in their jewelry making. Found stamps such as a screwdriver or nail may also be used, as well as jewelry tools including dapping and letter punches. Virtually anything that will leave an impression on metal when hit with a hammer is appropriate. Even the hammer itself will create impressions when the head is struck repeatedly against the metal. Patterns may be used as borders, overall texture, or a picture may be stamped using a line or dot stamp.

Materials. 18-gauge sheet metal; a metal straightedge; scribe; metal shears; hammer; stamping tools; anvil or polished steel plate; wooden or rawhide mallet.

Stamping

Begin by experimenting with the stamping tools to create various textures and patterns. Cut the metal sheet with a shears by cutting along a scribed line. A straight cut may be made by drawing the scribe along a metal straightedge and using that as your cutting guide.

Should the metal become distorted, it may be flattened with a mallet. The mallet is made from a soft material such as wood or rawhide and, unlike a hammer, will not mar the surface of the metal.

Stamp with the metal sheet supported on a smooth metal surface such as an anvil or steel plate. Hold the stamp with your hand braced against the metal, and strike the stamp squarely with a hammer. Try rotating or overlapping the stamped images. When you are able to stamp clear images and produce a pleasing pattern, you are ready to work on your final piece.

These two pendants by Bebe Duche are textured with many different stamps collected over the years.

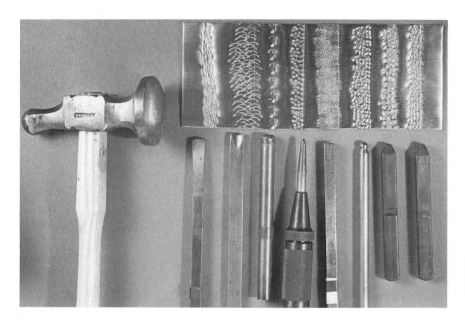

Each tool will make a unique impression when it is hammered into the metal to create a pattern.

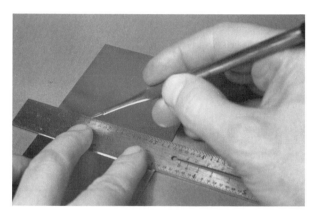

Scribe a line into the metal before cutting.

Use shears to cut along the scribed line.

Metal may be flattened by hitting it with a mallet.

With the fingers braced on the metal, hit the stamp with a hammer.

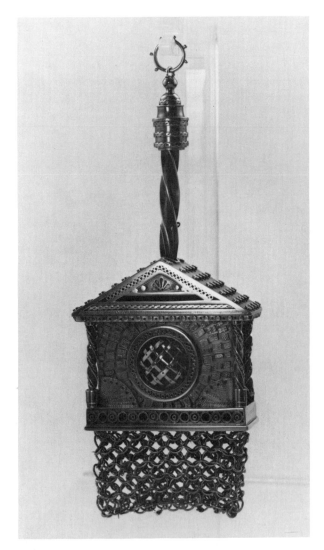

Peggy Simmons. COIN BANK. Sterling, 14-karat gold. An architectural motif dominates the elements in this fascinating piece.

To twist, the wires are held at one end in a vise and at the other end in a hand drill in which a cup hook has been tightened.

Twisting and Braiding Wire

By braiding and twisting, wires may be combined to create patterns, combinations of colored metals and wide bands. Any number of wires may be twisted or braided together. The finished product may be formed into a piece of jewelry such as a bracelet, or used as an element in a larger piece.

Materials. Flexible wires of different gauges, shapes and metals; wire cutters; a hammer; steel plate or anvil; bench vise; hand vise, or hand drill into which a cup hook has been tightened.

Twisting Wire

Choose a wire or combination of wires to be twisted. A single strand of square, rectangular, half-round or triangular wire may be twisted; however, round wire requires two or more strands to show a twist. Wires may be twisted once and then combined with a different type of wire and twisted again for interesting results. Wires may also be twisted and then separated to create wire that undulates in a regular pattern.

To twist more than one wire together, make certain that they are equal in length. Allow extra length to compensate for the amount that is taken up in twisting. The tighter the twist, the shorter the wire will become. Tighten the wires at one end in a bench vise. If the wires are different thicknesses and cannot be easily grasped in the vise, hammer each end against an anvil or steel plate until they are all equal in thickness. Hold the other ends in either a hand drill or a hand vise. Thin wires will twist easily in a hand drill. For thicker wires, you will need the strength of a hand vise. Twist by turning either the drill or hand vise. Pull gently as you twist and make the twist as tight as you wish.

Braiding Wire

Braiding is done with a minimum of three wires of equal length. Patterns may be created by using differently colored metals. The more wires you use, the wider the resulting band.

To braid, hold the wires, evenly spaced, in a bench vise. Working from right to left, braid the first wire over and under the wires to its left. Repeat, beginning again with the first wire on your right and weaving over and under to the last wire (which was the first wire in the previous row). Note that you always begin by braiding over the first wire to the left. Thus successive rows alternate an over and under pattern. Continue until you have braided the desired length.

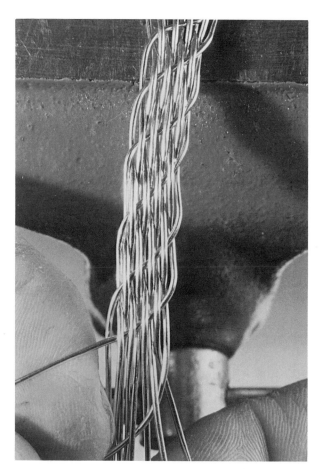

Braided wire.

Sawing and Piercing

The technique of sawing designs in sheet metal allows you to create any shape, from a basic circle to the most intricate design. Forms may be sawed out of sheet metal and left solid, or pierced with thin or thick lines, dots or shapes. You are limited only by your imagination. When working on a design, consider the positive and negative shapes created by piercing, as well as the outer contour of your piece.

Sheet metal is cut with a jeweler's saw. The blades used in this saw come in a variety of sizes and are very fine. Although easily broken, they make it possible to saw in minute detail: the thin-

Peggy Simmons. This bracelet of sterling silver, 14-karat gold and Delrin incorporates both positive and negative (pierced) decorations.

ner the blade, the thinner the sawed line, and the greater the possible detail.

Materials. 18- or 20-gauge sheet of nickel silver, brass, copper, sterling silver or gold; a pencil; tracing paper; a scissors; rubber cement; metal shears; masking tape; a jeweler's saw with at least 1 dozen saw blades (**#**1 or **#**2 are recommended for beginners); hard wax or a piece of soap; a hammer; nail or center punch; hand drill or pin vise, with 1/16" bit; V-board with clamp; wooden or rawhide mallet; half-round medium cut metal file; needle files: round, half-round and flat; wet or dry paper: **#**240, **#**320, **#**400 and **#**600 grits; crocus cloth; tripoli; rouge; two polishing sticks or a polishing machine with two buffs; water; ammonia; liquid detergent. Optional: a jump ring and two chain-nose pliers.

Preparing for Sawing

Begin by drawing your design on tracing paper. Use rubber cement to adhere it to the metal. Apply the cement to both surfaces to be joined and allow them to dry to the point where they become tacky before putting the paper onto the metal. Saw directly through the paper and metal.

Use a shears to cut the metal to the general size of the design. Do not attempt to cut out the actual design with the shears. If the metal becomes distorted during the working process, it may be flattened with a mallet. Hit the metal flat against a smooth, hard surface.

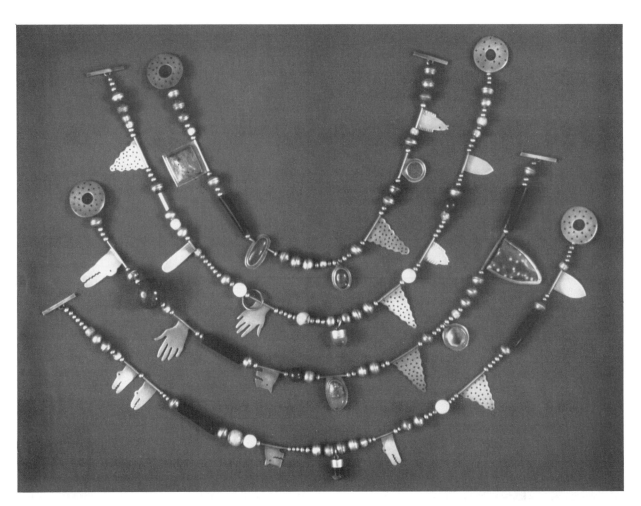

Roberta Williamson. Necklace of sterling silver, lapis, carnelian, glass, black coral, ivory, moonstone, sodalite, tiger eye, turquoise and shell. The silver charms on these fanciful necklaces were made by sawing and piercing.

Piercing

Since it is easiest to maneuver the saw when working on a larger piece of metal, it is generally advisable to saw internal shapes before you saw the outer edge. A hole is drilled in each internal shape to accommodate the saw blade. Use a nail or center punch to tap a dent wherever you wish to drill to prevent the drill from slipping on the metal. Insert the bit into this indentation and drill.

When the holes are drilled, you are ready to begin sawing. The blade is inserted, under tension, in the saw frame with the teeth pointing outward, and down toward the handle. Load the saw frame by first inserting the blade in the top clamp and tightening the clamp. Adjust the saw frame to a length 1/4″ shorter than the blade. Next, insert the blade into the hole that you have drilled in the metal and rest the metal at the top of the blade. Press the saw frame against the edge of the work-bench and tighten the blade, with the saw frame under tension, in the bottom clamp. If the blade is taut, it should have a high pitch when plucked. You may wish to lubricate the back of the blade with hard wax or a piece of soap. Large pieces of broken blades can be reused by adjusting the saw frame to accommodate the smaller size.

Hold the metal firmly against the V-board that is clamped to a table and begin to saw. Be certain to hold the saw blade at right angles to the metal. Do not exert a great deal of pressure on the blade for it is easily broken. Curves are most difficult and must be turned gradually. Quick changes in direction will cause the blade to break.

The design is glued onto the metal in preparation for sawing.

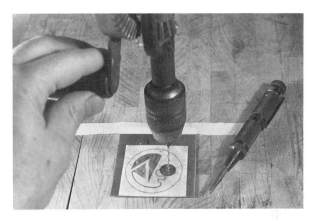

After dents are made with a center punch or nail to prevent the bit from slipping, a hole is drilled in each internal shape to be sawed.

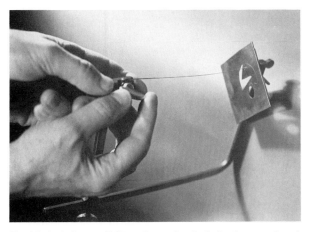

The blade is inserted first through a hole in the metal and then in the saw frame.

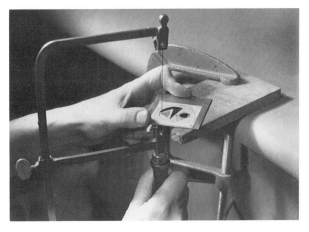

Saw gently, at right angles to the metal.

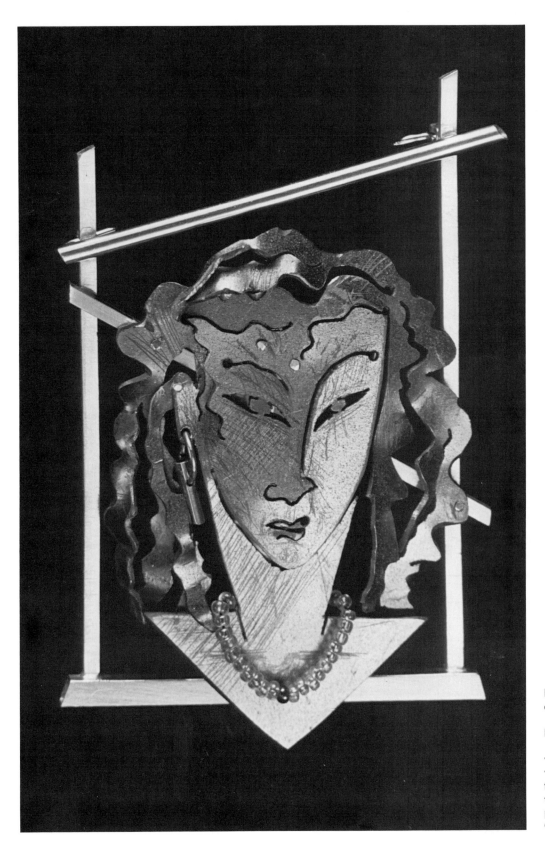

Enid Kaplan. JENNY. Brooch of sterling, niobium, 14-karat gold, mylar, glass beads. 2" X 2½" X ¼". 1985. The artist started out with a flat piece of metal which she sawed, pierced, folded and bent to create this three-dimensional portrait. Photo by Michael Grimaldi.

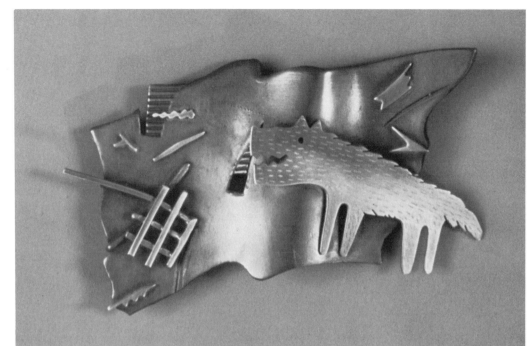

Roberta Williamson. I LOVE THE WAY THE WIND BLOWS THROUGH MY HAIR. 2½" X 2". 1983. The dog and floating objects on this copper and sterling silver brooch were sawed and sweat soldered to the background metal.

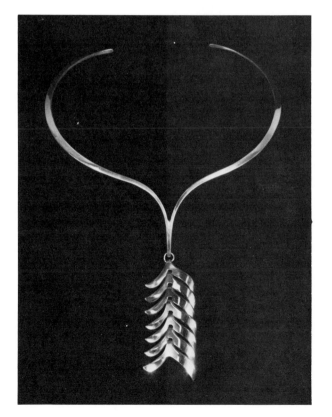

Dominic DiPasquale. Bracelet and neckpiece set, of sterling silver. The interlocking pierced pieces add an element of movement.

Filing

To refine and smooth the shapes that you have sawed, use files shaped to fit the contour of the edge. For small areas, use needle files. For larger areas, a half-round metal file will be more efficient. File with pressure on the forward stroke. Files should be cleaned with a metal file brush when they become clogged.

Sanding and Polishing

To further smooth the surface and edges of the metal, use progressively finer grits of wet and dry paper. Work from #240, #320, #400 to #600 grit paper. Do not proceed to a finer grit until the metal is sanded as much as possible with the rougher paper. The final sanding is done with crocus cloth. At this point the metal should be quite shiny and free of scratches.

Although it is not necessary, a high polish may be achieved by using polishing compounds. Tripoli is used first, and then rouge. Rub the compound across the metal surface with a polishing stick that has been purchased, or made from a flat 1″ x 10″ stick of wood to which a strip of felt or suede has been glued. Use a separate stick for each compound. An electric polishing machine may also be used for polishing.

After polishing, wash the piece in water with a dash of ammonia and detergent added.

Finishing

The pierced work may be made into any type of jewelry. However, a pendant requires no soldering and is therefore suggested for the first pierced project.

To hang a pendant, drill a small hole in the top of the piece to accommodate a jump ring. Use two chain-nose pliers or one pliers and your fingers to open the jump ring. Always open and close the ring by twisting the ends sideways rather than pulling them apart. After you have attached the ring, thread it on a chain, leather thong or silk cord.

Files of various sizes and shapes and a file brush for cleaning clogged files.

Refining the shapes with a file.

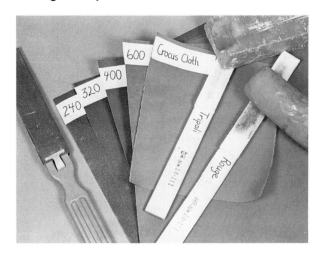

Sanding and polishing materials.

After sanding with progressively finer grades of wet and dry paper, the piece is hand polished with tripoli, and with rouge, if a high shine is desired.

Soldering

Soldering is one method of joining metals. Solder is an alloy which melts at a lower temperature than the metals which it is joining. A torch is used to melt the solder between the metals, thereby joining them.

Solder

Hard solder is available in many forms including wire, sheet and powder. Wire and sheet are most commonly used and can be purchased at a jewelry supply store. Sheet solder is cut into tiny pieces with a small shears. Wire solder is used uncut or is cut with a wire cutter.

Hard rather than soft solder is used for making fine jewelry because it is strong and will not tarnish to the extent of soft solders. Silver and gold

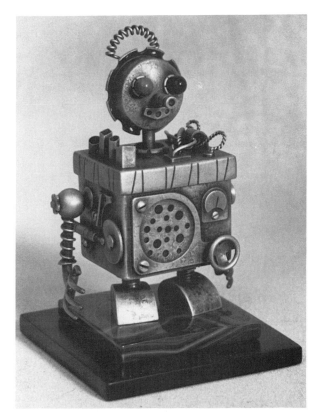

Earl Krentzin. ROBOT BOX. Sterling, malachite, ebony, carnelian, sodalite. 4" tall. Over fifty pieces of metal were soldered together to construct this elaborate box.

solders are available in a variety of alloys which melt at different temperatures for specific situations. Because of its relatively low cost and versatility, silver solder is most commonly used.

Silver solder is an alloy of silver, copper and zinc. It is available in easy-flo, easy, medium and hard grades, with melting points that range from approximately 1145°–1425° F (618°–774° C). The different grades of solder allow several soldering operations on a single piece, using solder with progressively lower melting points. The harder solder will not reflow when the solder with a lower melting point is used. Thus, on a piece where you plan to solder three times, you would first use hard, then medium and then easy solder. Easy-flo is used mainly for repairing jewelry. Silver solder is compatible with all the metals mentioned in this chapter. **CAUTION: Do not use solder that contains cadmium, sometimes used as an alloy to make silver solder. Cadmium is toxic.**

Flux

Flux is used to protect the metal from forming oxides while soldering. Although it is advisable to flux an entire piece before soldering, the specific areas to be soldered must always be fluxed. Fluxes are available at a jewelry supply store in liquid and paste form. One popular brand of hard solder flux is Handy Flux.

Torches

Although professional jewelers often use large, double tank torches such as the oxygen-gas torch, a single tank Prest-O-Lite (acetylene) torch, or even a simple, inexpensive propane torch with a disposable tank may be used. The propane torch is difficult to handle and will not produce enough heat for large pieces; however, it is adequate for the beginning jeweler who does not wish to invest in a large torch. A propane torch can be purchased at most hardware stores. **CAUTION: Do not allow a torch to fall. Large torches should be chained to a stable object. Keep torches away from heat and fire. Tank leaks may be detected by brushing soapy water onto the torch joints and checking for bubbles that would indicate escaping gas. Store a leaky tank outdoors until it can be fixed or replaced.**

Pickle

Pickle is an acid solution used to remove dirt and oxides from metal before and after it is soldered. Only clean metal may be soldered effectively. **Although strong acids such as sulfuric and nitric are sometimes used for this purpose, they are highly toxic and are not recommended.** Sparex, a commercially prepared pickle, is safer and will do the job well. Sparex is mixed with hot water in the proportion indicated on the package. Hot Sparex is a great deal more effective than cold. It should therefore be heated in a Pyrex container over a hot plate or in a ceramic-lined slow cooker. Use only copper, brass or stainless steel tongs (never iron or steel) to remove the metal from the pickle. **CAUTION: Do not allow the pickle to boil. Pickle fumes are toxic. Always cover the pickle immediately after use. Avoid contact with skin.**

General Precautions to be Taken When Soldering

 ✦ **Use local exhaust ventilation in the soldering area.**
 ✦ **Refrain from eating or smoking in the studio.**
 ✦ **Wash hands frequently when working.**
 ✦ **Keep a Class ABC fire extinguisher in the studio.**
 ✦ **Do not wear loose clothing or jewelry when working.**
 ✦ **Keep the workshop uncluttered and clean to avoid accidents.**
 ✦ **Do not use asbestos in any form. Substitutes are available from most large jewelry supply companies.**

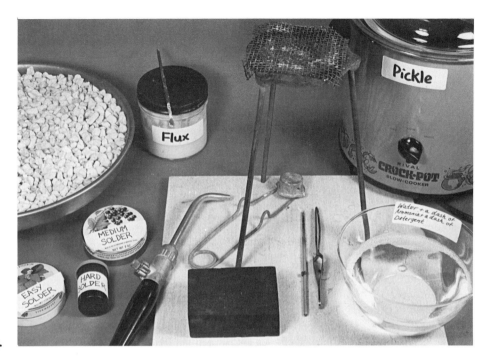

Materials for soldering.

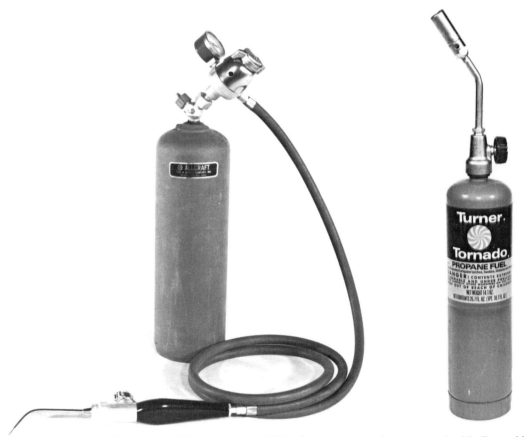

Prest-O-Lite torch. Photo courtesy of Allcraft.

Propane torch with disposable tank.

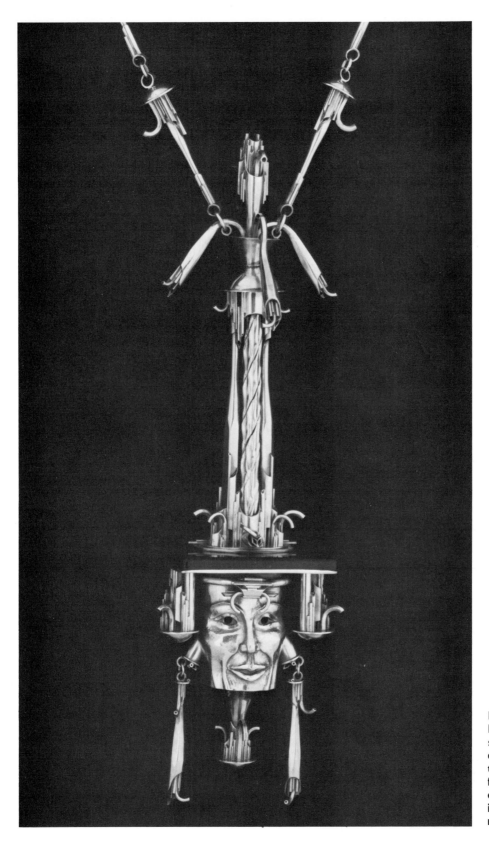

**Richard Mawdsley.
HEADRESS #2. Pendant of
sterling silver and black
onyx. The artist soldered
together tubing, wire,
formed sheet metal and a
cast form to create this
intricate, unified piece from
many diverse elements.**

Butt Soldering

When two wires or sheets of metal are soldered together, edge-to-edge without overlapping, the process is called butt soldering.

Materials. Metal to be soldered; files; pickle; copper tongs; torch; flux; small brush; silver solder; wire cutters if you are using wire solder or small shears if you are using sheet solder; tweezers; soldering pick; annealing pan or fire brick surface on which to solder; water; ammonia; liquid detergent; sanding and polishing materials.

Preparing the Metal for Butt Soldering. All surfaces to be butt soldered should fit squarely together. File the metal so that it offers as much surface for soldering as possible. Thus, wire ends should be filed flat before soldering. If you are soldering the ends of a twisted bracelet, be certain that the twist is continuous at the seam. In addition to fitting flushly together, surfaces should firmly butt against one another. When soldering a bracelet, for example, hold the ends together under tension by pushing them past one another and then springing them back together.

Soldering. After pickling and rinsing the metal to be certain that it is clean, brush flux onto the entire piece and the solder. Rest the metal on the soldering surface so that it is held securely and apply the solder, with a brush, to the inside of the joint. Very little solder is necessary. The perfect soldering job leaves little, if any, excess solder, avoiding unnecessary filing to finish the piece.

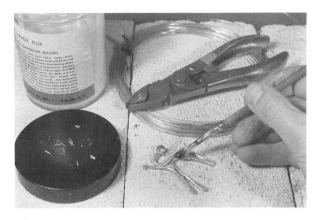

After the metal is cleaned and fluxed, solder is placed on the joints with a small brush that has been dipped in flux.

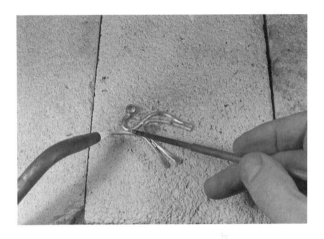

Melt the solder with a torch. A soldering pick is helpful for manipulating solder while heating the metal. Remove the torch immediately after the solder melts.

Earl Krentzin. SCIENTIST. Sterling, walnut. 5" tall. The materials in this work are ingeniously combined to portray a humorous scene.

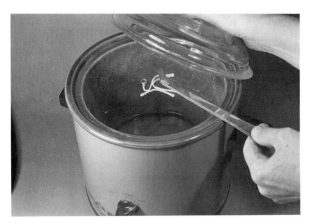

Use copper tongs to remove the cleaned piece from the pickle. After pickling, the metal may be polished by hand or with a polishing machine.

Heat the joint directly with the torch. The inner cone of the flame should be near but not touching the metal. Heat the metal rather than the solder since the metal must reach the flow temperature of the solder in order to adhere to the solder. The solder will flow towards the heat. It is therefore possible to direct the flow of the solder by moving the torch.

A soldering pick may be used to coax the solder over a seam when the solder is in the molten state. Remove the torch immediately after the solder flows. Do not overheat. When the metal turns red-orange, it is close to melting. Handle hot metal with soldering tweezers.

If you are having trouble soldering, be certain that: there are no gaps in the joint, your metal is clean, the flux has been applied thoroughly over the entire joint, and sufficient heat has been used.

After the metal has air cooled, immerse it in the pickle. Use copper tongs to remove the clean metal from the pickle. Rinse the pickle off in running water. Remove excess solder with files. Use a file that conforms to the contour of the metal. Use small files (needle files) for hard-to-reach surfaces. Use wet and dry paper and then polishing compounds to sand and polish the metal. (See Sanding and Polishing above.) Wash the polished piece in water with a dash of ammonia and detergent added.

Sweat Soldering

Two overlapping sheets of metal are soldered together by a process known as sweat soldering. Solder is melted between the two sheets of metal by heating the work from below with a torch. The two sheets may be of different sizes, and either left solid or pierced. Pierced designs in the top layer will expose sections of the bottom layer producing the effect of depth. Each layer may be made from a different metal for color contrast.

Materials. The materials for sweat soldering are the same as those used in butt soldering with the exception that a tripod with a wire mesh screen is used to support the metal while soldering. In this way, it is convenient to heat the metal from below.

Soldering. Begin by pickling and then fluxing all surfaces to be soldered. Place the top piece face down on the wire mesh and tripod. The tripod should be resting securely on the soldering surface. Use a small brush that has been dipped in flux to lay the solder on the exposed surface of the metal. Heat the metal with the torch directed downward until the solder melts. Spread the molten solder evenly over the entire surface with a soldering pick. Use just enough solder to coat the metal with a thin layer. Remove the torch.

Next, holding the metal with tweezers, position the top layer over the bottom layer, inner surfaces together. Heat them, directing the torch upward from below. To avoid overheating thin areas, aim the torch at the largest sections of metal. Since the bottom layer is usually solid, heat mainly from below. Some heat may, however, be directed from above. The aim is to heat all of the metal to the temperature at which the solder flows, at the same time.

When the solder begins to flow, press the top layer down with tweezers so that it makes good contact with the bottom layer. When the solder is visible as a shiny liquid around the edges, withdraw the torch immediately.

Allow the metal to air cool before cleaning it in the pickle. Rinse in water. Any dirt and oxides that have not been removed in the pickle may be filed and sanded off. Polish as described above.

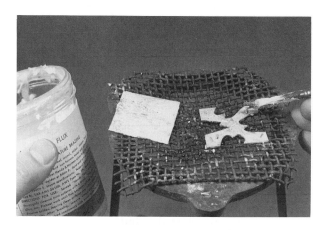

The piece is fluxed and solder is distributed over the surface.

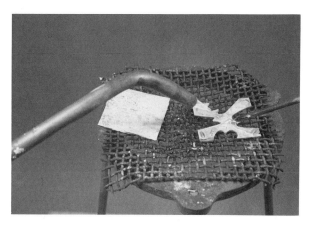

Spread the melted solder evenly over the entire surface with a soldering pick.

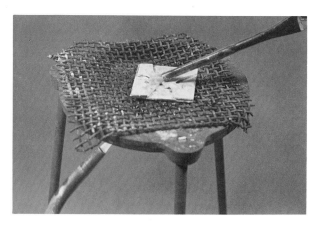

The top layer of metal is then positioned over the bottom and heated mainly from below until the two layers are soldered together.

The completed piece, after filing, sanding and polishing.

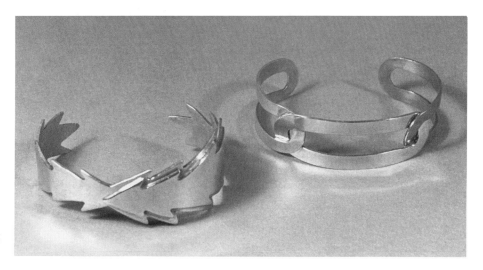

Student work. Two bracelets created by sawing and soldering.

Harold O'Connor. NEIGHBORHOOD WATCH. Cast and fabricated from silver and titanium. 30 X 30 X 7mm. 1983. The small overall size of this piece has not inhibited its detail.

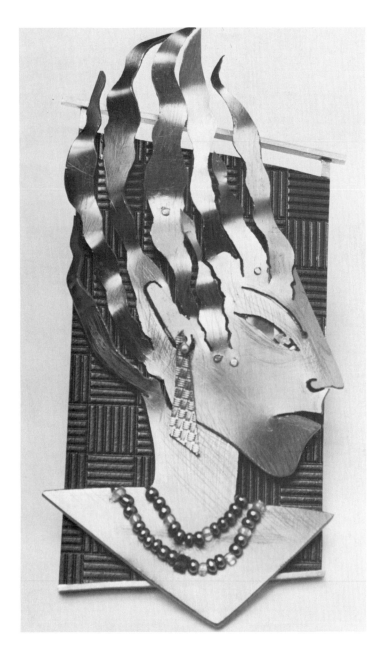

Enid Kaplan. ESMERALDA. Brooch of sterling, niobium, brass, mylar, paint and beads. 2" X 3" X ¼". 1985. The energy and character portrayed in this piece are enhanced by the artist's direct methods of working in metal. Photo by Michael Grimaldi.

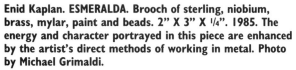

Victor Coochwytewa. (Hopi Pueblo). 1965. This silver and turquoise brooch was made in two layers. The top layer was pierced, sawed and sweat soldered to a solid disc of silver. Photo courtesy of the U.S. Department of the Interior, Indian Arts and Crafts Board.

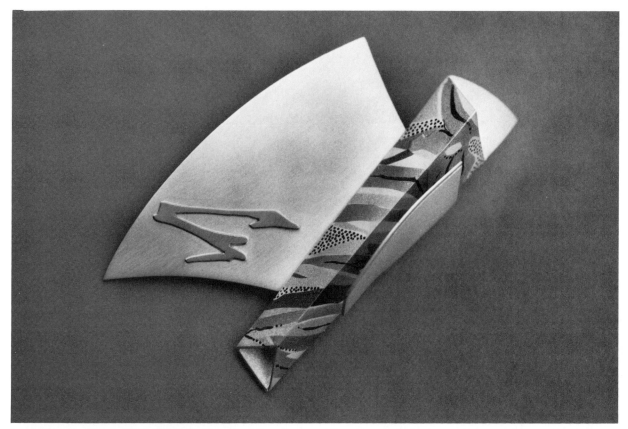

Lynda Watson-Abott. NEW START #5. Brooch of fine silver, sterling silver and 18-karat gold. Sandblasted and colored with permanent markers that were fixed with marker fixative and then waxed. 1½" X 2½". 1985. The two contrasting large forms complement one another while the colored surface designs add excitement to the work.

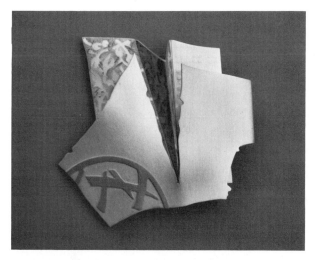

Lynda Watson-Abott. NEW START #1. Brooch of fine silver, sterling silver and 18-karat gold. 2½" X 2¼". 1985. The sawed metal design on the left-bottom of this piece was sweat soldered to the solid background. Photo by the artist.

Sawing and Soldering: Branching Out

+ Combine the techniques of butt and sweat soldering in a single piece. Pay careful attention to the design elements of line (wire) and form (sheet).

+ Try sawing out a shape and piercing it with drill bits of various sizes. The resulting pierced circles may be used to create a design or overall pattern.

+ Using as much detail as possible, pierce a still life, landscape, figure or animal design from a sheet of metal. You may wish to add details by texturing or soldering on small elements.

+ Saw a number of complementary shapes from a piece of sheet metal and use all of the resulting forms, both negative and positive, to create a piece of jewelry or small sculpture.

+ Use the method of sawing and piercing to make a functional object such as a moustache comb.

TANANA

7 · SCRIMSHAW

Scrimshaw originated on whaling ships when sailors were at sea for years at a time in search of the sperm whale. In their idle hours, they took to scratching designs into whale teeth with a sailmaker's needle. They filled the incised lines with black carbon from the oil lamp. The black emphasized the thinly incised design. These delicate drawings on ivory were usually based upon the themes of their voyages such as ships and whales. Scrimsaw gifts fashioned for loved ones back home included jewelry, pie crimpers, corset stays and letter openers.

Today, ivory is scarce and its use restricted. Most craftspeople make scrimshaw from substances other than ivory, including plastic, ivory nut and common cow bone. Cow bone is an excellent substitute for ivory and can be obtained from a butcher at little or no cost. It may be finished to a surprisingly refined surface.

Materials. To make scrimshaw from cow bone you will need a beef shank bone with the knuckles sawed off; a small knife; large pot; water; a hot plate; alum; baking soda; a hand saw such as a hacksaw or jeweler's saw, or an electric jigsaw or band saw; file; 220, 320, 400 and 600 grit wet and dry paper; toothpaste; a soft cloth; paraffin; a coffee can and pot of water in which the can may be heated; a pencil; sharp sewing needle supported in a pen holder, or any sharp, pointed implement; drawing ink or oil paint; a fine brush. If you wish to make a pendant from your scrimshaw, you will need a drill and a leather thong, silk cord or other material from which to hang the pendant.

Eskimo incised walrus tusk (detail), attributed to Happy Jack, ca. 1880. Native Alaskan carvers may have learned scrimshaw techniques from visiting American sailors. The reverse side of this tusk is a cribbage board. Collection of C.W. Mack and J.R. Mack.

Rhoda Goldstein. Scrimshaw on ivory. The hard-edged circular border centers the eye on the soft edges of the main image.

Preparing the Bone

The bone must be thoroughly cleaned, inside and out, with a small knife, in order to remove as much meat, grizzle and marrow as possible. Next, boil the bone for 1 hour in a pot of water with a tablespoon of alum and a tablespoon of baking soda added. It is best to work outdoors on a hot plate to avoid the unpleasant odor from this brew. Boiling the bone in this solution will tighten the grain and lighten the color leaving a white, strong surface on which to work.

If you are preparing more than one bone, it may be necessary to change the water several times and to boil the bones for a longer period to remove the extra fat.

When the bone is clean and dry, examine it and choose the most pleasing areas on which to work. Consider the curvature of the from as well as the tightness of the grain. Use a saw to cut the bone into the desired shapes.

To smooth areas of the bone that are still rough and to further define the shape, use a file or an electric sander. An electric sander will make this tedious task a great deal easier. Next, sand the bone with wet and dry paper, working from the roughest (220 grit) to progressively finer paper (320, 400 to 600 grit). Be certain to smooth the surface as much as possible with each grade before proceeding to a finer grade. After using the 600 grit paper, the bone will be smooth and shiny. The final high polish is created with toothpaste. This fine abrasive is rubbed over the surface with a soft cloth.

Seal the bone with melted paraffin so that the pigment will not penetrate areas unless they have been incised. Soak the bone in a pot of melted paraffin for a few minutes. A simple and safe set-up for melting paraffin is in an improvised double boiler. Use a coffee can placed in a pot of water heated on a hot plate. When you remove the bone from the paraffin, wipe off any excess wax. **CAUTION: Do not overheat wax. Wax must not be allowed to smoke. Overheated wax produces harmful fumes and may explode. Always melt wax in a double boiler. Avoid direct heat.**

Pendants by the author. Scrimshaw on bone.

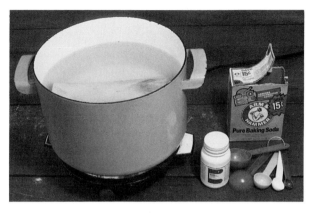

The cleaned bone is boiled in a solution of baking soda and alum to tighten the grain and lighten the color.

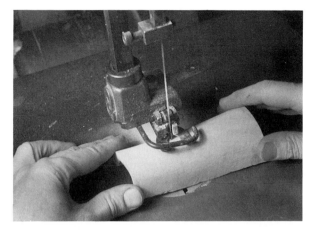

A jigsaw is a helpful machine for cutting bone. Hand saws will do the job too.

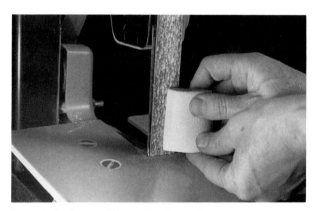

Smooth the bone with an electric sander . . .

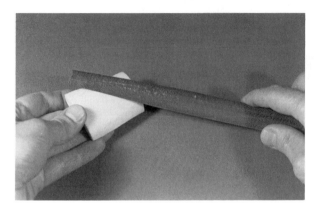

. . . or a file.

Sand all surfaces with wet and dry paper of progressively finer grits, and polish with toothpaste.

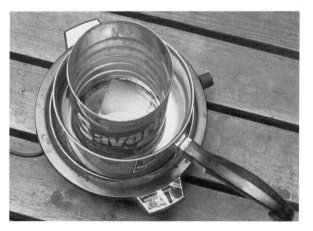

Soak the bone for a few minutes in melted paraffin.

Draw the design on the bone in pencil and gradually incise the lines until they are deep enough to accept the ink.

The ink is brushed onto the incised areas.

Surface ink is wiped off with a soft rag.

Incising the Bone

Next, draw your design directly on the surface with a pencil. Then, carefully following your pencil lines, inscribe the design with a needle, a dental tool that has been filed to a point, scribe or any pointed, sharp implement. Use light pressure. If you apply too much pressure, your hand may slip and the lines will not be true. Work slowly and easily, passing over each line several times, making it deeper on each pass. After several passes, the lines should be deep enough to accept the pigment.

In addition to these outlines, pigment can be held in areas that are textured with dots or tiny scratches. This is an excellent way to fill a large area with color or to shade a section of the design.

Coloring the Bone

Add color to the incised lines with a fine brush. Drawing ink or oil paint may be used in one or a variety of colors. Remove excess pigment from the surface with a soft rag.

Finishing the Piece

A pendant may be made from this scrimshaw by drilling a hole at the top of the piece and threading a thong, silk cord or other material through the hole.

Scrimshaw: Branching Out

✦ Saw buttons, beads or shapes from the bone and scrimshaw designs on the surface to decorate these items. Holes may be drilled to make the buttons and beads.

✦ Use the entire bone as a "canvas" on which to create a traditional seascape or more modern scene.

✦ Carve a small sculpture or amulet from the bone. Use a flexible shaft machine, Dremel tool or small files to shape the form. Polish the bone to a high gloss and add a few accents with scrimshaw.

✦ Try adapting this technique of incising lines and filling them with pigment, to different materials such as shells, wood or plastic.

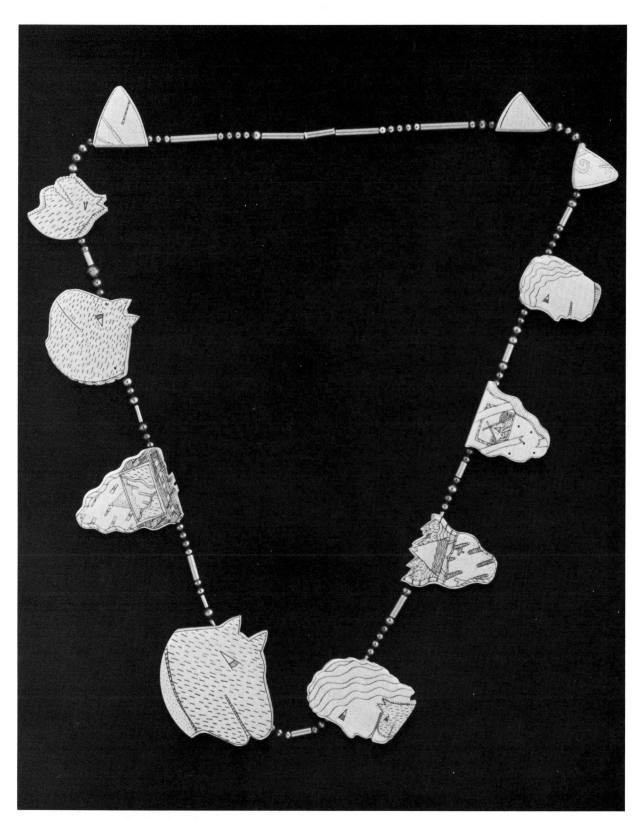

Roberta Williamson. Sterling silver and ivory.

Glossary

alloy A metal made by combining two or more metals in order to obtain a desirable characteristic such as color or hardness. Sterling silver, for example, is an alloy of silver and copper.

annealing The process of heating and then cooling metal to relieve stresses that have been built up as the metal was worked. Thus hardened metal can be returned to a more malleable state.

armature A framework used as a support for soft sculpting materials such as clay and papier-mâché.

batt One or several layers of carded wool (or other fibers).

beating In weaving, the process of compacting the weft with a comblike device.

bisque Fired, unglazed clay.

butterfly Weft yarn that is wound around the fingers in a figure eight pattern. The resulting bundle is easy to manipulate through the warp.

butt soldering Soldering pieces of metal together, edge to edge.

carding The process of aligning wool fibers to create a batt, accomplished with hand cards or on a carding machine.

cartoon A full-sized preparatory drawing.

cloisonné A form of enameling in which thin wires are used to separate colors.

core In basketry, the stronger foundation material around which more flexible material is coiled.

couching In making paper, the process of transferring a newly formed sheet of paper from the mold onto a felt.

counterenamel enamel fired on the reverse side of an enameled piece to counteract the tendancy of enameled metal to warp.

crackling The process of cracking wax before dyeing, to produce the characteristic veined effect in a batik.

deckle The upper section of a mold for forming a sheet of paper. The deckle is a frame that determines the shape of the paper.

felt a) A nonwoven, matted fabric formed when fibers interlock when subjected to moisture, heat and agitation.

b) In papermaking, the cloth onto which a newly formed sheet of paper is couched.

findings The elements of a piece of jewelry that join or close it, or attach it to the wearer.

flux A substance used to promote fusion in operations such as soldering metal and fusing glass.

fulling The process by which a hardened batt is transformed into felt by subjecting it to pressure, and shocking it with hot and cold water.

fusing The flowing together of substances when heated.

glaze The vitreous coating that is fused to clay by firing it in a kiln.

greenware Unfired pottery.

grog Ground or crushed fired clay that is added to unfired clay for texture and/or to reduce shrinkage and warpage.

heading The band of woven material at the beginning of a weaving that functions to spread the warp evenly.

hide Leather from a large animal such as a cow, horse or buffalo.

kiln A furnace for firing pottery, or for fusing glass or enamels.

kiln wash A substance applied to kiln shelves and the kiln floor to protect them from fusable materials such as glaze.

leather hard The stage in the hardening of clay where it is soft enough to be cut, yet dry enough to support itself.

mordant A chemical that promotes the permanent binding of dye to the material being dyed.

origami The art of Japanese paper folding.

pulp The suspension, in water, of pulverized cellulose, from which paper is made.

patina A film on metal that is formed by the process of natural or chemically induced oxidation. A patina changes the color of metal.

pickle An acid solution used to clean metal.

piercing Sawing or drilling designs into the surface of sheet metal.

plain weave (or tabby) The most basic weave, created when the weft travels under and over through the warp.

pyrometer A gauge used for measuring the interior temperature of a kiln.

pyrometric cone Small pyramids of ceramic material designed to bend at the maturing temperature of the clay being fired.

rawhide Untanned cattle hide.

resist A material such as wax that is applied to fabric to prevent dye from penetrating.

sgraffito Scratching into the surface of a substance such as clay or powdered enamel to create a design or texture.

shed The opening in the warp through which the weft is passed, formed when certain warp threads are raised or lowered.

shed stick A flat stick used to create a shed.

shuttle An instrument that holds the weft so that it can be easily threaded through the warp.

skins Leather from a small animal such as a pig, goat or calf.

slip Liquid clay.

slumping The sinking downward of a material such as glass or clay, usually into a mold.

soldering A method of joining surfaces of metal with an alloy of a lower melting temperature than that of the metals being joined.

stamping A method of creating a surface design or pattern with a punch, on metal or leather.

tanning A chemical process for preserving the skins of animals, thereby making them into leather.

tjanting tool A batiking tool used to hold hot wax for drawing designs on fabric.

tooling Making impressions in leather by compressing it with a tool.

undercut A cut in the contour of a mold which encases the material being cast and makes it difficult, if not impossible to remove.

warp Threads that run lengthwise in a weaving.

wedging Kneading clay to force out trapped air and make it consistent.

weft (or filling) Threads that travel across the warp in a weaving.

wet forming The process of soaking, modeling and then drying vegetable tanned leather to give it a permanent shape.

Bibliography

General

American Craft, American Craft Council, Membership Department, P.O. Box 1308-CL, Fort Lee, NJ, 07024. Monthly.

The Crafts Report, The Crafts Report Publishing Co., Inc., 700 Orange St., Wilmington, DE 19801. Monthly.

Griswold, Lester and Kathleen. *Handicraft*. New York: Van Nostrand Reinhold Company, 1969.

Howlett, Carolyn S. *Art in Craftmaking*. New York: Van Nostrand Reinhold Company, 1974.

Jefferson, Brian T. *Profitable Crafts Marketing: A Complete Guide to Successful Selling*. Portland, OR: Timber Press, 1985.

Lucie-Smith, Edward. *The Story of Craft. The Craftsman's Role in Society*. New York: Van Nostrand Reinhold Company, 1981.

McCann, Michael. *Artist Beware: The Hazards and Precautions in Working with Art and Craft Materials*. New York: Watson-Guptill, 1979.

Moseley, Johnson, Koenig. *Crafts Design; An Illustrated Guide*. Belmont, CA: Wadsworth Publishing Company, 1962.

Pearson, Katherine. *American Crafts: A Source Book for the Home*. New York: Stewart, Tabori & Chang Publishers, Inc., 1983.

The World Crafts Council. *In Praise of Hands*. Greenwich, CT: New York Graphic Society, 1974.

Clay

Ball, F. Carlton, and Janice Lovoos. *Making Pottery Without a Wheel*. New York: Van Nostrand Reinhold Company, 1965.

Brody, Harvey. *The Book of Low-Fire Ceramics*. New York: Holt, Rinehart and Winston, 1979.

Casson, Michael. *The Craft of the Potter: A Practical Guide to Making Pottery*. New York: Barron's Educational Series, Inc., 1977.

Cowley, David. *Molded and Slip Cast Pottery and Ceramics*. New York: Charles Scribner's Sons, 1978.

Kenny, John B. *The Complete Book of Pottery Making*, second edition. Radnor, PA: Chilton Book Company, 1976.

Nelson, Glenn C. *Ceramics: A Potter's Handbook*. New York: Holt, Rinehart and Winston, Inc., 1971.

Nigrosh, Leon I. *Claywork*, second edition. Worcester, MA: Davis Publications, Inc., 1986.

Rhodes, Daniel. *Clay and Glazes for the Potter*. Philadelphia: Chilton, 1957.

Fiber

Arnow, Jan. *Handbook of Alternative Photographic Processes*. New York: Van Nostrand Reinhold Company, 1982.

Baldwin, Ed and Stevie. *The Weepeeple*. New York: G.P. Putnam's Sons, 1983.

Bliss, Anne. *North American Dye Plants*. New York: Charles Scribner's Sons, 1976.

Gordon, Beverly. *Feltmaking*. New York: Watson-Guptill Publications, 1980.

Grae, Ida. *Nature's Colors: Dyes from Plants*. New York: Macmillan Publishing Co., Inc., 1974.

Hart, Carol and Dan. *Natural Basketry*. New York: Watson-Guptill Publications, 1976.

Held, Shirley E. *Weaving*. New York: Holt, Rinehart and Winston, Inc., 1972.

Howard, Constance, editor. *Textile Crafts*. New York: Charles Scribner's Sons, 1978.

Johnston, Meda Parker, and Glen Kaufman. *Design on Fabrics*. New York: Van Nostrand Reinhold Company, 1967.

Koehler, Nancy Howell. *Photo Art Processes*. Worcester, MA: Davis Publications, Inc., 1980.

Meilach, Dona Z. *Contemporary Batik and Tie-Dye*. New York: Crown Publishers, Inc., 1973.

———. *A Modern Approach to Basketry*. New York: Crown Publishers, Inc., 1974.

———. *Soft Sculpture and Other Soft Art Forms*. New York: Crown Publishers,Inc., 1974.

Robinson, Sharon. *Contemporary Basketry*. Worcester, MA: Davis Publications, Inc., 1978.

Sommer, Elyse and Mike. *Wearable Crafts*. New York: Crown Publishers, Inc., 1976.

Tod, Osma Gallinger. *Earth Basketry*. New York: Bonanza Books, a division of Crown Publishers, Inc., 1972.

Znamierowski, Nell. *Step-By-Step Weaving*. New York: Golden Press, 1976.

Glass

Bates, Kenneth. *Enameling: Principles and Practice.* Cleveland and New York: The World Publishing Company, 1951.

Erikson, Erik. *Step-by-Step Stained Glass.* New York: Golden Press, Inc., 1974.

Harper, William. *Step-By-Step Enameling.* New York: Golden Press, 1973.

Kinney, Kay. *Glass Craft.* Radnor, PA: Chilton Book Company, 1962.

Lundstrom, Boyce, and Daniel Schwoerer. *Glass Fusing - Book One.* Portland, OR: Vitreous Publications, Inc., 1983.

Rothenberg, Polly. *The Complete Book of Creative Glass Art.* London: George Allen & Unwin Ltd., 1974.

Leather

Garnes, Jane. *The Complete Handbook of Leathercrafting.* Blue Ridge Summit, PA: Tab Books, Inc., 1981.

Hayden, Nicky, editor. *Leather.* New York: Charles Scribner's, 1979.

Hills, Pat. *The Leathercraft Book.* New York: Random House, 1973.

Lingwood, Rex. *Leather in Three Dimensions.* Toronto, Canada: Van Nostrand Reinhold Ltd., 1980.

Matthews, Glenice Leslie. *Enamels, Enameling, Enamelist.* Radnor, PA: Chilton Book Company, 1984.

Newman, Thelma R. *Leather as Art and Craft; Traditional Methods and Modern Designs.* New York: Crown Publishers, Inc., 1973.

Metal

Bovin, Murray. *Jewelry Making for Schools, Tradesmen, Craftsmen,* rev. ed. by Peter Bovin. Forest Hills, NY: Bovin Publishing, 1979.

DiPasquale, Dominic. *Jewelry Making: An Illustrated Guide to Technique.* Englewood Cliffs, NJ: Prentice-Hall, 1975.

Evans, Chuck. *Jewelry: Contemporary Design and Technique.* Worcester, MA: Davis Publications, 1983.

Fisch, Arline. *Textile Techniques in Metal for Jewelers, Sculptors, and Textile Artists.* New York: Van Nostrand Reinhold, 1975.

McCreight, Tim. *The Complete Metalsmith.* Worcester, MA: Davis Publications, Inc., 1982.

Morton, Philip. *Contemporary Jewelry: A Studio Handbook,* rev. ed. New York: Holt, Rinehart and Winston, 1976.

Sommer, Elyse. *Contemporary Costume Jewelry: A Multimedia Approach.* New York: Crown, 1974.

Sprintzen, Alice. *Jewelry: Basic Technique and Design.* Radnor, PA: Chilton Book Company, 1980.

Untracht, Oppi. *Jewelry Concepts and Technology.* Garden City, NY: Doubleday & Company, 1982.

von Neumann, Robert. *The Design and Creation of Jewelry*, rev. ed. Radnor, PA: Chilton, 1972.

Paper

Harbin, Robert. *Origami: The Art of Paperfolding.* New York: Barns and Noble Books, a Division of Harper and Row Publishers, Inc., 1969.

Kasahara, Kunihiko. *Creative Origami.* Tokyo: Japan Publications, Inc., 1976.

Kenneway, Eric. *Origami: Paperfolding for Fun.* London: Octopus Books Limited, 1980.

Kenny, Carla and John. *Design in Papier Mache.* Radnor, PA: Chilton Book Company, 1971.

Newman, Thelma, Jay Hartley Newman, and Lee Scott Newman. *Paper as Art and Craft: The Complete Book of the History and Processes of the Paper Arts.* New York: Crown Publishers, Inc., 1973.

Rottger, Ernst. *Creative Paper Design.* New York: Reinhold Publishing Corporation, 1961.

Toale, Bernard. *The Art of Papermaking.* Worcester, MA: Davis Publications, Inc., 1983.

Zeier, Franz. *Paper Constructions: Two- and Three-Dimensional Forms for Artists, Architects, and Designers.* New York: Charles Scribner's Sons, 1974.

Scrimshaw

Linsley, Leslie. *Scrimshaw: A Traditional Folk Art, A Contemporary Craft*. New York: Hawthorn Books, Inc., 1976.

Ritchie, Carson I. A. *Scrimshaw.* New York: Sterling Publishers, 1972.

Sources of Supplies

Allcraft Tool and Supply Company
100 Frank Road
Hicksville, NY 11801
(jewelry and enameling supplies)

American Art Clay Co.
4717 W. 16th St.
Indianapolis, IN 46222
(ceramic supplies)

Anchor Tool and Supply Co.
231 Main Street
Chatham, NJ 07928
(jewelry supplies)

Bullseye Glass Company
3722 S.E. 21st Avenue
Portland, OR 97202
(stained glass)

**Ceramic Supply of New York and
 New Jersey**
534 La Guardia Place
New York, NY 10012
(ceramic supplies)

Cerulean Blue Ltd.
P.O. Box 21168
Seattle, WA 98111
(blueprinting and batiking supplies)

Createx ColorCraft Ltd.
P.O. Box 936
Avon, CT 06001
(dyes)

Cutter Ceramics
47 Athletic Field Road
Waltham, MA 02254
(ceramic supplies)

Dick Blick
Box 1267
Galesburg, IL 61401
(general craft supplies)

C.D. Fitzhardinge-Bailey
15 Dutton Street
Bankstown
New South Wales 2200
Australia
(natural dyestuffs)

Freed Co.
Box 394
Albuquerque, NM 87103
(beads, fur, leather, silk)

Gesswein
255 Hancock Avenue
Bridgeport, CT 06605
(jewelry tools and equipment)

Glass Emporium Studios
North Main Street
Davidson, NC 28036
(fused and stained glass supplies)

Greentree Ranch Wools
163 N. Carter Lake Road
Loveland, CO 80537
(felting and weaving supplies)

Grey Owl Indian Craft Co., Inc.
113-15 Springfield Boulevard
P.O. Box 507
Queens Village, NY 11429
(American Indian crafts supplies, beads, shells)

Harrisville Designs
Harrisville, NH 03450
(dyed carded fleece, looms and accessories, yarns)

Jack D. Wolfe Company
82 Harrison Place
Brooklyn, NY 11237
(ceramics and enameling supplies)

Lee Scott McDonald
P.O. Box 264
Charlestown, MA 02129
(papermaking supplies, cotton linter)

Maisel Company
1500 Lomas Blvd. N.W.
Albuquerque, NM 87104
(jewelry supplies, findings, stones)

The Mannings
P.O. Box 687
East Berlin, PA 17316
(weaving and basketry supplies, natural dyestuffs)

Miller Ceramics Inc.
4022 Mill Road
Skaneateles, NY 13152
(ceramics supplies)

Nasco
Fort Atkinson, WI 53538
(general crafts supplies)

Nervo International
4365 Arnold Avenue
Naples, FL 33942
(stained glass supplies)

Peerless Rattan & Reed
P.O. Box 636
Yonkers, NY 10702
(basketry supplies)

H.H. Perkins Co.
10 South Bradley Road
Woodbridge, CT 06525
(basketry supplies)

Pro Chemical & Dye, Inc.
P.O. Box 14
Somerset, MA 02726
(dyes, batiking supplies)

Pyramid Paper Co., Inc.
Box 877
Urbana, IL 61801
(papermaking and general crafts supplies)

Rio Grande Jewelers Supply
6901 Washington N.E.
Albuquerque, NM 87109
(jewelry supplies, findings, stones)

RIT
Best Foods North America
1437 West Morris Street
P.O. Box 21070
Indianapolis, IN 46221
(Rit dyes)

School Products Co., Inc.
1201 Broadway
New York, NY 10001
(weaving supplies)

Sheffield Pottery
Box 399
U.S. Route 7
Sheffield, MA 01257
(ceramics supplies)

Straw Into Gold
3006 San Pablo Avenue
Berkeley, CA 94702
(dyes, silk, yarns)

Takhi
92 Kennedy Street
Hackensack, NJ 07601
(imported yarns)

Tandy Leather Company
(See phone directory for local listings)
(leather supplies)

Thompson Enamels
P.O. Box 310
Newport, KY 41072
(enameling supplies, lead-free enamels)

Twinrocker Paper Co.
RFD 2
Brookston, IN 47923
(papermaking supplies)

Wausau Woolen Company
408 South Fourth Street
Wausau, WI 54401
(carded wool batts)

The Weaver's Knot
121 Cleveland Street
Greenville, SC 29601
(basketry, felting and batiking supplies, silk)

Western Ceramics Supply Company
P.O. Box 939
San Carlos, CA 94070
(ceramics and enameling supplies)

Westwood Ceramic Supply Company
14400 Lomitas Avenue
City of Industry, CA 91746
(ceramics supplies)

Whittemore-Durgin
P.O. Box 2065
Hanover, MA 02339-0265
(stained glass supplies)

Wilde Yarns
3705 Main Street
Philadelphia, PA 19127
(felting supplies, yarns)

Worth Leather Company
23 Newtown Rd.
Plainview, NY 11803
(leather supplies, buckles)

Index

Nevelson, Louise, 20

O

O'Connor, Harold, 145, 162
O'Neill, Tim, 110
Origami, 3-5

P

Paper, 1-27
 braided, 12
 couching, 16
 curled, 1, 13
 cut, 1, 8-11
 folded, 1, 2-5
 hand formed, 18-19
 mold, 15
 papier-mâché, 22-27
 scored, 1, 5
 sheet, cast, 15-19
Paper pulp, 15-19
 cotton linter, 15, 16
 hand formed, 18-19
 sheet, cast, 15-19
Papier-mâché, 22-27
Parker, Sharron, 65
Plain weave, 34, 35
Plaster molds, 90-92
 for clay, 88-89
 for leather, 128-130
 for paper 15, 19, 21
 undercuts in, 90
Potter's wheel, 96-101

R

Rya, 35

S

Sauer, Jane, 72
Sawing, metal, 149-153
Scoring
 glass, 114, 115
 paper, 5-6
Scrimshaw, 164-169
 cow bone, 165-168
Sgraffito, 123
Simmons, Peggy, 125, 148, 149
Slabs, clay, 83-89
 draping, 89
 joining, 86
 slumping, 89
 stamping into, 86
Slumping
 clay, 89
 glass, 107, 110, 111
Soldering
 and enameling, 118
 metal, 155-163
 butt, 159-160
 sweat, 160-161
 stained glass, 116-117
Soumac weave, 34, 35
Spiegel, Dorothy, 55
Stained glass, 112-117
 cutting, 114
 scoring, 114
 soldering, 116
Stamping
 in clay, 86

in leather, 135-136
in metal, 146
Stenciling, enamels, 122
Stevens, Bertha, 37
Stocking figures, 51-55
Struhl, Ruth, 61

T

Tapestry weaving, 35-39
Tie-dye, 42-44
 dyes for, 44
Tiffany, Louis Comfort, xi, 112
Tjanting tool, 45
Tooling leather, 135-137
Torches, 156, 157
Twining
 in basketry, 71-75
 in weaving, 34-35

W

Wahnetah, Cora, 82
Wansor, Alice, 71, 77, 79
Warp, 29, 31, 32, 33-34, 35, 71
Watson-Abott, Lynda, 163
Weaving, 29-39
 beating, 33
 cartoon for, 38
 finishing, 39
 heading, 33
 joining colors, 38-39
 looms, 31-32
 stitches, 34-35
 tapestry, 35-39
Weaving, paper, 12
Weaving stitches, 34-35
 basket weave, 34
 plain weave, 34
 rya, 35
 soumac weave, 34
 twining, 34
Webb, Aileen Osborn, xiii
Weber-Grassi, Graziella, 31
Wedging clay, 81-82, 96
Weft, 29, 33, 34, 35, 71
 starting and ending, 33
Welch, Ann, 45, 49
Wet forming, 128-133
Williamson, Dave, 100
Williamson, Roberta, 150, 153, 169
Wolf, Ronnie, 109, 111
Wolff, Julian, 144
Wolff, Sylvia, 20, 21

X

Xerox transfers, 60-62